IMPRESSIONISM

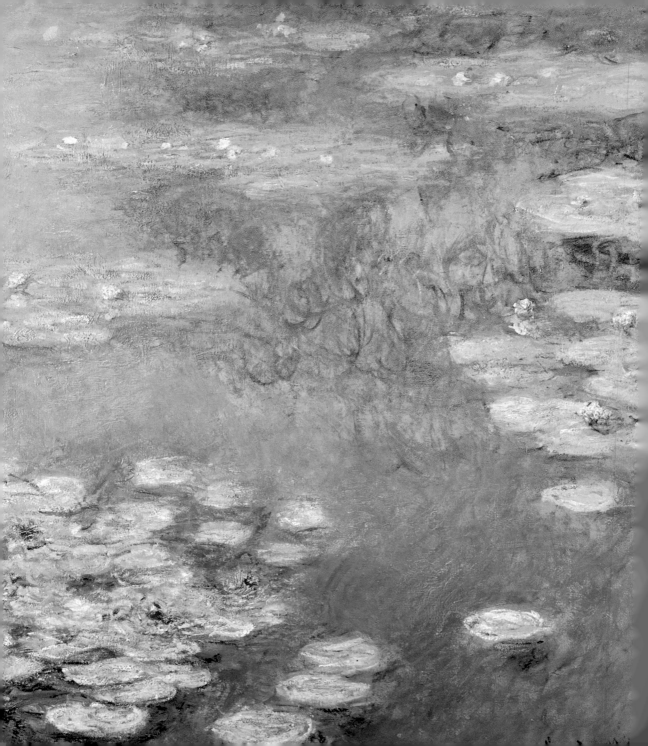

Martina Padberg

IMPRESSIONISM

With contributions by
Anke von Heyl,
Antonia Loick
and Holger Möhlmann

*h.f.*ullmann

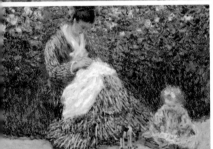
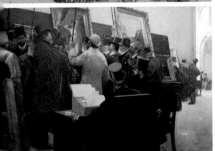

Contents

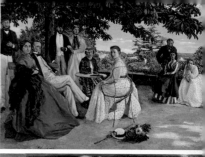
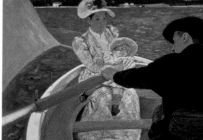

Illustration, p. 2:
Claude Monet, *Water Lilies in Giverny,* 1908 (see p. 223)

Introduction: An Exhibition and its Consequences

On 15 April 1874 an exhibition that would make history was opened in the former studio space located on the Boulevard des Capucines in Paris of the famous photographer Gaspard-Félix Tournachon, known as Nadar (1820–1910). Thirty artists who called themselves the "Société anonyme des artistes peintres, sculpteurs, graveurs" (Incorporated Society of Artists, Painters, Sculptors and Engravers) presented 165 works. Many of the participants are long since forgotten, while others are among the most famous artists of the late 19th century. Paul Cézanne, Edgar Degas, Claude Monet, Berthe Morisot, Camille Pissarro, Alfred Sisley, and Auguste Renoir made up the core of this informal "society," which was united by close personal friendships and common artistic ideas. Between 1874 and 1886, a total of eight group exhibitions were mounted, although often with the participation of different artists.

At the time of the first public exhibition, all the important protagonists were already over 30 years old.

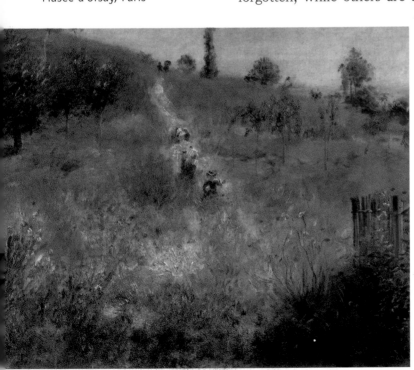

Auguste Renoir,
The Path Through The Long Grass, 1875,
oil on canvas, 59 × 74 cm,
Musée d'Orsay, Paris

They were, therefore, not beginners in the least and most of them had completed some kind of academic training in art. Their experiences with the official French art institutions, the École des Beaux-Arts and the Salon, had, however, usually been characterized by disappointment.

In short, the artists who would later be united under the name "Impressionists" were not at the beginning of their careers in 1874 but rather had already had a long, often common journey behind them. Several of them had known each other for more than a decade, had studied together, had discussed things vehemently in the cafés of Paris, had traveled into the countryside to paint together or had worked in shared studios during the Franco-Prussian War (1870/71).

Those artists who did not have financial reserves were hard hit by the economic crisis of 1873; artists such as Pissarro, Sisley, and Monet, who already had families to feed, truly suffered. Initiatives to improve their financial situation were, thus, imperative in this situation. At the end of 1873, an idea from the 1860s was taken up anew and eleven artists signed the corporate charter of the Society on 27 December, although there was no consensus with regard to their aims and future plans. While the politically active Pissarro preferred the idea of a cooperatively organized artists' union and wished to use the bylaws of the bakers' union of his hometown of Pontoise as the Society's statutes, Degas preferred the more open form of a "partnership of convenience," in order to avoid the impression of belonging to a group of rejects, or possibly even agitators.

Gaspard Félix Tournachon (Nadar),
The Studio of the Photographer Nadar, 35 Boulevard des Capucines, 1855, photograph, Private collection

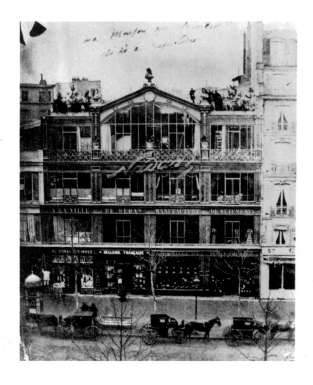

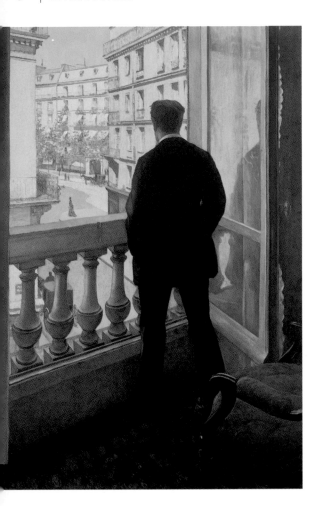

Gustave Caillebotte,
Man at the Window, 1875,
oil on canvas, 117 × 83 cm,
Private collection

The protagonists finally agreed to a minimum amount of common ground; for a contribution of 60 francs, each member had the right to participate in a self-organized exhibition submitting two works apiece. The paintings were to be hung by drawing lots in order to avoid injustices. There was no other program organized by the Society. In order to finance the cost of lighting, rent, insurance, wages, posters and printing a catalogue, 19 additional artists were ultimately also invited to join the group. This measure, too, was characterized more by differences than by what they had in common; while Pissarro instigated the participation of Paul Cézanne, whose painting was considered unbridled and cold, Degas was more drawn to the established Salon artists.

The result was ultimately a very heterogeneous exhibition that was a far cry from one that made a programmatic statement! Nonetheless, the works submitted by Monet, Pissarro, Morisot, Renoir, and Degas attracted far more attention than those of the participating Salon painters. Critics and visitors both sensed that there was something new to be discovered here and reacted very differently, with biting ridicule or intrigued encouragement. Malicious reviews, including one published in the satirical magazine, *Le Charivari,* may have actually led to an increase in the number of exhibition visitors: many may have come to the Boulevard des Capucines out of a craving for sensation. In the wake of this exhibition came the name describing this new style of painting, one that is still used today. Legend has it that Auguste Renoir's brother, Edmond,

who was in charge of editing the catalogue, was so annoyed by the monotonous titles Monet had suggested for his paintings, ("Path into the Village," "Path out of the Village," "Morning in the Village") that he demanded in exasperation that the artist improve them. Monet is said to have glanced at one of his paintings, one with a view of the Le Havre harbor, and said: "Why don't you just write 'Impression'"? And that is how it came to be – and the critics, then as now, seeking to find fitting categorizations for artistic phenomena, gratefully adopted the term. The term was not a derisive nickname, as is often maintained, but rather a very perceptive description of the particular character of this type of painting. In his exhibition reviews from April 29, 1874, the critic Jules Castagnary (1830–1888) described the artists surrounding Pissarro as "Impressionists … in the sense that they do not reproduce a landscape but rather the feelings aroused by that landscape." Even today the special quality of Impressionist painting cannot be described any better than this.

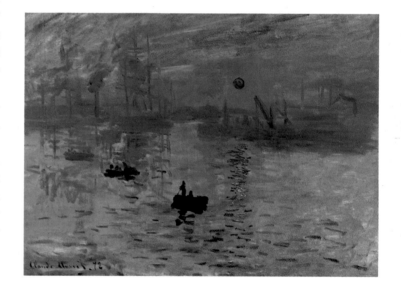

Claude Monet,
Impression, Sunrise,
1872/73, oil on canvas,
48 × 63 cm,
Musée Marmottan Monet, Paris

In order to enjoy the undivided attention of the Parisian public, the exhibition was strategically opened two weeks before the Salon's annual event and could be viewed from 10am to 6pm, as well as from 8 to 10pm. The entrance fee was one French franc, the modest catalogue 50 centimes. Approximately 3,500 people visited the exhibition during its four-week run and some 50 reviews appeared in the

press – not a bad response. The sale of paintings, in contrast, was slow: the most successful painter was Alfred Sisley, followed by Claude Monet, Auguste Renoir and Camille Pissarro. Degas and Morisot sold nothing. When the representatives of the Society met in Renoir's studio to close the accounts on December 17, 1874, they recorded a deficit of 3,713 francs. The Society was dissolved amid frustration and its members scattered to the winds: Cézanne went to Aix-en-Provence, Sisley took up an invitation to visit England and Monet went back to his family in Argenteuil. Pissarro, who, because of his desperate financial situation, had not even come to Paris in the first place, had to leave his home in Pontoise just a few weeks later. "I suffered unspeakably ..." he wrote to a friend about this period. "And yet I would not hesitate to do the same thing if I were to do it all again." It was Pissarro who instigated another exhibition two years later. This time only 18 artists participated – a smaller but more clearly defined group, which included Gustave Caillebotte, another very interesting artist and motivated comrade-in-arms.

Following the decline of the Second Empire and the bloody suppression of the Paris Commune in May 1871, Paris became the spectacular scene of the Belle Époque at the end of the 1870s. Emperor Napo-

Camille Pissarro

(10 July 1830 Saint-Thomas/French Antilles – 13 Nov. 1903 Paris)

In **1855** Pissarro emigrated from the French Antilles to Paris and began to study at the Académie de Suisse, where he met Claude Monet. Strongly influenced by Corot and Daubigny, as well as by Courbet, Pissarro discovered the rural landscape of the Île-de-France.

Between **1874** and **1886** he helped to organize the eight Impressionist exhibitions. Always interested in new developments, Pissarro worked with Cézanne and Gauguin.

In **1886** he temporarily adopted the Pointillist painting technique of Georges Seurat and Paul Signac. Plagued by financial worries, Pissarro lived a life of deprivation in the country with his wife and seven children.

It was only in the **1890s** that his economic situation improved. His later work is impressive, with its outstanding boulevard scenes and cityscapes of Paris, London and Rouen.

leon III had already transformed the city into a modern metropolis. The Impressionists were the first to react to this modernity with an absolutely contemporary style of painting. Neither Classical mythology, nor the glorious past of their nation, presented them with subject matter for their paintings; their own lives did. The public staging of Parisian society at the opera and on the boulevards interested the artists just as unconditionally as did the atmosphere of the private realm; the unspectacular was just as worthy of being represented as the sensational. "Impressionism" signified, above all, an uncompromising painting style without traditions and hierarchies. In spite of all its supposed easy-viewing qualities, this was precisely the reason for its explosive power, as it still is today.

Maximilien Luce,
A Paris Street in May 1871 (The Commune), 1903–05, oil on canvas, 151 × 228 cm, Musée d'Orsay, Paris

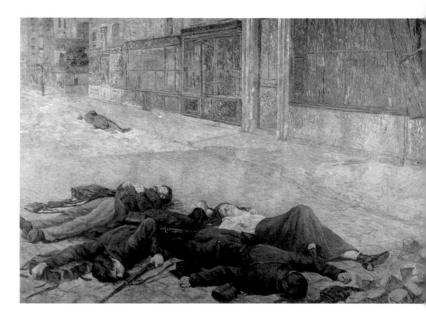

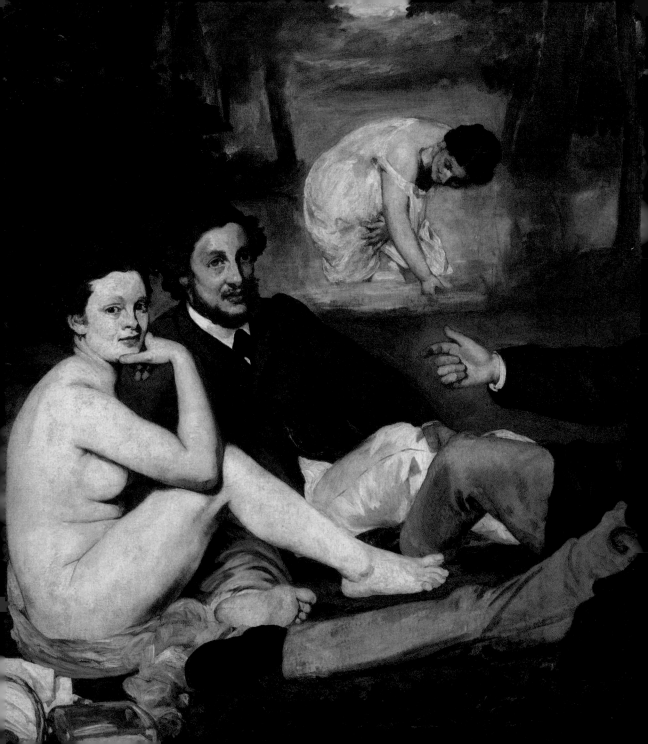

Édouard Manet and Modern Life

A strange picnic: two bourgeois men, both dressed in frock coats and ties and holding canes, sit together with a nude woman on the ground in a forest. In the background, strangely distant from the scene, another woman wades in her slip in a lake. What kind of people are these and what unites them? While the man on the right – with an outstretched gesture – seems to speak, the one opposite stares into space, lost in thought. The young woman in the foreground, by contrast, very confidently – almost impertinently – stares at an imaginary viewer despite her defenseless nudity. Is this really a harmless excursion into the countryside? What kind of a story is being told by this painting that Parisian society greeted with hysterical laughter and sharp criticism? And: Who painted it?

Édouard Manet,
Luncheon on the Grass (detail of p. 17), 1863, oil on canvas, 208 × 264 cm, Musée d'Orsay, Paris

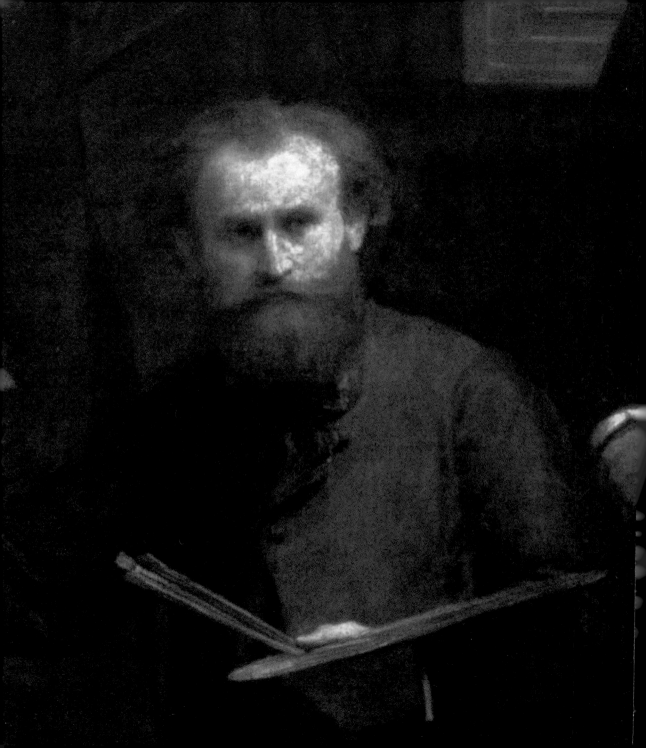

Manet – "King of the Impressionists"

Édouard Manet (1832–1883) enjoyed a special status in the Impressionist art scene. By fusing together new, contemporary themes with representation possibilities that had been handed down by and borrowed from art history, he became one of his era's great innovators. Manet was considered a well-educated intellectual and knowledgeable about art history and as someone who had excellent contacts with the most important literary figures, thinkers and art critics of his day. He was an exceptional person, unmistakable in his painting style, persistent and independent in the way he marketed himself. His studio was an important meeting place and he was a valued dialogue partner and advisor to his artist friends. He stayed resolutely clear, however, of the exhibition activities of the Impressionists. To the end of his days, his efforts, rather, were dedicated to being recognized by the official, institutionalized art scene, the Salon and the Academy (see Chapter 2).

The group portrait, painted in subdued colors (p. 15) by Henri Fantin-Latour (1836–1904), depicts a concentrated Manet at the easel, surrounded by fellow painters, such as

Henri Fantin-Latour,
A Studio at Les Batignolles,
1870,
oil on canvas, 204 × 273.5 cm,
Musée d'Orsay, Paris

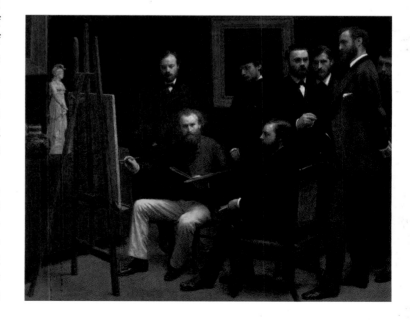

Claude Monet, Frédéric Bazille and Auguste Renoir, as well as the writer Émile Zola (1840–1902). Carrying on in the Dutch tradition of the friendship portrait, Manet's special role, his impressive charisma and his seriousness are detectable through his central position in the room and in the painting's composition. The painter's models and interests are referred to in the studio's sleek interior by the small classical sculpture of Minerva, the Roman goddess of wisdom, and by the Japanese vase.

Manet is clearly both the external and internal center of the group. On the other hand, Claude Monet, eight years younger than Manet, is placed on the right-hand edge of the painting, and Camille Pissarro, the quarrelsome organizer of the Impressionist exhibitions, is not even present. The journalist and art critic, Zacharie Astruc (1835–1907), is seated next to the easel, obviously serving as the model for the portrait being painted. Astruc for his part introduced Manet to Parisian society in various art publications and described him in the following manner: "Manet's talent has something amazing, piercing, reserved and energetic about it, which explains his reserved and yet enthusiastic character, and, above all, his great receptiveness to strong impressions." Also a painter, Astruc was – in contrast to Fantin-Latour and Manet – represented in the first Impressionist exhibition four years later.

The "Heroism of Modern Life"

Manet longed for his ambitious works to have a place in museums; this is already obvious from his preference for large format paintings that were unsuitable for private collections. In Manet's day, however, museum art had to fulfill certain requirements. The favored style was, above all, elaborate historic paintings. Manet however, did not fulfill these demands: as a rule his paintings did not deal with Classical or biblical myths and tales, but rather depicted modern

"He will never completely overcome the weaknesses of his temperament, but he has temperament, and that is the most important thing," wrote the poet Charles Baudelaire about his friend Édouard Manet in 1865.

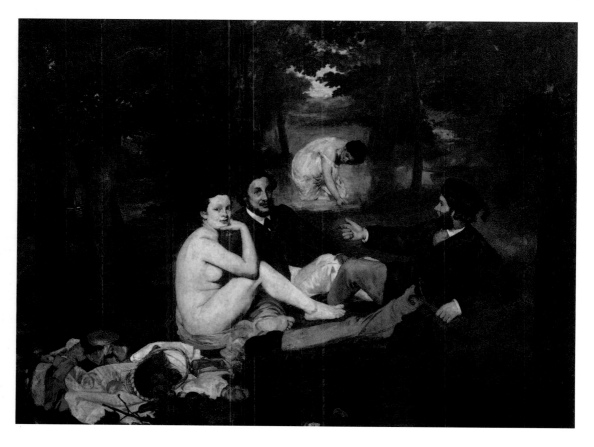

people in urban settings: in parks, cafés or on the street, provoking and stimulating his public to protest. When he then also revealed the double standards of his own society, as he did in *Luncheon on the Grass (Le Déjeuner sur l'herbe"* (p. 17), by unmistakably alluding to the widespread prostitution in the Bois de Boulogne in his depiction of two well-dressed men with an attractive nude woman, a scandal broke out. When the painting was exhibited as *Le Bain (The Bath)* in 1863 in the Salon des Refusés, the public's laughter made "the walls shake," as one eyewitness noted. The reaction disappointed and hurt Manet deeply,

Édouard Manet,
Luncheon on the Grass, 1863, oil on canvas, 208 × 264 cm, Musée d'Orsay, Paris

Following double spread:
Édouard Manet,
Luncheon in the Studio (detail), 1868, oil on canvas, 118 × 153 cm, Neue Pinakothek, Munich

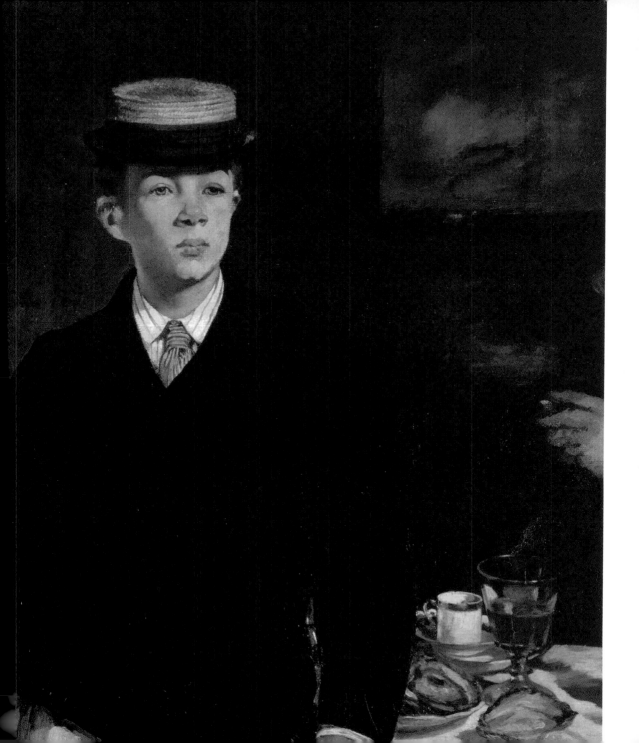

for he believed he had been completely misunderstood. He wanted to be nothing less than a revolutionary. The painting's explosive quality was its radical re-evaluation of previously established categories and conventions. The representation of the nude female body had had its place in art since the Renaissance, although only in the veiled framework of Classical mythology. A sprawled out nude could appear anytime as Venus, but never be obviously recognizable as a Parisian cocotte. Manet broke this firm tradition. Additionally, he chose the sophisticated format of a history painting for this seemingly trite theme and even quoted art-historically prestigious, and thus untouchable, compositions: The group of three in the foreground was modeled on an engraving by Raimondi after Raphael (*c.* 1515/16) and he borrowed the combination of the figures from the famous *Rural Concert* (*c.* 1510) by Giorgione, which he had studied and copied in the Louvre. The exemplary art of the Old Masters was thus degraded to a stereotype for the representation of bohemian escapades – this was at least the opinion of the infuriated Parisians.

Such extensive modernization was part of an intellectual debate: The need to create paintings that depicted typical, contemporary life was a demand that the literary figure Charles Baudelaire (1821–1867)

Édouard Manet

(23 Jan. 1832 Paris – 30 Apr. 1883 Paris)

Manet grew up in a wealthy family. After initial desires to become a sailor, he began to study art in **1850** with Thomas Couture.

In **1861** in the Louvre he met Edgar Degas, with whom he would have a lifelong friendship. In **1865** he studied the works of Velázquez and Goya during a journey to Spain.

After being rejected several times by the jury of the official Salon, Manet organized his own exhibition in **1867** in a wooden pavilion built for the occasion.

Despite his continued failure to gain success on the official art market, he did not participate in the exhibitions of the Impressionists.

In **1880** his work finally began to gain recognition and in **1881** he received a medal from the Salon and became a member of the Legion of Honor. His health had already begun to deteriorate, however, and he died in **1883** following the amputation of a leg.

had already made painters take to heart in his early Salon reviews from 1845 and 1846. With the heading "On the Heroism of Modern Life," the 24-year old predicted: "He will be the painter, the true painter, who will reclaim life's epic side from contemporary life, who will teach us to understand, with his colors and drawings, just how great and poetic we are with our neckties and patent leather boots." Manet embodied this ideal brilliantly. He created completely novel, suggestive paintings that grasped the modern city dweller in all his ambivalence. His collage-like style, with regard to both composition and the irregular painterly rearrangement of the representational, also provided subsequent generations of artists with a wide variety of impulses.

Édouard Manet,
The Croquet Party, 1873, oil on canvas, 73 × 106 cm, Städel Museum, Frankfurt am Main

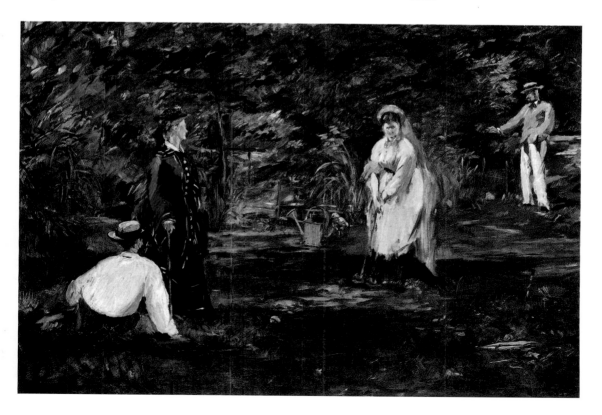

Manet places an elegant city dweller with her little dog in front of train tracks. It is Victorine Meurent, who also served as a model for *Luncheon on the Grass*. Next to her is a girl in her Sunday dress. Trains and train stations, which were new a phenomenon in the cities, found their way into paintings for the first time.

The Art Scene in Batignolles

Manet's eventful career, which he initially followed against the massive protest of his father, began in the studio of perhaps France's last great history painter of the 19th century, Thomas Couture (1815–1879). Manet entered the studio when he was 19 and for six years witnessed a style of painting that was technically brilliant and included an enormous array of figures, architectural prospects and drapery, but that ultimately lacked innovative strength. With his large-format history paintings, Couture regarded himself as a successor to the Italian masters, above all to Raphael and Veronese. Manet also tirelessly studied and copied the Old Masters in the Louvre. He was particularly influenced by Titian, Tintoretto, and Giorgione, as well as Delacroix. Manet's intense studies led to a technical perfection that was soon recognized and admired by both colleagues and critics. Already his *Spanish Singer* (now in the Metropolitan Museum of Art, New York), which he exhibited in the Paris Salon in 1860, attracted attention.

As an independent artist Manet settled in the newly developed neighborhood around the Boulevard Batignolles in Paris's northwest. The area between Montmartre and the Saint-Lazare train station became the preferred area to work and live in for many artists of the period. In the evenings the preferred meeting place was the Café Guerbois at no. 11, Grande Rue de Batignolles (today's Avenue de Clichy). A regular group of artists and writers met there, including Edgar Degas, Paul Cézanne, and the art critic, Louis-Edmond Duranty, as well as those depicted in Fantin-Latour's group portrait. People met up in studios and cafés in order to enjoy intense and often highly controversial discussions about art, aesthetics and techniques, as well as about composition and how to handle literary sources. The fact that these were not half-hearted debates is demon-

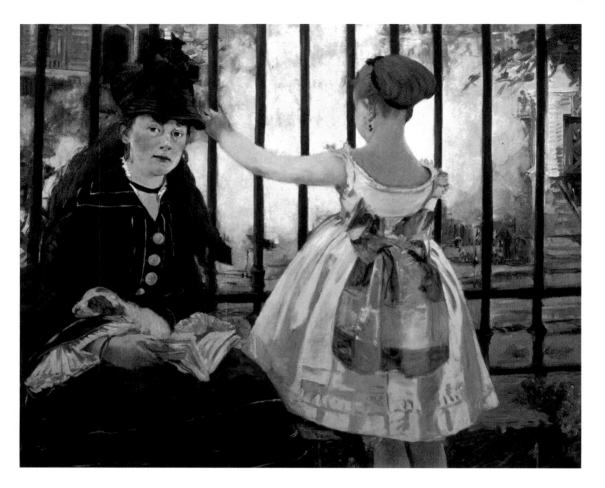

strated by a legend claiming that Manet, angered by a review written by Duranty, fought a duel with him in 1870.

Édouard Manet,
The Railway, 1872/73,
oil on canvas, 93 × 114 cm,
National Gallery of Art,
Washington

Figure and Space

Manet was, above all, a great painter of figures and people were always the focal point of his works. Although his calculated, cool compositions put the individual or group of figures in a special context, be this the interior of a studio, a private room, a bar, a public park, the beach or the street, it

is primarily the impressive portraits of his major works that viewers remember: the provoking gaze of his *Olympia,* the dandy's lascivious nonchalance in *Luncheon in the Studio* (p. 18) and the melancholic look of the young woman behind the counter in his *Bar at the Folies-Bergères.*

While the Impressionist painters surrounding Claude Monet carried their easels out into the countryside and adapted their painting style to the changing conditions of natural light, Manet's paintings were created in a lengthy process in his studio, prepared with sketches and designs and completed with the help of models and props. Individual paintings show, however, that he tried out different possibilities. In *The Railway* (p. 23) the atmospheric appearance of the engine's sporadic escape of stream became a new painterly formulation. Manet's approximation of the Impressionist style is even clearer in a snapshot image of two couples playing croquet (p. 21) and in the view of his studio near the Rue Mosnier (p. 27). If black had played an important role in Manet's paintings before this, a bright light spreading over this painting attacks objects in their structure and dissolves them into a shining brightness. The expressive brushstroke with which Manet outlines a group of construction workers in the foreground of the street scene no more than hints at the actual motif. Instead, a bright background of colors opens up the entire painting, leveling all details. When the magazine, *Les Contemporains* (The Contemporaries), depicted Édouard Manet on the title page in 1876 and referred to him as "the king of Impressionists," caricaturing him on a throne made of a converted palette wearing a lop-sided crown, it was not really a question of these painterly experiments. Although he did not participate in any of the eight Impressionist exhibitions, Manet had opened the door to a new form of painting that relentlessly incorporated the contemporary era into painting and art.

An expressive brushstroke hints rather than describes. The palette is bright and light. Manet, too, experiments occasionally with "plein air" painting.

Édouard Manet,
The Rue Mosnier with Pavers
(preceding double spread:
detail), 1878,
oil on canvas, 65.5 × 81.6 cm,
Kunsthaus Zürich

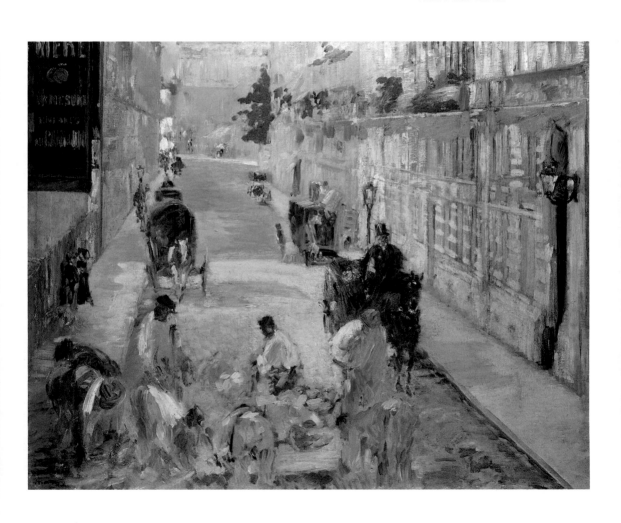

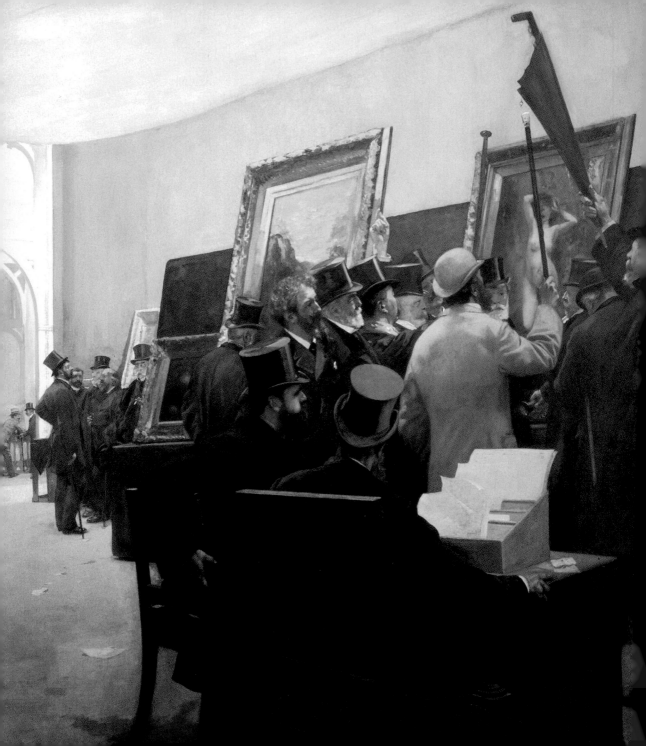

Institutions:

The Academy and Salon

The financial value of a painting was ironically easiest to read for an interested buyer in 19th-century Paris by looking at its reverse: If it was marked with an "R" then caution was advised. This signified that the painting had been "rejected" by the jury of the official Paris Salon. It had not been awarded a place in the annual exhibition and was, therefore, of much less value than an exhibited work would have been. Several rejections by the Salon usually signified the end of a painter's career. This was because the Salon enjoyed an undisputed monopoly and it was only there that artists could present their work to the public, the important collectors, gallery owners and critics.

Henri Gervex,
A Meeting of the Judges of the Salon des Artistes Français, 1885, oil on canvas, 299 × 419 cm, Musée d'Orsay, Paris

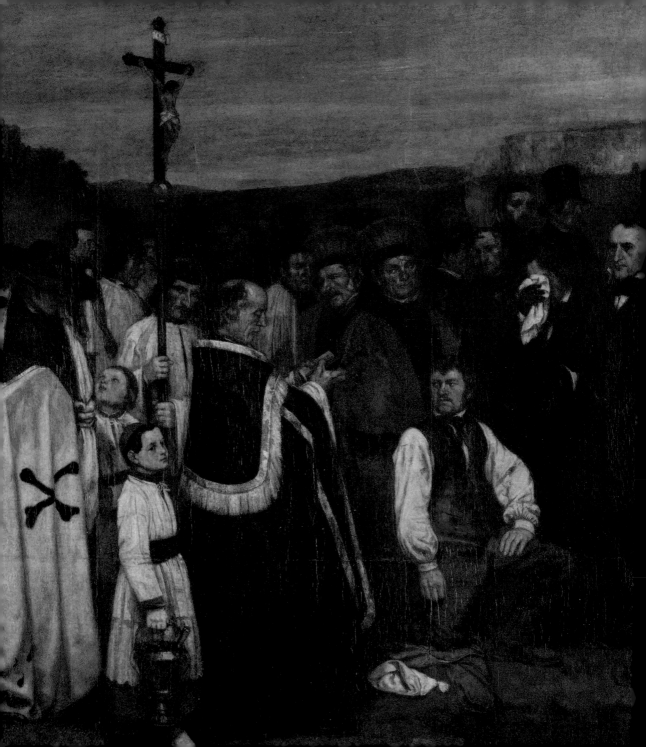

Out of the Provinces into the Salon

Finding new ways to reach the public became an essential task for Impressionist artists. Initial attempts to free themselves from the restrictive shackles of official French art politics were apparent in the various private activities of individual artists. The pavilion that the artist Gustave Courbet (1819–1877) set up on the grounds of the 1855 Universal Exposition was particularly spectacular; on his own initiative and under his own direction the painter exhibited his works inside the pavilion under the heading "Realism". The works included one that was 7 meters wide and more than 3 meters high and depicted a larger-than-life sized *Burial in Ornans* (p. 31).

The enormous painting depicted a small-town funeral at the cemetery in Courbet's hometown in Franche-Comté.

Gustave Courbet,
A Burial at Ornans, 1849/50, oil on canvas, 315 × 668 cm, Musée d'Orsay, Paris

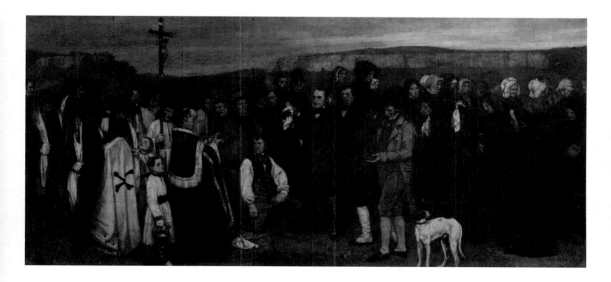

The coffin has just been lowered into the ground, a few mourners are already turning away, while others give their tears free reign or pause piously in front of the open grave. The extensive array of figures, which include Courbet's friends and family members, are placed in such a way that many faces are recognizable.

The forceful presence of the physically rather crude rural group in the elegant Parisian Salon seemed scandalous. Additionally, the visitors did not like the obvious discrepancy between the subject and its representation: The fact that the artist, in distressing and complete inappropriateness, lent "a modest grieving ceremony the dimensions of a historic scene that had gone down in history" enraged the writer Théophile Gautier. Yet the height of tastelessness was the artistic execution; the dirty brown tones of the landscape and the sky, as well as the black of the mourning clothes, created a crushing and hopeless overall impression. The entire painting was an utter imposition on the educated and aesthetically spoiled Parisian public.

"The Salon suffocates and ruins sensations of greatness and beauty ... (It) is actually nothing more than a painting shop, a bazaar filled, ad nauseam, with countless things, where the business of art is driven out."
Jean-Auguste-Dominique Ingres (1780–1867)

The Salon's Taste

Just how much Courbet's "modern history painting" shocked his contemporary viewers can only be assumed today when one compares it to Alexandre Cabanel's (1823–1889) *The Birth of Venus*. The large painting was presented in the Salon in 1863, honored with an award and finally purchased by Napoleon III himself. A nude is lasciviously sprawled out on the ocean's surging waves. The *putti* who hover above her emphasize that this figure of pale shades of pink and blue must be a mythological one. There is no doubt: it is the foam-born Venus, the ancient goddess of love, who was given form – one that corresponded to what was then considered to be the ideal of feminine beauty – by a nude model. The erotic presentation of the body and the bashful hiding of the face reflect the passivity

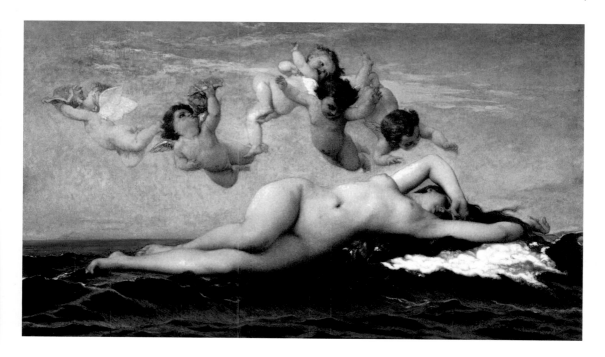

that society ascribed to female sexuality. With such paintings Cabanel, who had undergone a demanding education at the École des Beaux-Arts and in Rome, represented a late Classicism that contained a pronounced sugary touch by borrowing from the Rococo. Technically brilliant in drawing, coloring and paint application, as well as beholden to traditional subject matter, his works represented the taste in art at the time. Cabanel, who is not even honored today with an entry in *Kindlers Malereilexikon* (Kindler's Painting Encyclopedia), was a celebrated painter-prince, honored with numerous positions and awards and enjoyed a very influential position as a professor at the École des Beaux-Arts.

Artists and the Art Market in the Second Empire

The French art market of the 19th century was inflexible and not in a position to accept the new impulses of the

Alexandre Cabanel,
The Birth of Venus, 1863,
oil on canvas, 130 × 225 cm,
Musée d'Orsay, Paris

Following double spread:
Jules Alexandre Grun,
Friday at the French Artists' Salon, 1911,
oil on canvas, 360 × 610 cm,
Musée des Beaux-Arts, Rouen

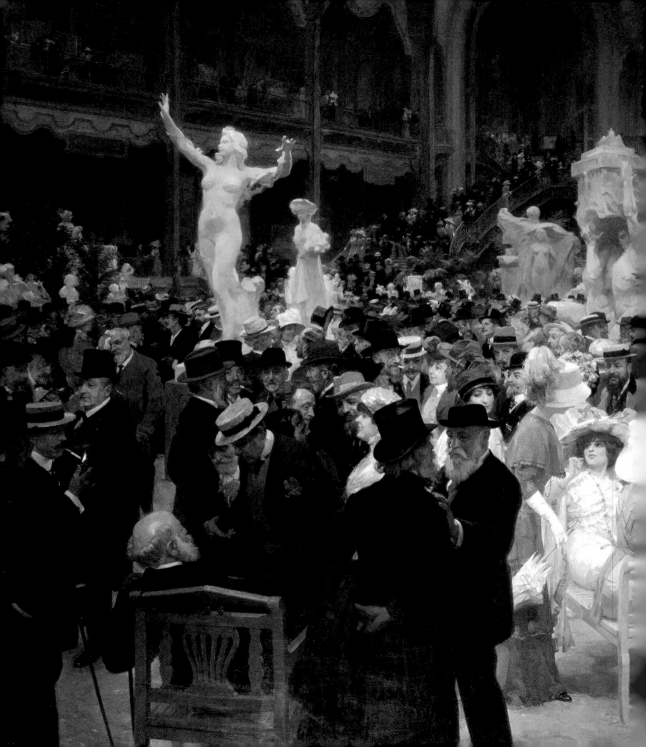

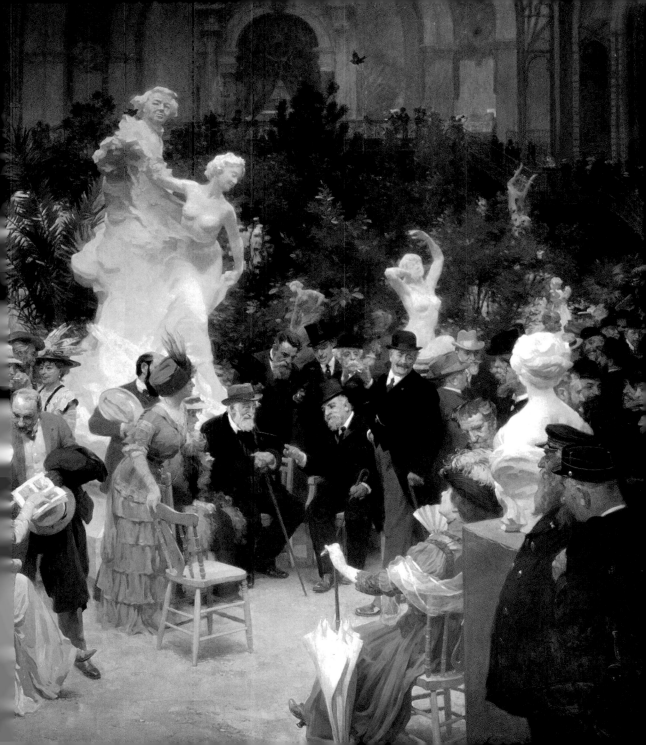

Edgar Degas,
Mary Cassatt in the Louvre,
c. 1879/80, pastel,
64 × 48 cm,
Private collection

Impressionists without resistance. The Salon and École des Beaux-Arts in Paris guarded over the preservation of an extremely conservative concept of art as a pair of closely interlocked institutions with a monopoly. The education of the younger generation at the École des Beaux Arts, which had emerged out of the former Royal Art Academy, concentrated primarily on drawing from Classical plaster casts, life drawing and the analysis of the Old Masters. Older paintings, which were considered exemplary, served as the only points of orientation. Students of the École often found their education to be a disappointing affair. They had to prove their mastery of various artistic techniques in endless exams and their professors usually came across as authoritarian and pedantic – there was not the slightest trace of individual encouragement.

Alternatives for frustrated younger artists and for all women with artistic ambitions – women were not even admitted to the École des Beaux Arts until the early 20th century – were provided by numerous private academies. Even if such institutions provided little more than a heated studio, life-drawing classes and a teacher's critique every now and again, these academies developed into the most important meeting places for young artists and became the decisive centers in which new artistic ideas were exchanged. Manet, Monet, Pissarro and Cézanne met at the Académie Suisse on the Île de la Cité, while Renoir, in addition to his studies at the École des Beaux-Arts, also worked at the Académie Gleyre, where he met Sisley, Monet and Bazille.

It was, however, very difficult for these artists to present their works in public once they had completed their studies. The Salon, founded in the 17th century by Louis XIV as the exhibition venue of the Royal Art Academy, was opened to all social groups following the French Revolution (1789). Nonetheless, the selection of

paintings by a jury soon became a political affair; only exemplary, state-approved and morally flawless art was allowed to be presented here. More and more submissions were rejected – in 1863 more than half the submitted works – resulting in massive protests by artists. That same year, Emperor Napoleon III finally felt obliged to establish a "Salon des Refusés," or an "exhibition of rejected works." The strong reactions by the public, who had doubled over in laughter at the sight of works by Manet, Pissarro and Cézanne exhibited there, however, made the jury's selection for the Salon seem justified in the end. This is why a jury-free Salon could not be justified and only occurred twice (1864 and 1873). Nonetheless, with this, the first steps to a fundamental opening-up of the state regulated art scene had been taken. The now famous first group exhibition of the Impressionists (1874) and the establishment of the "Société des Artistes Indépendants" (1884) by the Neoimpressionists were additional landmarks in the fight against obsolete academicism and its powerful institutions.

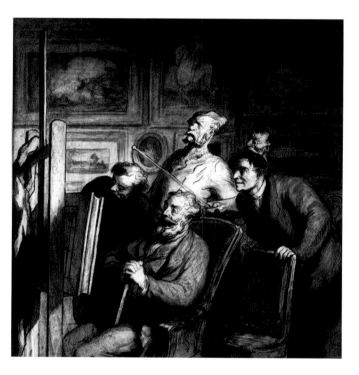

Honoré Daumier,
The Amateurs, after 1862,
chalk, watercolor and gouache
on paper, 32.4 × 30.8 cm,
Walters Art Museum, Baltimore

From the Studio into the Countryside – Painters of Barbizon

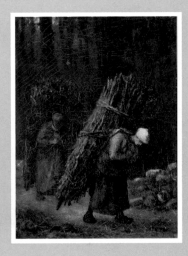

Jean-François Millet,
Peasant Women with Brushwood,
1858, oil on canvas,
Hermitage, St Petersburg

The Impressionist conception of the landscape was not created without role models and precursors. As early as the 1820s and 30s the first artists' colony was established in France whose members lived a life close to nature and who wanted to experiment with painting "en plein air" (outdoors). Many artists found the forest of Fontainebleau, a former royal hunting ground about 60 kilometers outside Paris and still largely undeveloped, particularly attractive. Barbizon – the name of one of the villages located on the edge of the forest – ultimately gave this artistic movement its name, although it was in no way a fixed group of artists, and certainly not a "school," but rather a "plein-air studio," in which artists who were friends met to work together occasionally or for longer periods of time. Members of this circle included Camille Corot (1796–1875), Théodore Rousseau (1812–1867), Jean-François Millet (1814–1875) and Charles-François Daubigny (1817–1878). Corot, who was the oldest member of the group and who was both respectfully and lovingly referred to as "Papa Corot" by the Impressionists, was most certainly influenced by the 18th-century academic tradition in his understanding of landscape painting, while Daubigny, 20 years his junior, bridged the gap to the younger generation of artists around Pissarro and Monet with his painting style and eagerness to experiment. All the aforementioned artists played a decisive role in the formation of a fundamentally new concept of the landscape that, from this point on, was characterized by a direct study of nature. This ideal was reflected not only in their painting, but also in the way they lived their lives: These artists lived a very spartan and rural existence and sought direct contact with a countryside that

was still largely unspoiled by industrialization. The artists lived in simple inns or with farmers in the area – some for just weeks or months, others, such as Rousseau and Millet, almost continuously from 1848. Paul Huet (1803–1869), also a painter of the Barbizon group, described the group's daily activities in a letter he wrote in 1832: "We spend all day in the forest, return and gather at the table, staying there until the mail arrives. In the evening we take a short walk; afterwards we gather in the sitting room and have just enough strength to wish each other good night and to go to bed. At six in the morning we wake and go with a cabriolet into the forest, traveling an hour and a half. We only stop working to have lunch or – when it is too hot – to sleep in the grass." This makes it clear that the artist's studio had been shifted into the open countryside. Here, in front of a varied forest landscape containing a dense population of broad-leaved trees, as well as bright heaths and rivers, caves and gorges, the artists drew and painted watercolors, oil

studies, or sketches were completed and work was even done on paintings. Canvas paintings, however, were usually finished later on in the studio. This is apparent, in contrast to the

Théodore Rousseau,
The Forest of Fontainebleau,
c. 1850–55,
oil on panel, 40.5 × 30 cm,
Hamburger Kunsthalle, Hamburg

The painter's new perception of the countryside reflected that of the viewer: in the increasingly industrialized society the countryside was perceived as a rejuvenating oasis for the first time.

works of the Impressionists, in the clear harmonic overall structure of the colors, as well as in the attention to individual motif details that were not to be achieved in the time spent painting outside. Daubigny was probably the only artist at the time who was completely dedicated to painting "en plein air." In the 1850s he had a boat built for this purpose so that he could gain new views of the river banks from the water. Claude Monet would later take up this idea anew. Nonetheless, the study of nature – the sketch – was clearly central to their artistic activity and no longer simply served as an act of preparation, but rather had a special quality that was to be present in the final works whenever possible. Not the regulated lighting of the studio, but rather the darkness of the thick forest, the bright green of spring and the reflections on the water characterized the works of these artists in such a way that all the idealizations of the landscape according to academic norms were fundamentally questioned. It is not surprising, then, that these artists were misunderstood and rejected by academic institutions: Théodore Rousseau was given the nickname, "Le Grand Refusé" (The Great Reject) following his negative experiences with the jury in the 1840s. Nonetheless, Parisians were ultimately enthusiastic: at the same time as tourists discovered the city's hinterland, people began to enjoy hanging these images in their city apartments. Society's new growing perception of nature was reflected in the individual painter's view of the landscape: as industrialization slowly began to make itself felt, the forests of Fontainebleau became a picturesque retreat and an area that was not so much sought out as visually explored. Even the world of the farmer, which Millet especially felt represented a simple yet honorable form of human existence, became a kind of space for projection, in which individual sentiments of alienation felt in the city could be eradicated.

At the end of the 1840s a network of rail tracks was built in the area around Fontainebleau. With this began the intense

commercial use of the forests and the quarries. The area's character changed fundamentally. The artists there tried to fight this or retreated further into remote, deserted areas. This change was not reflected in their work, however, for they continued to depict a pristine, intact nature, which was increasingly a dream rather than a reality.

Camille Corot,
Souvenir of The Bresle at Incheville, c. 1870,
oil on canvas, 38 × 55 cm,
Private collection

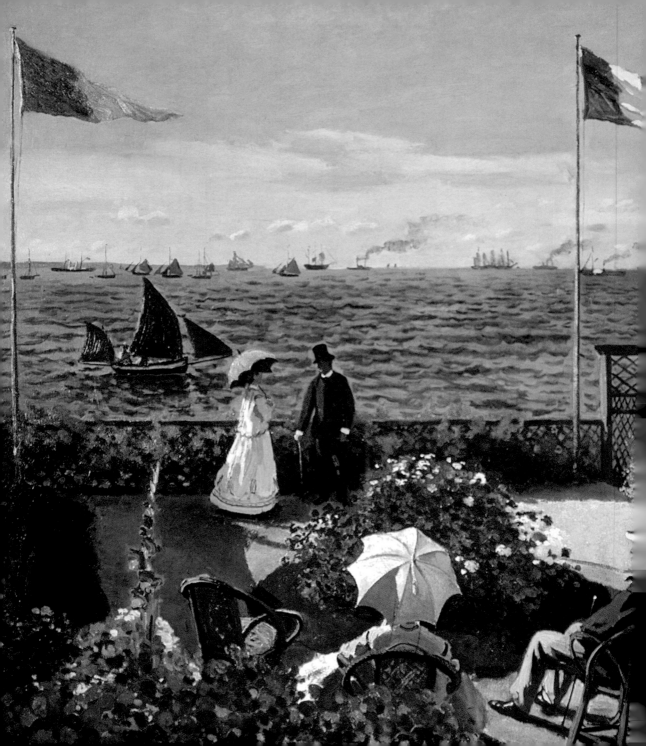

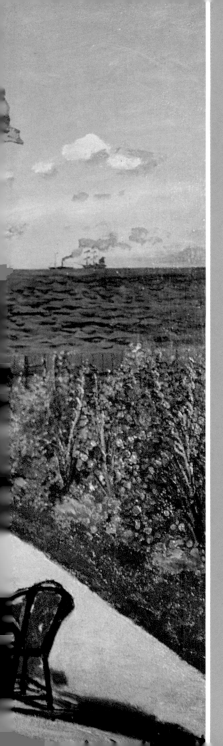

The Bathing Beaches of Normandy

An elegant bourgeois party has gathered on a sunny terrace to enjoy the view of the expansive ocean with ships crossing in the background. Seated in a wicker chair is the painter's father, Adolphe Monet. Next to him, under the parasol, is probably Sophie Lecadre, an aunt, who was highly critical of her nephew's artistic development. Her daughter, Jeanne Marguerite, is standing at the ledge facing the water with her father, the owner of the lovely house in Sainte-Adresse. In this painting, which is anything but a family portrait, the specific atmosphere of a sunny and crisp day at the sea is relayed by means of bright colors and the brilliant contrasts of the glowing yellow and the dark blue-gray.

Claude Monet,
Garden at Sainte-Adresse, 1867,
oil on canvas, 98 × 130 cm,
Metropolitan Museum of Art, New York

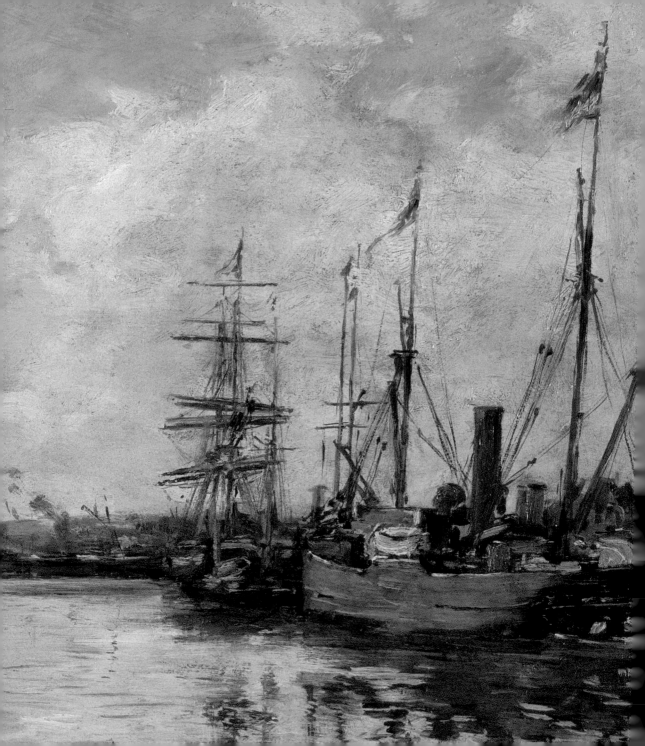

Under the Shifting Sky of the Coast

Time and again in the history of art it is apparent that certain artistic transitions are associated with specific places, whether this is because of motifs specific to such places or a particular light or atmospheric quality found there. The coastal landscape of Normandy was such a place for the Impressionists. Here, on the bathing beaches along the English Channel that were just becoming fashionable and were easy to reach from Paris by train, is where the decisive breakthrough to uncompromising "plein air" painting occurred in the 1860s. The expansive sky and the reflections of light on the ocean resulted in a brighter palette, while the ever-changing light and the continuous wind, which kept clouds and water in movement, provoked an increase in painting speed and inspired experimentation with images being executed sketch-like manner. These were innovations that had a decisive effect on the Impressionist image conception.

Eugène Boudin,
Le Havre, The Port (detail), 1884, oil on panel
Brooklyn Museum of Art, New York

Eugène Boudin,
Beach Scene at Trouville, c. 1865,
oil on canvas,
Private collection

Gatherings at the Ocean

Perhaps even more important than a location are the people that gather there. And, at the end of the 1850s, many artists went to Normandy to paint together on the coast and on the beaches around the Seine

estuary. In addition to Camille Corot and Charles-François Daubigny, who were already members of the older generation and of the Barbizon School (see p. 38). Gustave Courbet, Édouard Manet, Berthe Morisot and Alfred Sisley went to Normandy, as well as Edgar Degas, who otherwise had little interest in landscape painting. For some of these painters this excursion remained an episode, while others returned continually, in particular Claude Monet, who had grown up in Le Havre.

It is not the subject, but rather the particular atmosphere of a landscape that interests Jongkind. "He is an artist through and through," was how the critic Castagnary described the painter.

Pioneers

The decisive, mediating role was played by Eugène Boudin (1824–1898), whom Corot had once in amazement called "king of the sky" because of the brilliant cloudscapes that usually filled most of his beach scenes. From a seafaring family, Boudin opened a stationery store in Le Havre when he was 18 years old. In his shop window he exhibited paintings that had been painted by artists who worked in the area regularly. Encouraged by Jean-François Millet (1814–1875), who later was part of the Barbizon group, Boudin eventually became a painter himself. Following a study visit to Paris, he settled permanently in his home town of Honfleur in 1855 and concentrated his efforts after this on coastal landscapes, which, because of their small format and sketch-like quality, the forward thinking Charles Baudelaire merely referred to as "notes." "He will undoubtedly expand on the manifold magic of the water and air later in his accomplished paintings," commented Baudelaire. It never came to this, however, because Boudin only painted "en plein air," directly in front of his subjects, including the coast, beaches and harbors of his home. In order to identify his small paintings as true snapshot images, he would even sometimes write the date, time and direction of the wind on the reverse. Boudin was convinced of this method of "plein air" painting and advised his young

Johan-Barthold Jongkind,
Étretat, 1865,
oil on canvas,
Private collection

student, Claude Monet, to try it. In 1911 Monet recalled: "I was willing to follow his suggestion and paint with him 'en plein air' ... I watched him distrustfully, then attentively and then it was if a veil had been ripped off my eyes: I understood, I grasped what painting could be ... That I became a painter is only thanks to Boudin."

Another important pioneer of Impressionism was the Dutch painter, Johan-Barthold Jongkind (1819–1891), who traveled to Normandy as early as the 1850s, eventually settling in France in 1860. Although his activities of "plein air" painting were restricted to watercolors, his painting technique, with its expressive, short and quickly applied brush-

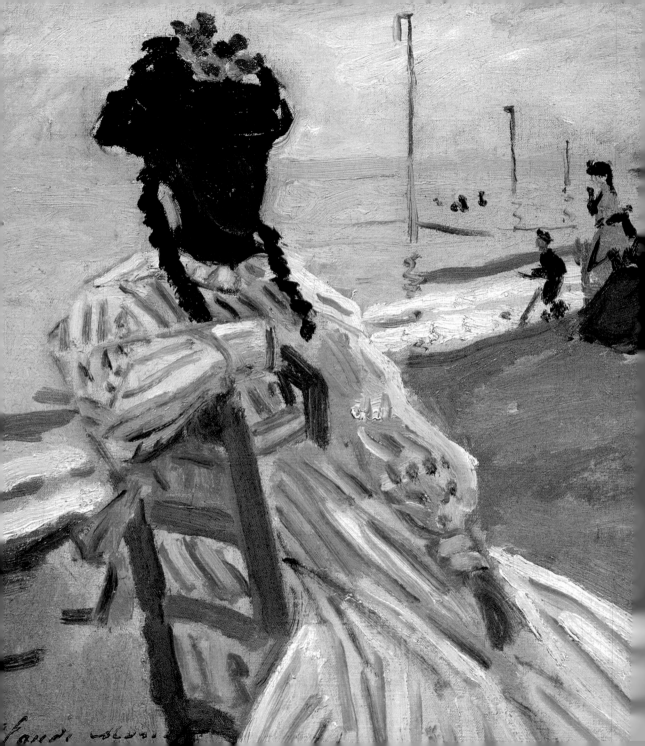

Following his marriage in June 1870, Claude Monet spent the summer with his wife and young son in Trouville on the English Channel, where he painted this beach scene that captures beach bathing in a sketch-like manner. The low perspective, which focuses on two young women with their decorative sailor outfits while still incorporating the expanse of the coastline, creates an unusual and exciting composition.

Claude Monet,
On the Beach at Trouville, 1870,
oil on canvas, 38 × 46 cm,
Musée Marmottan Monet, Paris

strokes, had a decisive influence on Monet and his painter friends. Jongkind's sea- and landscapes, which were well received by the French public because of their light and bright colors, united a fundamentally poetic atmosphere – in keeping with the Dutch tradition – and the immediacy of a precise observation of nature.

From the Landscape to Light

In summer 1869 Gustave Courbet journeyed yet again to Normandy. In little more than a month, he painted 20 seascapes, of which two large format works were exhibited in the 1870 Paris Salon. Courbet's composition encompassed the austere landscape in its entire expanse: in the foreground is a wide pebble beach devoid of people, behind this the famous rock arch of Étretat

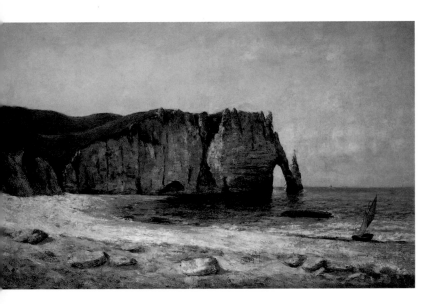

Gustave Courbet,
The Sea-Arch at Étretat, 1869,
oil on canvas, 79 × 128 cm,
The Barber Institute of Fine
Arts, Birmingham

with its significant alabaster color and lichen. The various material structures of the stone, sand, sea, sky and boats are painted with detail and contrast sharply with each other by clear lighting. Claude Monet, in contrast, strove to create an atmospheric unification of sky, water and cliffs twenty years later. His practically identical view of beach and rock arch depicts the dissolution of space in a vibrating interchange of colored reflections of light. The visible rhythm of the brushstrokes reflects and intensifies the dynamic quality in Monet's landscape painting. It is not the space but the light that becomes the main motif.

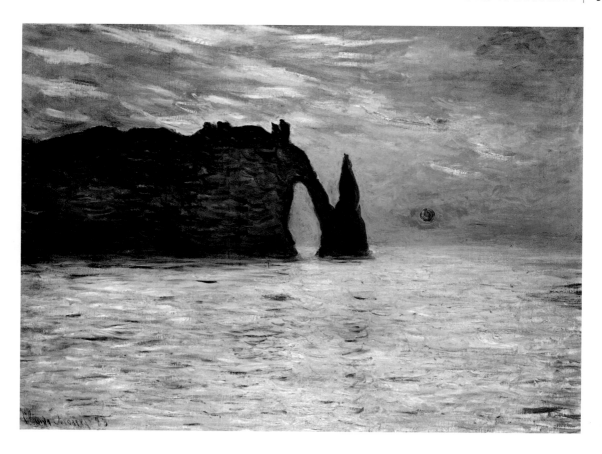

Claude Monet,
Falaise d'Étretat, 1883,
oil on canvas, 60 × 80.5 cm,
Private collection

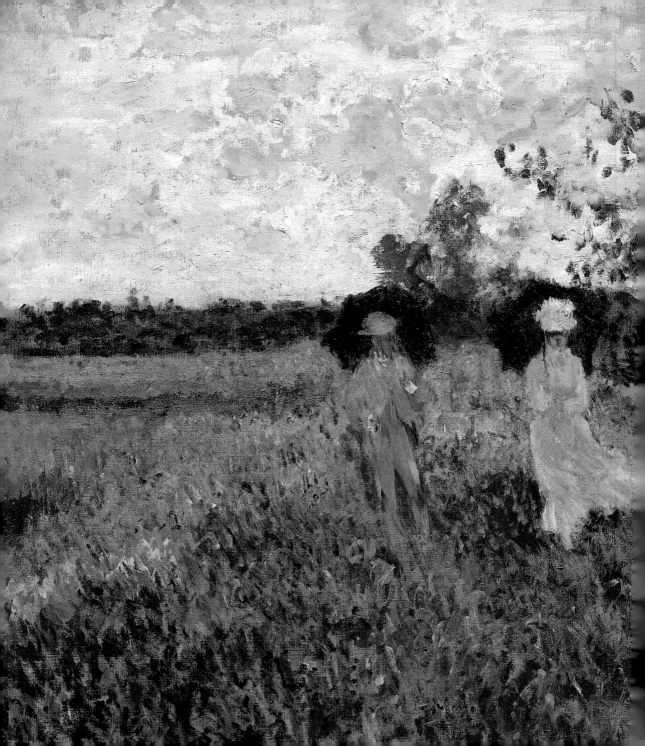

Claude Monet and the Landscape in Light

A Sunday in the countryside. The young family are taking an excursion. The three of them take a walk across the unmown meadow. A light breeze blows. Plants and figures, fore and background melt into a lively and animated brushstroke. The rustle of the leaves, the passing clouds and the smell of the summer are relayed through color. Claude Monet created a completely new kind of landscape painting that attempts to capture that which cannot be depicted: the atmospheric quality of a situation, the lightness and cheerfulness of a short, transitory moment.

Claude Monet,
Promenade near Argenteuil,
1873,
oil on canvas, 60 × 81 cm,
Musée Marmottan Monet, Paris

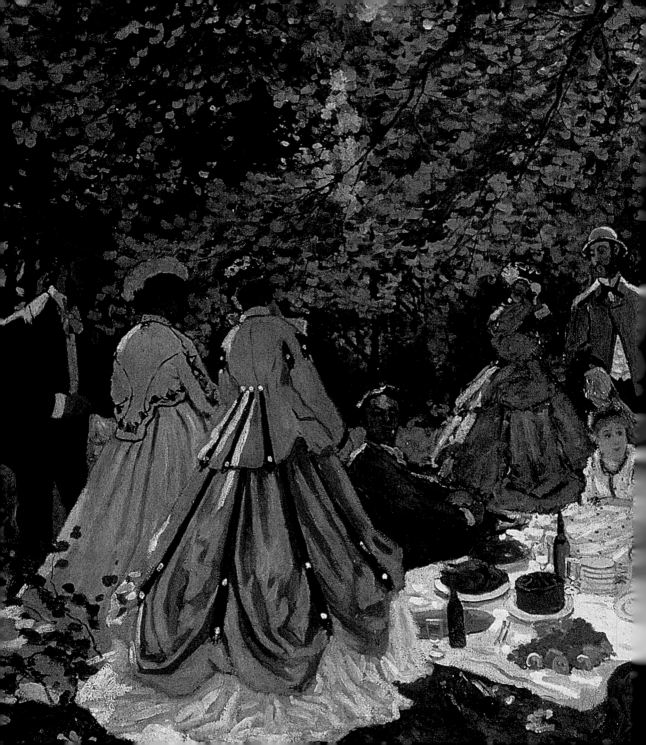

Monet – "The Eye"

Like no other artist in the Impressionist circle, Claude Monet seemed to be the only one to concentrate on the main task of the painter: seeing! He was not a theorist, was not interested in establishing any theoretical or ideological creed or forming a school or programmatic group, something he stressed his entire life. No. "My only merit is having painted directly from nature and trying to relay my impressions of the most transitory moments," were the words he wrote shortly before his death in a frequently quoted letter. Experts at London's National Gallery can prove that Monet set up his easel in even the most unfavorable weather conditions in places like the beach in Trouville: they found particles of sand on the canvas surface (pp. 48/49). Working "en plein air," under the open sky, where earlier generations of artists only went to make preparatory sketches, became a fundamental decision for Monet that characterized his image conception and execution.

Claude Monet,
The Breakfast in the Greenery
(detail of p. 99), 1866,
oil on canvas, 130 × 181 cm,
Pushkin Museum, Moscow

Claude Monet,
Still Life with Bottles, 1859,
oil on canvas, 41 × 60 cm,
Private collection

Beginnings: Figure and Landscape

A spectacular project marked the beginning of Monet's attraction to "plein air" painting. Encouraged by his successful participation in the Salon of 1865 in Paris with two seascapes painted in Normandy, as well as by several commis-

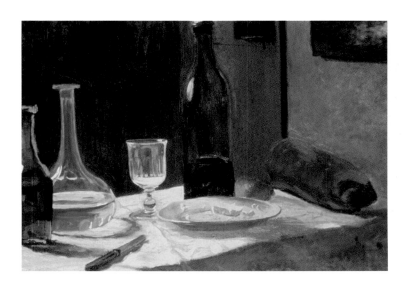

sions for portraits, the 25-year-old embarked on a ambitious project: prepared with numerous sketches, an enormous *Breakfast in the Greenery* was to be painted using his partner Camille and his friend Frédéric Bazille as models. Monet worked in the forest of Fontainebleau, which had already served as a motif for painters of the Barbizon group. Never before had a painter tried to create such a large figurative composition in the open landscape, although it is still unclear if Monet painted just the preliminary sketch or the actual painting outside.

The painting was never completed and today is preserved only as a fragment in the Musée d'Orsay in Paris; a much smaller version (pp. 54, 99) relays, however, a fine impression of the motif: in contrast to the seemingly staged scene, filled with art-historical quotations, painted by his friend Manet (p. 12), an actual picnic can be seen here. Several young men and women have gathered under the leafy canopy of several birch trees. A roast chicken, fruit, pâté and a bottle of wine have already been laid out. Several of the day-trippers, dressed in their Sunday clothes, have spread themselves out, while others stand casually around in groups. This seems to be a snapshot

Claude Monet

(14 Nov. 1840 in Paris – 5 Dec. 1926 in Giverny)

Raised in Le Havre, Claude Monet began his artistic training there in **1857** under Eugène Boudin. In **1859** he went to Paris: First he attended the Académie Suisse, where he met Pissarro, then the Atelier Gleyre, where Renoir, Sisley, Bazille and others worked. In **1865–1868** he experienced his first success at the Salon. After returning from London, where he went to avoid doing military service (**1870/71**), Monet settled in Argenteuil and dedicated his artistic efforts primarily to landscape painting. In **1874** he organized the first Impressionist exhibition together with Caillebotte and Pissarro. His painting *Impression, Sunrise* (**1874**) lent the artistic movement its name. In 1878 financial difficulties forced him to move to Vétheuil, where his wife Camille died (**1879**). In 1883 Monet bought a house in Giverny. In **1892** he married Alice Hoschedé, his partner of many years. In the **1890s** Monet experienced success and growing prosperity. His Japanese garden became the main subject of his last productive period.

image with no one posing for the painter. The women's elaborate wardrobe and the men's proper dress characterize the group as city folk who have taken a day trip away from Paris by train into the countryside. Monet's painting is a successful balancing act between the precise registration of material qualities and their free, abridged form of representation. Glimmering and transparent materials, tucks, buttons, stitching, a lush fold of fabric – all this is present in his texture, yet it is "transformed by the magic of light and shadow," is how the Goncourt brothers described the work in a review at the time. With this painting Monet did, in

Claude Monet,
Bathers at La Grenouillère, 1869, oil on canvas, 73 × 92 cm, National Gallery, London

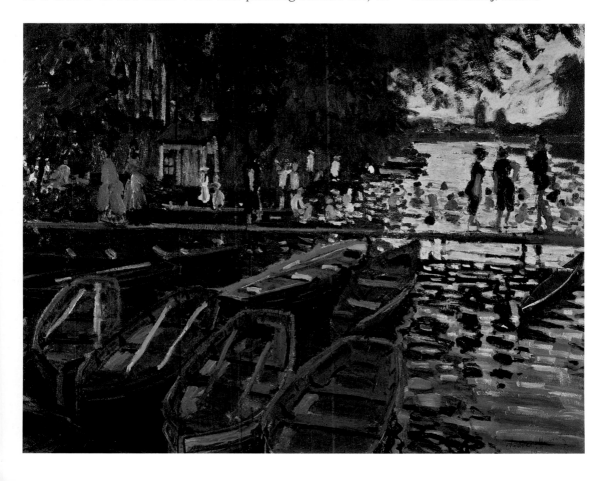

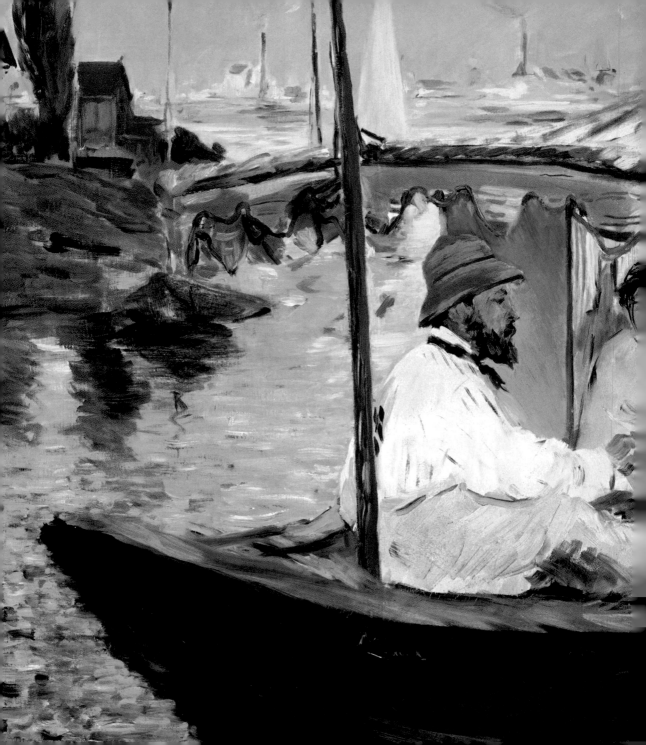

With their reflections and light reflexes, riverscapes provided Impressionist painters with particularly interesting motifs. Claude Monet reconstructed an old boat with a simple cabin into a floating studio so that he could work amidst nature and change location quickly. Manet depicts him here together with his wife Camille. A landscape painting in progress is visible on the floating easel.

Édouard Manet,
Monet in his Floating Studio,
1874,
oil on canvas, 80 × 94 cm,
Neue Pinakothek, Munich

Claude Monet,
Rue Saint-Denis on June 30th,
1878,
oil on canvas, 82 × 101 cm,
Musée des Beaux-Arts, Rouen

"The strong and cheerful
heartbeats of the endless
tricolor, the surge and
movement of the cele-
brating crowd that flood
the side walks and paths;
all these things are
relayed here in a way that
could be called mas-
terful," were the words
Ernest d'Hervilly wrote in
1879 about Monet's *Rue
Saint-Denis.*

fact, set out on his uncompromising path of a style of painting that is full of light and color.

Shifting Landscapes: Water and Wind

Four years later, in 1869: Monet and Renoir were in Saint-Michel, a small village west of Paris. They were working together on several paintings of *Bathers at La Grenouillère,* a favorite excursion destination on a small island in the Seine with boat moorings and bathing areas: another scene of an idle Sunday, the little flight from the city and everyday life in the form of the organized recreation of an outing. While the mundane bathing beaches of Normandy served as a summer resort only for wealthy Parisians, the less well-off could easily reach the simple establishments along the Seine by train. "A lot of strollers walked along under the enormous trees of the Grenouillère that, from this vantage point, is the most beautiful park in the world," wrote Maupassant. Monet, however, did not produce a genre painting. The figures function rather as accessories and all the motifs are only summed up as contours. Monet experiments instead in the composition and application of paint. Surprisingly, he dedicated half the canvas to the mundane motif of an empty boat. He was surely intrigued by its green color, in consonance with the vegetation, as well as with the combination of the foreground. Furthermore, the view's depth provided an interesting perspective. However, the main 'figure' in this work, which Monet referred to as a sketch, is the water. As a light-reflecting, animated and almost metallic shining surface, it is recorded – by means of wide, individually applied brushstrokes – with a free and yet surprisingly convincing materiality. From this point on, Monet's interest in water would continually recur.

Not only riverscapes provided the Impressionists with motifs, but city streets as well; the Parisian boulevards also corresponded with their image conception, leading Monet

to paint his *Rue Saint-Denis on June 30th.* The opening of the World's Fair was the occasion for this "Fête de la Paix" (Festival of Peace) – the first national holiday following the loss of the Franco-Prussian War of 1870/71. Monet came into the city from Vétheuil, a small village on the Seine. He fixed his view from a balcony directly onto the fluttering flags and the moving crowds of people. The colors of the Tricolor create strong accents on the painted surface, which is otherwise composed of light and dark tones. There is movement everywhere and the execution of the painting seems as dynamic as its motif. With rapid brushstrokes that lack contours and are blurry yet still precise, Monet threw the street scene onto the canvas. A sense of direction would be nearly impossible without the light, peaceful strokes that make up the sky. "What a swarming crowd below the flags and how the wind ruffles them

In 1877 Monet painted twelve paintings depicting the Saint-Lazare train station, the surrounding tracks and the Pont de l'Europe from different vantage points. He presented seven of these works the same year in the third Impressionist exhibition. Train stations appeared in the city in the 19th century as new places that embodied the will to progress. They symbolized speed, mobility and the expanding horizon of personal experience.

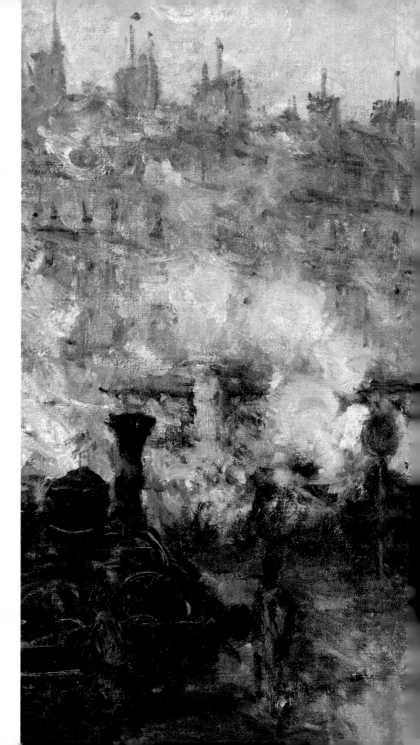

Claude Monet,
The Pont de l'Europe, Gare Saint-Lazare, 1877,
oil on canvas, 60 × 80 cm,
Musée Marmottan Monet, Paris

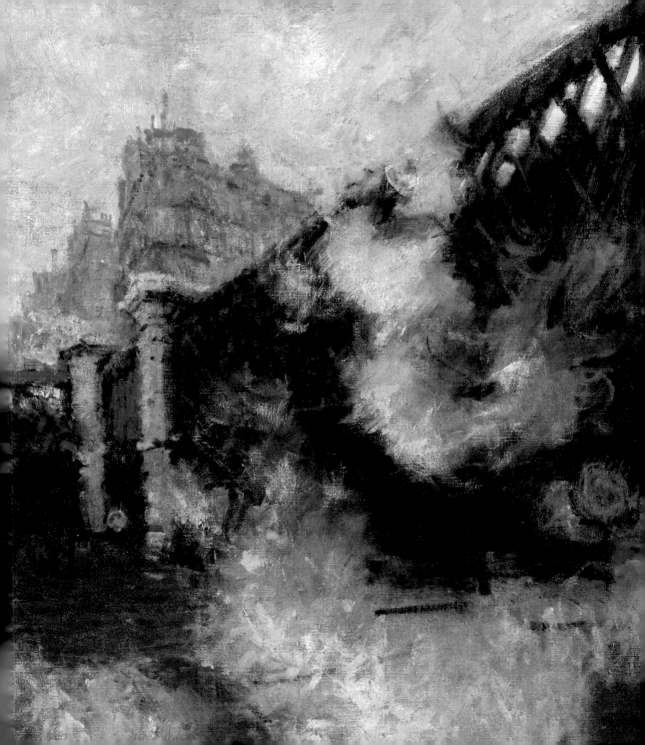

in the wind! One thinks of a storm and the waves that crash against a ship with sails of the Tricolor," was how the author Paul-Armand Silvestre described this painting in his review of the Impressionists' fourth exhibition (1879). The stormy ocean metaphor makes it clear that Monet regarded and portrayed Paris as a modern landscape. Totally new urban experiences, such as feelings of anonymity and the dissolution of the individual into the crowd, were first given visible form in Monet's paintings.

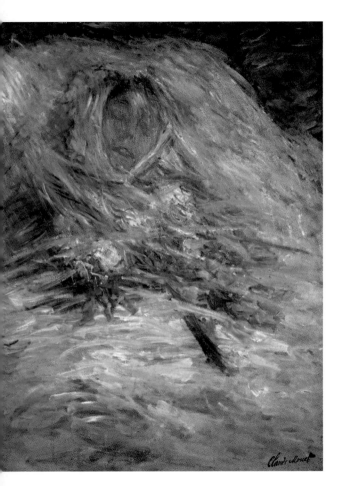

Claude Monet,
Camille Monet on the Deathbed,
1879,
oil on canvas, 90 × 68 cm,
Musée d'Orsay, Paris

"Nothing More than a Colored Impression"

Monet's conception of the landscape became the basic principle for all his painting. His preoccupation with a specific detail of nature and the concrete conditions of the wind, light and weather resulted in a meaninglessness of the image that was shocking to the contemporary viewer. Monet's paintings told no stories, taught no lessons, referred to no glorified past and urged no one to abide by any rules, laws or values. Instead everything seems to be captured in a single sensation: Seeing. The artist's visual experience became the painting's contents. The manual transformation of this sensation conflicted with the traditional demands placed on painting. The loose, visible brushstrokes that remained were regarded as "crude scribbling." The elevation of materiality to an independent, painted element with an intrinsic value questioned the representational function of art at a basic

level. After all, if painting is only a "vigorous and, at the same time, delicate transcription of nature," as Monet described it himself, where, then, was its enlightening power, that had always been attributed to it, that improved people and the world? This particular problem became especially apparent at a difficult point in Monet's life. Monet's first wife Camille died on September 5, 1879 when she was 32 years old. For thirteen years she had stood by the artist as his model, lover and wife, sharing his worries, financial hardships, his successes and setbacks and bearing his two children, Jean (1867) and Michel (1878). The family's situation was often hopeless in these years. Pressing debts forced them to move frequently and they often had to ask friends and patrons to lend them money. Monet frequently complained in his letters of his inability to fulfill the most basic needs of his wife and children. He finally had to sell his last possessions to pay his sick wife's doctor bills. When Camille died

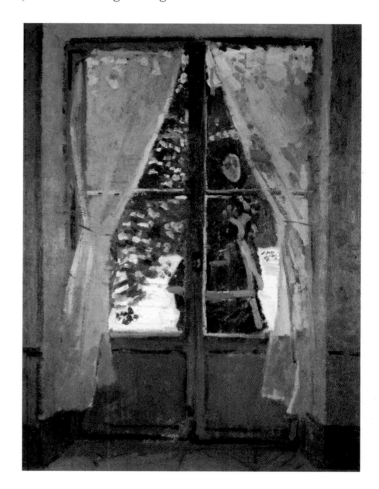

– whether this was from a chronic sickness or an botched abortion is still unclear – Monet painted her portrait on her death bed at dawn. There is hardly another painting that records so pervasively how foreign the familiar becomes in death. The young face already seems to dissolve in the cold

Claude Monet,
The Red Cape (Madame Monet),
1870, oil on canvas,
99 × 79.3 cm, Cleveland
Museum of Art, Cleveland

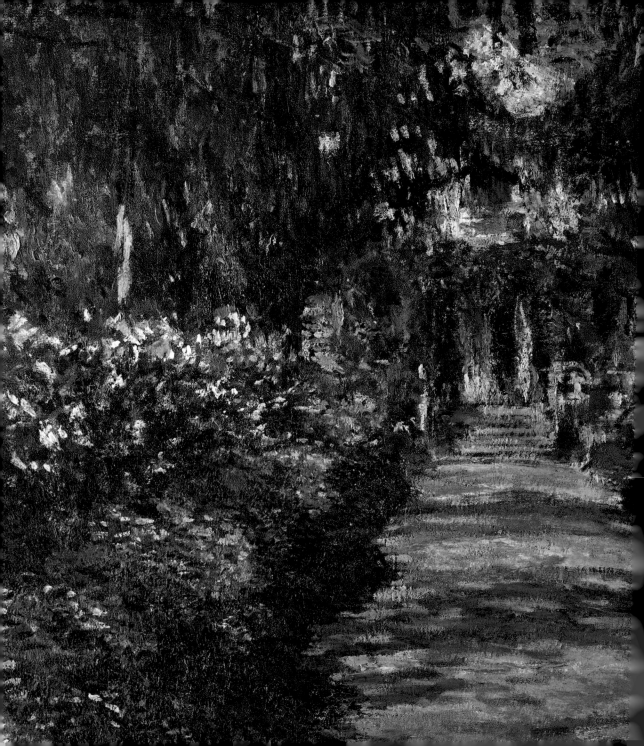

Finally free of financial worries, Monet began to plant a carefully designed garden in 1893, which would provide the most important motifs for his paintings from then on. This view of his house through a shaded path lined with willows was created as a symphony of colors. Spatial depth and a flat color scheme contrast with each other here in a similar manner as the complementary violet and green do. Light is the main, animating factor. In many ways Monet's paintings of Giverny summarize his career as a painter, which spanned almost fifty years.

Claude Monet,
Garden Path at Giverny, c. 1902,
oil on canvas, 89 × 92 cm,
Österreichische Galerie Belvedere,
Vienna

violet of rigor mortis. The body seems to sink into the bed and lose its presence in a room of colors. After painting this, Monet was shocked by the fact that, even in "the horror of it all, [he] perceived nothing more than a colored impression."

Modern Landscape: Space in Light

Monet's painting illustrates a fundamental modernization of art: the abolition of old conventions, the leveling of hierarchies, and the shift from the narrative to the aesthetic. Instead of the settled and the static, Monet's paintings express, right down to the brushstrokes, an agitated momentariness, a visible acceleration in the act of painting

Claude Monet,
Waterloo Bridge, 1900,
oil on canvas, 4 × 100 cm,
Hugh Lane Gallery, Dublin

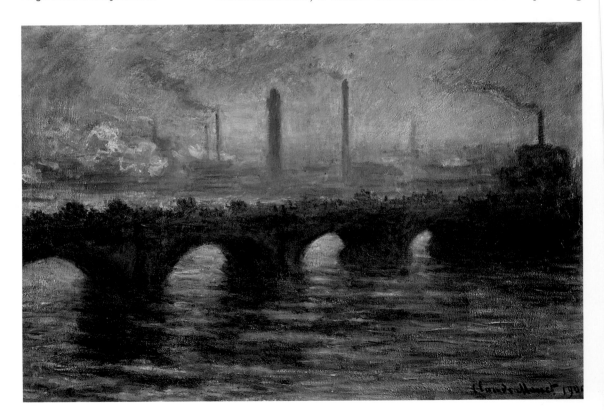

that reacts to the new speed of an industrialized society. Today's viewer may not be aware of how much Impressionist painting was affected by the new experiences of the modern world and the enormous upheavals of the 19th century leading towards a mobile, labor-divided capitalistic form of work and life. This is apparent not only in the uncompromising choice of motifs – views of London's smoking factory chimneys became just as interesting as a summer's stroll in the country – but, above all, in the fluctuating application of paint and the dissolution of space into light. Monet's work made it abundantly clear that painting was no longer supposed to teach or enlighten, but to invite viewers to observe works in their own individual manner. A dialogue between the public and the artist about the perception of the world was established. "Monet is nothing more than an eye, but what an eye," commented his fellow painter, Paul Cézanne.

Claude Monet,
plein air study: *Woman with a Parasol (Facing Right),* 1886, oil on canvas, 131 × 88 cm, Musée d'Orsay, Paris

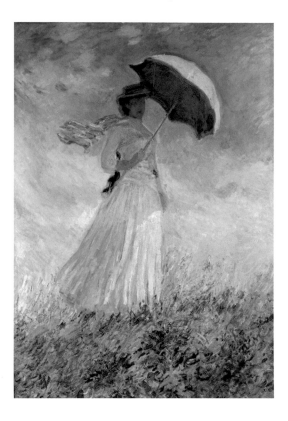

From the Life of a Bohemian –
The Café and Studio as the Artists' Meeting Place

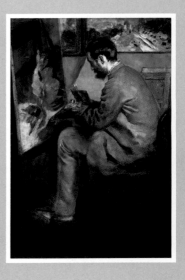

Auguste Renoir,
Frédéric Bazilleat his Easel,
1867,
oil on canvas, 105 × 75.5 cm,
Musée d'Orsay, Paris

Edgar Degas,
Portrait of Henri Michel-Lévy in his Studio, 1879,
oil on canvas, 41.5 × 27.3 cm,
Museo Calouste Gulbenkian,
Lisbon

Not only did a new generation in art history begin with the Impressionists, but one in the history of painters as well. Faced with an art scene that was negatively disposed towards them and characterized by antiquated and rigid academic institutions, such as the École des Beaux-Arts and the Salon, these artists had to organize themselves and their own exhibitions and find their own public and, above all, buyers and collectors. To use a modern catch-phrase: They had to create their own functioning network. It was primarily the cafés of Paris and the artists' studios that became the "hubs" where new ideas were discussed. Each location served different functions. If the cafés provided a public place that was open for discussions in every sense and with a continuous flow of new participants and protagonists, then the 19th and 20th-century studio went from being a place that origi-

nally was filled with apprentices and workers to one of refuge, where the artist could be alone, concentrate on his work and perhaps reflect with fellow artists. Even today the artist's café and studio have a certain magical quality: here one has the feeling of being particularly close to the work process, as well as to the artist. "They began an animated discussion over drinks. They compared 'plein air' painting with painting in the studio. They

held forth in detail about the Salon jury that was dedicated to the past and how one could be accepted by them without having to imitate the imitators. One suggested blowing up the Beaux-Arts building during a full meeting of the Academy. Another said the Louvre had to be burned to the ground. Cézanne had the idea of giving the Academy members five acres of land in Algeria and sending them there on early retirement with honors. There was a lot of laughing." In his novel *Depths of Glory* (1985), Irving Stone set this fictitious scene in the Café Guerbois, the cafe where Monet, Pissarro, Bazille and Cézanne liked to meet in the 1860s and 70s. The book brilliantly captures the rebellious, ironic and sneering tone that prevailed among artists at the time. The artistic and social exclusion that afflicted these young artists, who had mostly came from good, middle-class families, transformed them into reluctant revolutionaries and united them, despite all internal differences, into a group that had to search for its own principles and for new places to present itself. The cafés and brasseries thus became the preferred locations for the nightly discussions in

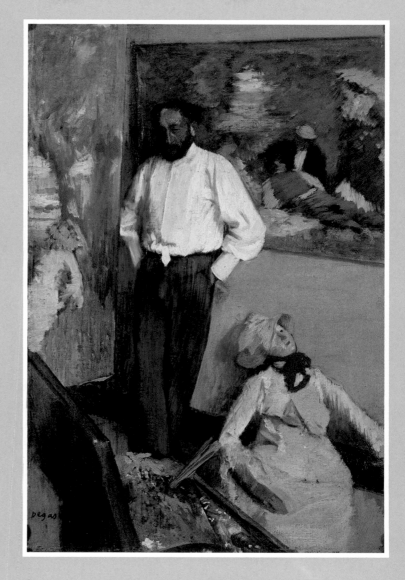

Artists fought and discussed with each other in their studios. New exhibition projects were considered and personal problems shared.

which artists conversed not only with each other, but also with critics, literary figures and gallery owners. This is where the idea for a common group exhibition, which eventually took place in 1874 in the studio of the famous photographer Nadar, was probably born.

There were obviously heated debates about art theory and painting techniques, as well as polarizations and quarrels: "Nothing was more interesting than these battles of words," Monet later remembered. "They gave us our spirit, filled us with enthusiasm ... We left the cafés with stronger wills, clear thoughts and elevated spirits." Who met with whom where was all routine. The social-revolutionary minded "realists" surrounding Gustave Courbet chose the simple Brasserie des Martyrs and the sleek Andler Keller to serve as their headquarters. The students of Charles Gleyre's studio, including Monet, Renoir and Bazille, gathered in the evening at the Café Fleurus, which was decorated with murals by Courbet, whom they so admired. Édouard Manet and his friends preferred, by contrast,

the Café de Badin in the city center until 1866, after which they met at the previously mentioned Café Guerbois in the Grande-Rue de Batignolles (today's Avenue de Clichy). There, not far from Montmartre and the Gare Saint-Lazare, is where Manet was elevated to the intellectual center of the so-called Batignolles Group to which the Impressionists also belonged. In 1877 the new meeting place became the Café Nouvelles Athènes on Place Pigalle that had been a gathering place for the political opposition during the reign of Napoleon III (1848/52–1870). Several of Degas's (ill. p. 92) and Manet's works depict the interior of the famous café that the English writer George Moore once called "the better École des Beaux-Arts."

While the cafés served as places of discourse, artistic production and reflection took place in the studios. Personal seclusion and loyal cooperation were both thematized in paintings of artists' studios (ill. pp. 15, 188). With this a central change occurred that still characterizes the contemporary im-

age of the artist's personality; the more the distinctiveness of a work determines its quality, the more the artist becomes the focus of attention. The idea that an artist has to be particularly interesting, sensitive, different from others, perhaps even a bohemian, is a virulent 19th-century idea. The personal "handwriting" was and still is the most important qualitative feature of a mature artist – and finding this was and remains his main task. The studio, regardless of where it was, thus became the *genius loci*.

Auguste Renoir,
The Studio in the Rue Saint-Georges, 1876,
oil on canvas, 45.1 × 36.8 cm,
Private collection

Inspirations:

Japanese Art

The foreign and exotic inspired European artists time and again. While the first half of the 19th century was marked by their personal discovery of the Orient, the 1860s and 1870s were marked by Japan's role as a source of inspiration. The Impressionists, as well as others, were fascinated with Asian patterns and motifs, the decorative forms and rich color schemes of Japanese materials and porcelain, as well as the simplicity of the artistic methods of artistic forms, such as calligraphy and print making. In their studios artists surrounded themselves with Japanese vases, lacquer boxes and prints and dressed themselves in strange kimonos – Toulouse-Lautrec allowed himself sometime around 1892 to be photographed in one. Claude Monet painted a portrait of his wife Camille clothed in Japanese dress in an interior decorated with fans.

Claude Monet,
Camille Monet in Japanese Costume (detail of p. 104), 1876, oil on canvas, 231.8 × 142.4 cm, Museum of Fine Arts, Boston

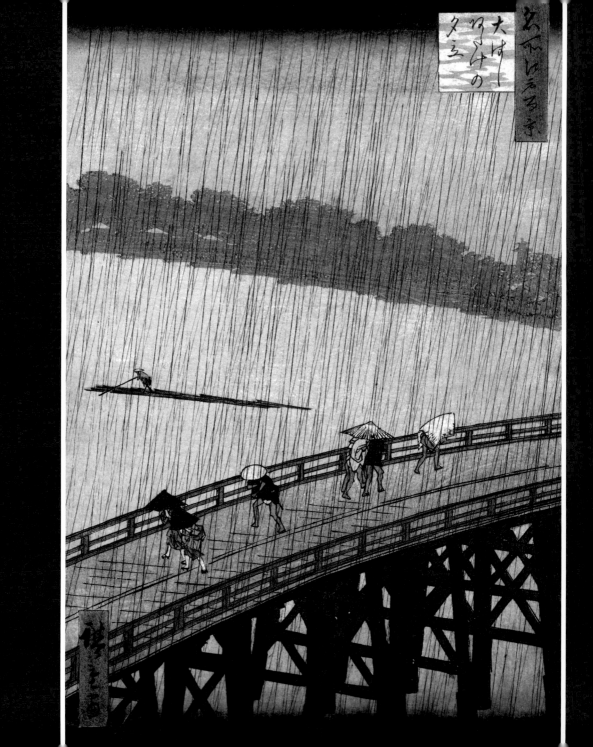

"Japan in Paris"

For more than 200 years Japan had enjoyed "splendid isolation." While large parts of the world had been divided up and Christianized by the European colonial powers, the Asian island realm had shut itself off from the world in 1637, conducting a limited amount of trade with Holland and China. Culture and religion remained continuously free of Western influences and their art and knowledge gained great inner and outer stability during this long period. In the mid 19th century several trade and friendship agreements with European countries and the United States led to an opening up of the country. It was now possible for Europeans to discover a virtually unknown Japan. Expeditions and trips were made but, more significantly, Japanese products came to Europe: in addition to tea, rice and spices came art and craft products, such as porcelain, kimonos and prints. Japan became fashionable and Paris became the center of European "Japonism," or "Japonisme," the name the collector and art critic Philippe Burty (1830–1890) used to describe the Japanboom in 1872. Refined Parisian society established Japanese-styled salons, had kimonos made of beautiful silk fabrics and celebrated the traditional Japanese tea ceremony. Small societies and clubs were founded in which Japanese culture was studied.

Ando (Utagawa) Hiroshige,
Ohashi Bridge in the Rain (from the series: *One Hundred Famous Views of Edo*), 1857,
colored woodblock print
39.3 × 26.5 cm,
Musée Claude Monet, Giverny

Katsushika Hokusai,
The Great Wave (from the series: *Thirty-six Views of Mount Fuji*),
c. 1830,
colored woodblock print,
25 × 37 cm,
Musée Claude Monet, Giverny

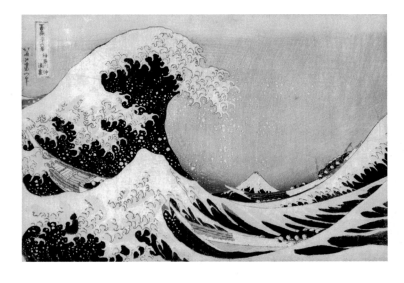

Mary Cassatt,
The Letter, 1890/91,
Etching, 40.6 × 29.2 cm,
Worcester Art Museum,
Massachusetts

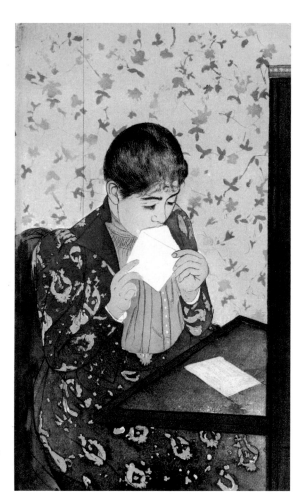

"Revolution in Seeing"

The examination of Japanese aesthetics became a major source of inspiration in the second half of the 19th century: "Japanism is nothing more and nothing less than a revolution in seeing for the Europeans," were the words the writer Edmond de Goncourt (1822–1896) recorded in his diary in 1884. "I would like to maintain that it brings with it a new sense of color and decorative design, and even a poetic fantasy into the artwork that has never before....existed." Above all it was 18th and 19th-century Japanese prints that had an exemplary and inspiring effect. These first came to France as packaging for Japanese goods and, from about 1860, as products that could be bought in numerous Oriental dealers in Paris for about two to four French francs. Even artists such as Claude Monet and Vincent van Gogh, who often lived in poverty, built up extensive collections of such works. These prints were popular color prints that usually depicted ordinary scenes, as well as landscapes, illustrations of popular stories and erotic motifs. The Japanese refer to this kind of representation as "ukiyo-e," meaning "images of a flowing, changing world," or, as it is often translated, "the floating world." In these works artists such as Manet, Degas, Monet and later Seurat, Signac and van Gogh first discovered an image tradition that managed to exist without any illusionism. In Japan a picture was not understood to be a virtual window to the world but rather a designed surface. The aban-

donment of three-dimensional space and the sculptural modeling of forms to the benefit of organically flowing contour lines and a strong, pure color scheme seemed too revolutionary. With this came the elevation of the decorative as a principle of an aesthetic world outlook.

The inspirations from the Far East were dealt with in a variety of different ways by the art world of the time. Manet and Gauguin decorated their studios with prints by the popular "ukiyo-e" masters, such as Katsushika Hokusai (1760–1849), Ando Hiroshige (1797–1858) and Kitagawa Utamaro (1753–1806). In paintings by Manet (p. 202), Monet and van Gogh (p. 81), Japanese woodblock prints, kimonos and fans appeared as citations. It was, however, primarily the design principles of Japanese print-making that was appropriated: Mary Cassatt's (1845–1926) etchings divulge their Japanese inspiration in the elegant lines the artist used to depict female domesticity. In their strong two-dimensionality, their contrasting spatial division and their motifs, the famous posters by Henri de Toulouse-Lautrec (1864–1901) demonstrate the artist's deep understanding of the Japanese model. It was not without reason that he was called the "Utamaro of Montmartre."

Mary Cassatt,
The Bath I, 1890/91,
etching and aquatint on paper,
37.9 × 25.6 cm,
Brooklyn Museum of Art,
New York

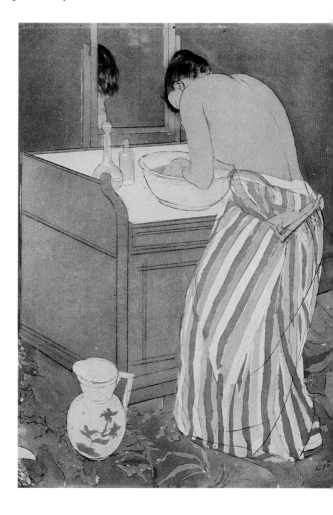

In Front of the Screen

Julien Tanguy (1825–1894) was a Parisian institution: At his store one could get paint, canvases and other artists' materials. Above all, though, he gave penniless artists large credits, usually with objections from his wife. His store near the Rue Lafitte was a meeting place for artists and he was often a friend and advisor to his customers, who endearingly referred to him as "Père Tanguy" (Father Tanguy). Because he was willing to exchange his products for paintings, by the end of his life he had acquired a superb collection of modern art. Van Gogh painted his portrait three times during his stay in Paris between March 1886 and February 1888. Tanguy's favorite painting depicts the then 62-year-old store owner in front of numerous Japanese prints. The motif and color density of the background intensifies Tanguy's quiet and dignified appearance. His gaze seems to be directed more inward than at the viewer. A slight smile and the humble hands folded in his lap allude to his gentle nature. Tanguy was unwilling to part with this painting during his lifetime. It was later bought by the sculptor Auguste Rodin, in whose museum it is still found today.

Vincent van Gogh,
Père Tanguy (Father Tanguy),
1887,
oil on canvas, 92 × 75 cm,
Musée Rodin, Paris

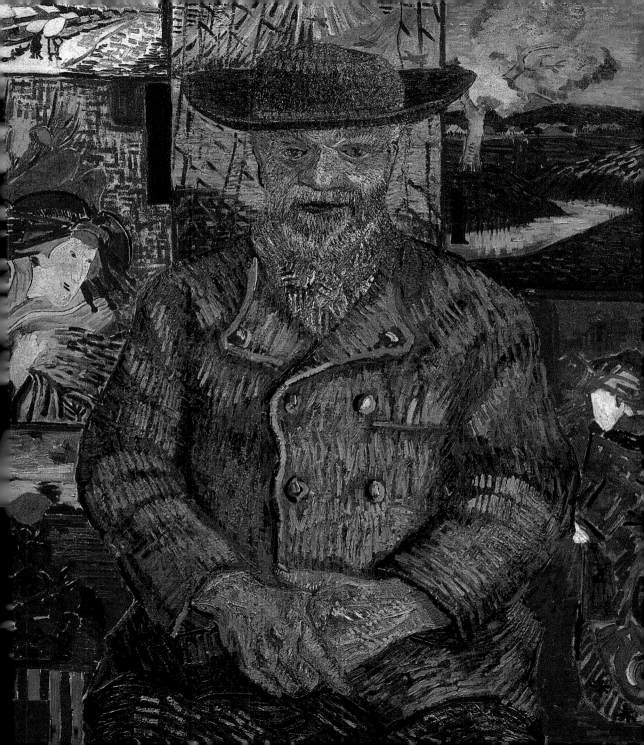

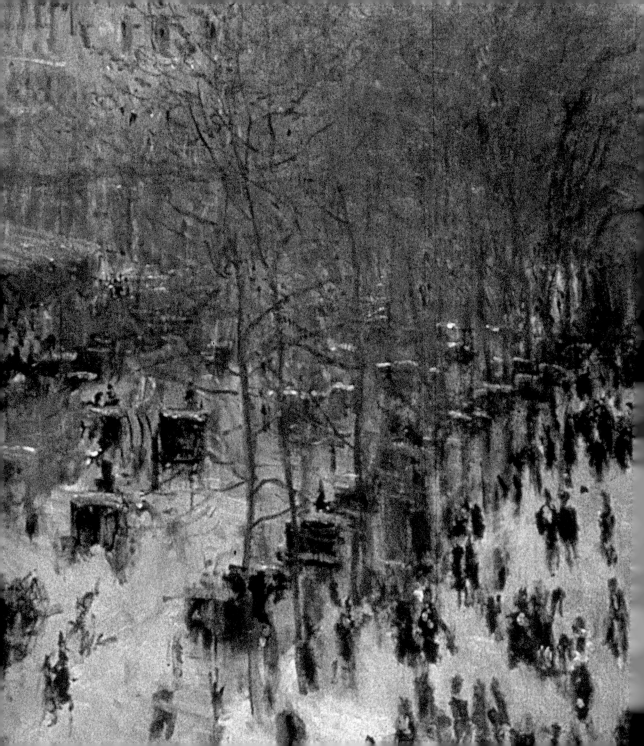

Paris – Europe's Art Metropolis

"The unusual vitality of the public street, the crowd that fills the sidewalks, the coaches on the cobblestones and the trees of the boulevards, which are cradled in dust and light – never before has the indeterminable, transitory and momentary quality of movement, in all its enormous changeability, been grasped and frozen better than in the unusual and amazing study that Monet calls 'Boulevard des Capucines.' [...] But move closer to it and everything disappears. All that remains is an indecipherable chaos that approaches what is left on a scraped down palette."

Ernest Chesneau on May 7, 1874 in his review of the first Impressionist exhibition in the Paris Journal.

Claude Monet,
Boulevard des Capucines, 1873,
oil on canvas, 79.4 × 59 cm,
Nelson Atkins Museum of Art,
Kansas City

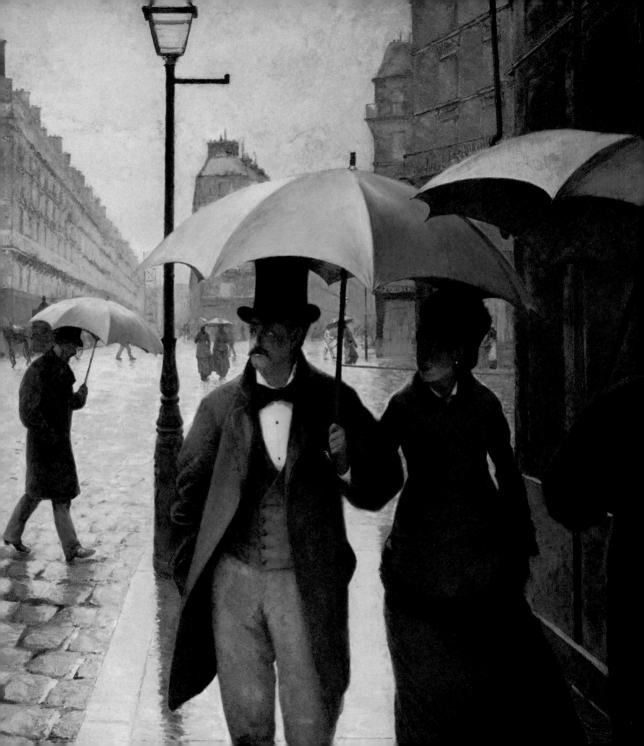

"Nouveau Paris" – The City as an Experience

The Impressionist generation was witness to an unbelievable transformation. In the second half of the 19th century, Paris went from being a partially medieval city to a modern metropolis in record time. This "Transformation de Paris" was the work of two men. Under the direction of Emperor Napoleon III (1808–1873), crowned in 1852, and his prefect, Georges-Eugène Baron Haussmann (1809–1891), all of Paris was transformed into an enormous construction site. Between 1853 and 1872 nearly 25,000 buildings were demolished and about 40,000 new structures erected. Haussmann was not particularly gentle in his approach: almost all the medieval structures on the Île de la Cité were torn down. An extensive expropriation law gave him all the legal power he needed to do this. Wide openings, today's boulevards and avenues, now cut through the narrow neighborhoods of Paris in order to speed up traffic, provide access to new living quarters and fundamentally improve the city's catastrophic public hygiene. Modern urban society developed along these new axes with luxu-

Gustave Caillebotte,
Paris Street, Rainy Day, 1877, oil on canvas, 212 × 276 cm, The Art Institute of Chicago, Chicago

Camille Pissarro,
The Boulevard Montmartre at Night, 1897, oil on canvas, 53,3 × 64,8 cm, National Gallery, London

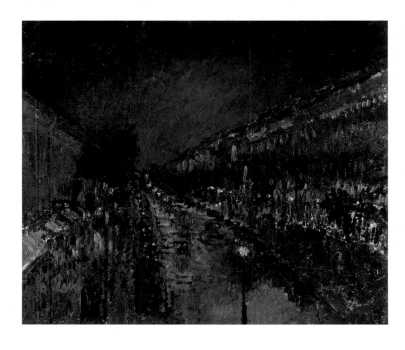

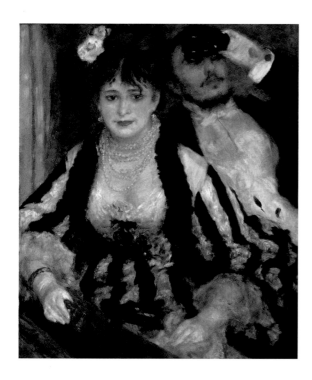

Auguste Renoir,
La Loge (The Theater Box),
1874,
oil on canvas, 80 × 73 cm,
Courtauld Institute of Art,
London

rious department stores, elegant theaters, vaudevilles, restaurants, a spectacular opera, grandiose train stations and glass-covered arcades. The "Grands Boulevards" were soon the public stages for Parisian society. On the fringes of a well-heeled scene made up of the aristocracy, the "haute bourgeoisie", bankers and speculators, was the "demi-monde" of parvenus, leeches and cocottes, as well as artists and literary figures, who were hoping and waiting for success. Tireless lives were led, filled with innumerable pleasures at balls, receptions or the race-tracks. With its extravagant splendor, Charles Garnier's Opéra, completed in 1875, served as the major backdrop for the social game of seeing and being seen. The flaneurs even became free of the restrictions of the weather and the time of day thanks to the covered arcades, the new artificial world of the large department stores and modern gas street-lighting; all of the city's wares, pleasures and offerings could now be consumed any time. The only thing one needed to participate in social life was a sufficient supply of money and the willingness to spend it without restraint.

Boulevard and Outskirts: Paris in the Paintings of the Impressionists

Not just countryside, but the city as well became one of the most important subjects for Impressionist painters. The newly created neighborhood between the Opéra and the Gare Saint-Lazare became a preferred place to work and live for many artists. This is where they lived during their stays in Paris and where their exhibitions took place – and

where they became the interpreters of the modern capital: in 1873 Monet captured the animated hustle and bustle on the Boulevard des Capucines in two paintings (p. 82) and in the 1890s Camille Pissarro painted the area in a series of works that captured the view of the Boulevard Montmartre and the Boulevard des Italiens, as well as the area around the opera house, at different times of the day (p. 85). Both artists also chose the Gare Saint-Lazare as a subject for their work. Gustave Caillebotte (1848–1894) eventually discovered completely new possibilities of portraying the city with its promenading citizens here. While Monet and Pissarro both transferred the movement on the street into their dynamic and animated paintings, Caillebotte concentrated on perspective, local color and precision in his drawings. The large painting *Paris Street, Rainy Day* (ill. p. 84) con-

Édouard Manet,
Music in the Tuileries Gardens,
1860,
oil on canvas, 76 × 118 cm,
National Gallery, London

fronts the viewer with a seemingly arbitrarily chosen street that stretches deep into the distance. A whole group of pedestrians fills the street, either alone or as couples. Based on their demeanor and dress, it is obvious that they are city-dwellers. They are individuals, but are interchangeable – just like the architecture around them, which could be a stage set. Obviously inspired by photography, Caillebotte's street scene reflects on the uniformity and anonymity of the city and its inhabitants, as well as the estrangement and rootlessness of the individual in this new urban structure. The photographic precision of the representation suggests a high degree of realism, although the work represents a constructed space: This street in the rain could be anywhere and nowhere in Paris.

City life was also, however, reflected in countless portraits; it is the opera-goers in their genteel gowns (p. 86), the elegant city-dwellers taking a Sunday stroll and the men in their top hats during their evening outings in the city's various establishments that illustrate the splendor and misery of urban existence.

It was not only the city's glamorous side that became the focus of painting at the end of the 19th century but its outskirts as well. It was, above all, very rural areas, such as Montmartre, that were discovered as fertile ground by artists, including Henri de Toulouse-Lautrec and Vincent van Gogh. "There are windmills, cabarets and gazebos; rural fields and quiet lanes are lined with straw huts, sheds and tree-filled gardens." It was in this idyllic way that the writer Gérard de Nerval (1808–1855) described the hill in the north of Paris in 1854, an area that was first incorporated into the city in 1860. It was here – where Parisians had built country-houses a century before because of the fine air quality – that all those retreated who could no longer afford to live in the newly renovated neighborhoods following the city's redevelopment by Haussmann. The pop-

Towards the end of the 19th century the city's outskirts, with their industrial complexes and workers' neighborhoods, began to attract artists' interest.

ulation exploded and misery and poverty increased. At the same time, the quarter, with its many cabarets and dance halls, became the city's red-light district. A regular guest of the area, the draftsman and printmaker Henri de Toulouse-Lautrec, became a chronicler in the 1890s of this demi-monde. He made portraits of the dancers at the "Moulin Rouge" and the prostitutes in the brothels, as well as of the dubious impresarios and bizarre figures. His posters were

Vincent van Gogh,
The Factory at Asnieres, 1887, oil on canvas, 44.2 × 54 cm, The Barnes Foundation, Merion, Pennsylvania

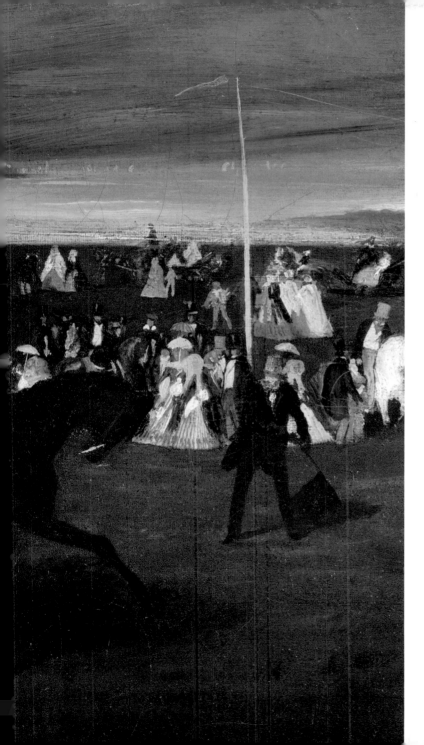

The racetracks in Longchamp, Auteuil and Vincennes were magnetic attractions for "tout Paris" and one of Edgar Degas and Édouard Manet's favorite subjects. They depicted the tense atmosphere before the race, the elegant horses with their jockeys and the public that waited in anticipation for the race to begin.

Edgar Degas,
At the Races: The Start,
1860–62,
oil on canvas, 33 × 47 cm,
Fogg Art Museum, Harvard University Museums

Henri de Toulouse-Lautrec,
The Dance at the Moulin Rouge
(detail), 1890,
oil on canvas, 115.6 × 149.9 cm,
Philadelphia Museum of Art,
Pennsylvania

Edgar Degas,
In a Cafe, or The Absinthe,
c. 1876,
oil on canvas, 92 × 68 cm,
Musée d'Orsay, Paris

soon omnipresent in the streets of Paris and became the incunabula that still characterize Montmartre's image today. Other artists, including Auguste Renoir, the brothers Theo and Vincent van Gogh, Edgar Degas and Georges Seurat, also moved to the area because of the cheap rents and, perhaps more so, because of the particularly liberal atmosphere. The undefined area between city and countryside, unordered and wild, industrialized yet with a few picturesque corners, was painted numerous times by Vincent van Gogh, whose studio was on the Rue Lepic, during his stay in Paris between March 1886 and February 1888. This artist, who had always felt déclassé and more at home with farmers and workers, found an environment here that corresponded with his self-image. It was in this cityscape that he first experimented with a brighter color scheme and a Neo-impressionist brushstroke.

Subject Matters:

Portraiture and the Figure

It is Sunday and the sun is shining. The atmosphere is cheerful and relaxed. The rest is taken care of by the pretty summer dress and the new hat with the red ribbon. People are enjoying the fresh air and the free time in one of the many popular restaurant destinations along the Seine, just a short train trip from Paris. The table is already set and the food will be served shortly. Auguste Renoir's portrait of a young woman in front of a riverscape is hardly surpassable in its sense of light-heartedness and ease, and even appears a bit too harmless and gay at first. Figure and landscape are united in a harmonic color scheme and a dabbed surface structure. Nothing disturbs this idyllic situation in nature, other than the knowledge of its transience. Tomorrow the working week will begin in the city.

Auguste Renoir,
Alphonsine Fournaise on the Isle of Chatou, 1879,
oil on canvas, 73 × 93 cm,
Musée d'Orsay, Paris

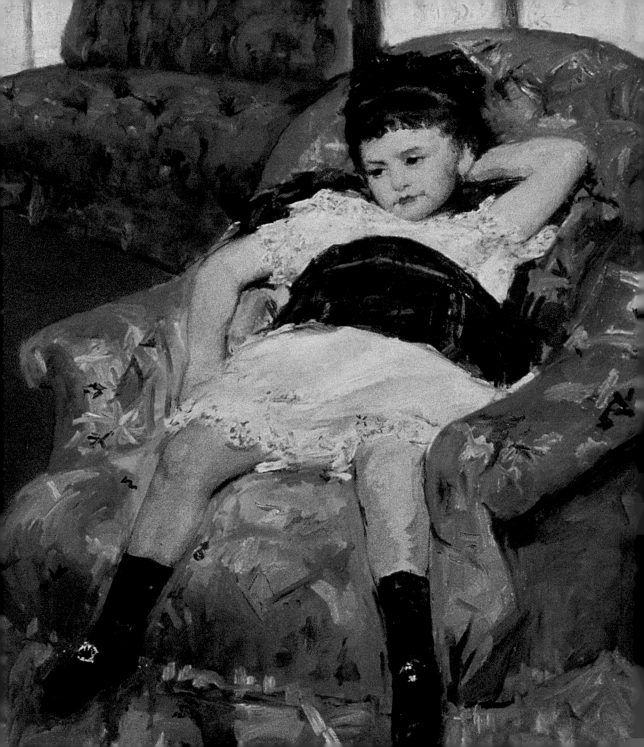

Private Lives

Portraits show more than a person's appearance, age and gender. They tell viewers about his or her position, self-image and role in the world. They also reveal information about the period in which he or she lives through clothing, posture, gestures and charisma. For centuries portraits were usually painted as commissions. Popes and kings, as well as wealthy citizens and scholars, gave great thought to the execution of their portraits because, even if a portrait depicts someone at a specific point in life, it primarily creates an "image" with a claim to eternity. Only in this way would the appearance of the sitter outlive his or her physical existence. Dress, props, atmosphere, posture and gesture were chosen with corresponding care and agreed upon with the portraitist. This is especially true of the period in which photography was discovered in the second half of the 19th century.

Not all people had the same right to a presence after they died, which is why, for centuries, full-length portraits were reserved for rulers and members of the aristocracy. The gentry and successful businessmen had to make do with portraits to the knees or half-length portraits. Most people never had their portrait painted. Craftspeople, farmers, day laborers, menials and

Mary Cassatt,
Little Girl in a Blue Armchair
(detail),
1878, oil on canvas, 89 × 130 cm,
Mellon Collection,
National Gallery of Art,
Washington

Mary Cassatt,
The Tea, 1880,
oil on canvas, 64.77 × 92.07 cm,
Museum of Fine Arts, Boston

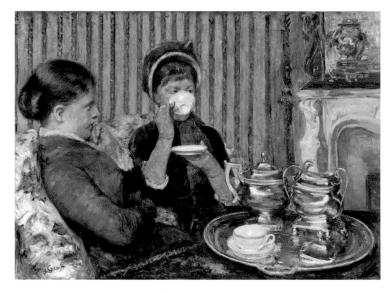

workers were never in a position to afford a costly portrait. Their individual appearance disappeared with their death, sinking into oblivion.

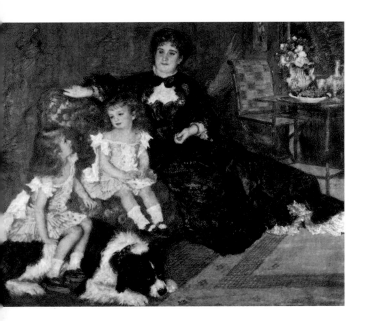

Auguste Renoir,
Madame Charpentier and her Children, 1878,
oil on canvas, 153.6 × 190 cm,
The Metropolitan Museum of Art, New York

Portrait Painting in the Era of Photography

It was only with the development of photography that the culture of memory was fundamentally transformed; anyone who wished to could now present their face and pass their image on to the next generation. The elaborate process of portrait painting was fundamentally questioned with the advent of these new technical possibilities: why go through many sittings in a studio to have an image painted that could be created in just minutes with the click of a button? Or did paintings depict more or at least something different from what a photograph did?

Impressionist artists initially reacted to photography's new possibilities by using them in a variety of ways. It is known that Edgar Degas, as well as Gustave Caillebotte and Claude Monet, took photographs in order to try out certain perspectives or compositional effects. Even Frédéric Bazille's *Family Reunion* (ill. p. 100) seems to be highly influenced by a "photographic view." The situation he composed gives the impression that the family members present were called together for a moment on the terrace and were arranged for the shot so that they would be easily recognizable, while at the same time their positions create a lively ensemble: The young woman at the small table, one of the painter's cousins, turns for this purpose away from her mother and towards a possible

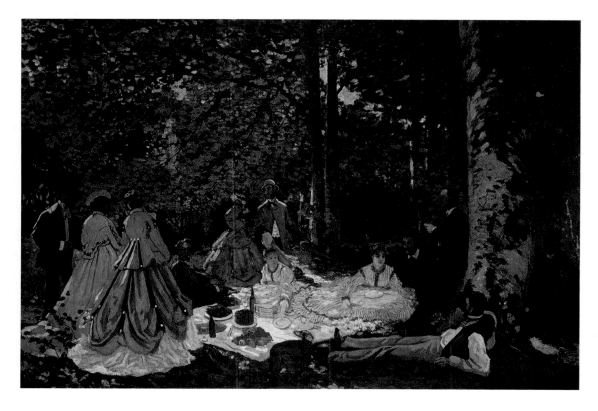

viewer; Bazille's brother has placed himself behind the two women on the low wall; another cousin and his wife join the group, perhaps just back from a stroll through the garden; the parents sit on a diagonally placed bench and the painter himself seems to have assumed his position on the leftmost edge of the image at the last minute. It is not only the posture of the figures that is reminiscent of a photograph, but also the conspicuous "depth of field," with the precise lighting situation under the shadow of the chestnut tree, as well as the smooth structure of the painting's surface. Although only a black-and-white photograph would have been possible at the time, Bazille revels in colors and materials, distinguishing between shiny silk and transparent

Claude Monet,
The Breakfast in the Greenery,
1866,
oil on canvas, 130 × 181 cm,
Pushkin Museum, Moscow

Frédéric Bazille
(1841–1870), who was
killed in the Franco-
Prussian War when he was
just 29, was awarded
entry into the 1868 Salon
with this large group
portrait. Set on the
terrace of the family seat
in Méric near Montpellier
in the south of France,
the image shows members
of the painter's family.
In his review of the exhi-
bition, Émile Zola praised
the young artist's confi-
dent depiction of light
and his precision in the
depiction of the figures.

Frédéric Bazille,
Family Reunion, 1867,
oil on canvas, 152 × 230 cm,
Musée d'Orsay, Paris

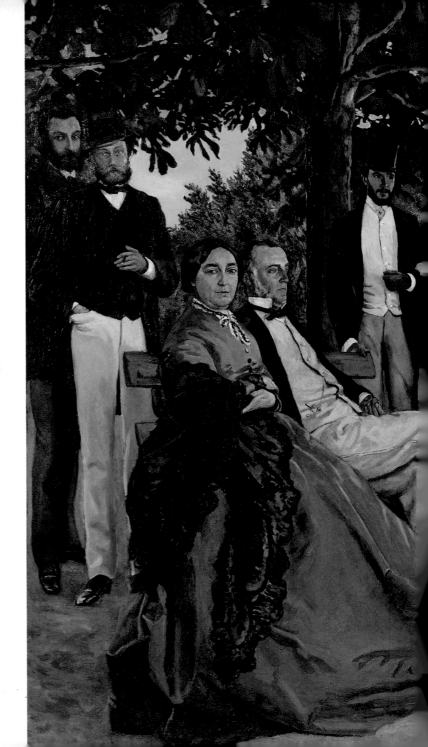

muslin, stressing the fashionable polka-dot patterns of the summer clothes and setting a particularly colorful accent with a bouquet in the foreground. The large format also makes it obvious that the suggestive and rhetorical power of painting is superior to that of photography at this point in time.

Portraits play an important role in Impressionist painting, although one may not think so at first: Bazille, as well as Édouard Manet, Eva Gonzalès, Edgar Degas, Auguste Renoir, Mary Cassatt, Berthe Morisot and Marie Bracquemond, were primarily active as portrait and figure painters. Monet's first challenging project as a young artist was for a large group portrait in the countryside (ill. p. 99). The subject matter and formulation of portraiture was, however, fundamentally redefined by the Impressionists: Conventional, stiff poses became snapshots; staged group portraits became paintings in which people casually stood or sat with each other, paintings in which people spoke with one another seemingly without regard to the painter and

Eva Gonzalès,
Awaking Girl, undated,
oil on canvas, 81.5 × 100 cm,
Kunsthalle Bremen – Der Kunst-
verein in Bremen

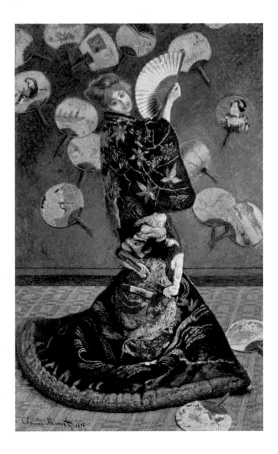

Claude Monet,
*Camille Monet in Japanese
Costume,* 1876,
oil on canvas, 231.8 × 142.4 cm,
Museum of Fine Arts, Boston

even seemed to turn their backs on him. Impressionist portraits were hot on life's trail in a completely novel manner: they portrayed the private realm of their subjects rather than public poses, stressing movement and the changeability of human existence, as well as the excerpt-like and transitory quality of a specific situation. Photography also did this in a similar fashion since it was also able to capture images of moving objects thanks to the even-then short exposure time. The new photographic process was, however, not copied by painters: on the contrary, while photography "froze" a brief moment mechanically, Impressionist painting captured the transitory moment by the emphasized disclosure of the painterly process. The lively brushstrokes in the painting "tell" of its origin as a temporally defined event.

The "Modern Individual"

Impressionist painters often chose a moment for their portraits that even a photographer would have scrapped at first glance: a young girl in her Sunday dress who a moment ago was probably just sitting quietly in the blue sitting room, but who now lounges around with straddled legs in a large cushioned armchair (ill. p. 96). This casual, even improper, posture is in strange contrast to her carefully chosen clothing with matching accessories: Her stockings, sash and hair ribbon all have the same tartan pattern. In the quiet of the darkened room the child seems to have forgotten all the manners she has been taught. She has forgotten herself. The composition, with its emphasized low vantage point, reflects the childlike perception of space and time: The confusing arrangement of

the furniture, whose extreme detail suggests a lack of orientation, and the direction of light lend the harmless blue sitting room an almost surreal atmosphere.

The portrait as the representation of a person in the most recognizable and flattering manner is the conventional minimum demand of this genre; yet in Mary Cassatt's depiction of the two tea-drinkers in *The Tea* the artist chose the moment in which one of the women is lifting her cup to her mouth, practically concealing her face (ill. p. 97). Edgar Degas, who shared many parallels with Cassatt, proceeds in a similar way with the two women in *The Laundresses* whom he depicts working in their austere parlor. While one of the women leans over to increase the pressure on the iron with the weight of her body, the other one yawns heartily (ill. p. 106). And finally – it is hardly possible to be more radical – Gustave Caillebotte paints a man who, having just gotten out of the bath, is drying his leg (ill. p. 214). Such an intimate moment involving one's own body was not considered to be a motif for a painting before this. "What we need is the special touch of the modern individual, depicted in his own clothing, in the midst of one of his ordinary habits, at home or on the street," was how Louis Émile Edmond Duranty formulated his thought in 1876 in his essay, *La nouvelle peinture* (The New Painting). The Impressionist painters honored this claim with their innovative contribution to portrait painting. They showed the faces and environments of modern people from new and exciting perspectives.

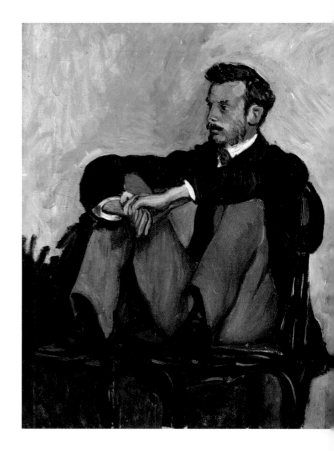

Frédéric Bazille,
Portrait of Auguste Renoir, 1867, oil on canvas, 122 × 107 cm, Musée d'Orsay, Paris

"Peinture pure" – Pure Painting

Portrait painting was traditionally considered to occupy an inferior position in the hierarchy of painterly tasks. After all, when painting a portrait the painter only had to try to imitate nature as best he could and create nothing himself; this was the shortened version of the accusation that had been thrown from the art-theorist camp for centuries. It was precisely this proximity to nature that interested the Impressionists: if a person could be captured in a painting the way a flower, tree or an apple could, then this was close to the Impressionist idea of a "peinture pure," or a pure painting. "The painter puts his ability to observe especially to the test when painting a portrait; he engages in an awful battle with nature…" was how Zacharie Astruc put it. The task and challenge for artists was not flamboyant history painting with its borrowings from ancient mythology, but rather the depiction of the present. Thus, the supposedly private realm was elevated to an expression of "real life" (Zola). Impressionist portrait painting is, in this sense, a "tranche de vie," a – well painted – slice of life, and therefore usually depicts people in their private realms doing ordinary tasks. The specific atmosphere of a warm summer day in the garden; the rich, patterned fabric of the clothing and of the

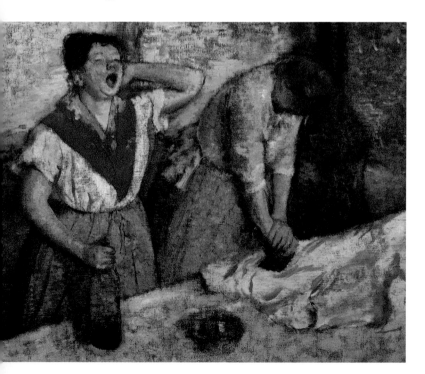

Edgar Degas,
The Laundresses, 1884–86,
oil on canvas, 76 × 81 cm,
Musée d'Orsay, Paris

chair in the parlor; the decoration of the wall coverings; a lavish arrangement of fruit or flowers; the shining silver of the tea service – all these things unfold in Impressionist portraits and relay the love of texture, surfaces, light reflections, colors and nuances.

In doing this, the artist's focus was often centered on the usually neglected sphere of women, whose domain was the private living quarters of the home rather than the public streets and squares of the city. Their works show friends chatting in the parlor and capture intimate moments of togetherness between a mother and child (ill. p. 124). They are portraits of self-forgotten women bent over manual tasks (ill. p. 166) and of self-confident ladies in elaborate gowns at the opera (ill. p. 86). In addition to this peep into the bourgeois world, sheltered if not somewhat boring and stagnant, there are also images of "little people," such as milliners, seamstresses, farmers' wives, stone-breakers, floor polishers, maids, waitresses, ironers, and even prostitutes. This coexistence of different social realities reflects the Impressionists' open and non-hierarchical choice of motifs. Their modernity is demonstrated by the reflection of modern life's diversity in their paintings

A short moment of relaxation: stretching and yawning, maybe drinking a sip of wine to chase away the weariness. Degas depicts his ironing women doing their exhausting daytime work in an unadorned and unsentimental way. The simplicity of the subject matter is also reflected in the subdued colors and the rough surface of the painting.

Tone Paintings – Impressionist Music

Claude Debussy
(1862–1918),
photograph *c.* 1900

Claude Debussy
with his Daughter,
Claude-Emma,
photograph 1916

As with their painting, the Impressionists also cleared the path for the Modern movement in music. With the dissolution of traditional chord sequences, composers such as Claude Debussy, Maurice Ravel, Erik Satie and Camille Saint-Saëns paved the way for new musical experiences with their free experimentation. Established musical forms, including sonatas and symphonies, were disregarded and atmospheric "fiddling around" was placed in the foreground.

Without doubt, Claude Debussy was one of the main protagonists of this musical direction with pieces such as *Prélude à l'après-midi d'un faune* (The Afternoon of a Faun, 1894) or *La Mer* (The Sea, 1903). After initial studies in piano, in 1880 Debussy transferred to the composition class taught by Ernest Guiraud. At the end of the 1890s he was a frequent visitor to Bayreuth, and the influences of Wagner are obvious in his

work – although he denied this. Debussy's most productive phase began in 1890 and reached its height in his composition of the opera *Pélleas et Mélisande,* which would make him famous. The opera, which had its premier on April 30, 1902 after a decade of struggling with the piece, caused different reactions – some critics accused it of being decadent, while others were fascinated by the novel atmospheric sounds. Debussy had already rung in the Impressionist era in music in 1894 with the composition *The Afternoon of a Faun,* based on a poem by Mallarmé. The composer described his music as a sequence of images that pass by in the faun's dreams in the afternoon heat. With the combination of the faun theme (flute) and the dark background sounds, Debussy created a true painting of sounds.

The Sea is the most Impressionist of all Debussy's works and

seems to be the tonal translation of the famous woodblock print by Hokusai, *The Great Wave* (ill. p. 77). The premiere took place in 1905. *The three symphonic sketches for an orchestra* were as follows: From dawn to midday on the sea – Play of the waves – Dialogue of the wind and the sea. Debussy created a magnificent fusion of nature and fantasy that very few people at the time could recognize. The most important influence on the path to freedom that Debussy took from his composition was his encounter with the gamelan music of Java to which he had been introduced in 1889 at the Exposition Universelle in Paris. The transformation of the sea's natural power into a painting of sounds is created by means of rhythmic shifts that are combined with delicate floating sounds.

With Erik Satie the music of the Belle Époque took its final step into the Modern movement. After breaking off his studies in music, Satie initially worked as a pianist in the bars of Montmartre. Satie was an eccentric, living alone after the end of his relationship with Suzanne Vala-

don. He joined the secret Rosicrucian society and loved to disguise the musical effect of his work with strange presenta-

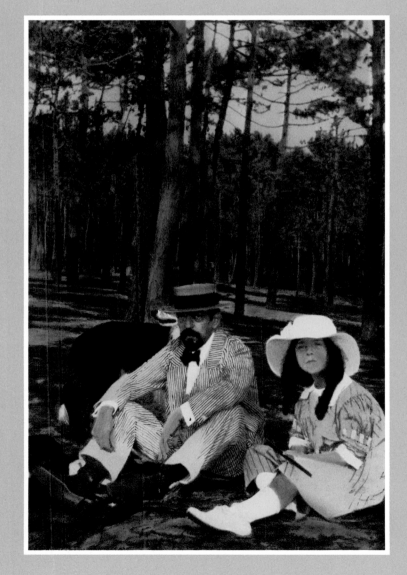

tion methods and titles. While still the pianist in the legendary cabaret, Le Chat Noir, Satie composed his works *Gnossiennes* and *Gymnopédies* (1888–90), which, with their

Maurice Ravel
(1875–1937),
photograph *c.* 1930

combination of medieval church music and modern songs, made the critics wonder if Satie was really a genius or not. In 1893 Satie wrote *Vexations*, a passionate reckoning with his classical music education at the conservatory from which he had recently been dismissed because of his lack of commitment. It is a very slow, four-line étude in the theory of harmony from the conservatory entitled *Omission of an Existing*

Bass, which, Satie directed, was to be repeated 840 times.

Satie was playing in the cabaret Auberge du Clou when he met Claude Debussy in 1891 and promptly started to give his fellow musician lectures on the importance of freeing himself from the influence of the overpowerful role model, Richard Wagner. Just how much Debussy, who would later become a celebrated composer, was influenced by the "little" Satie is obvious from his composition, *Sarabande,* of 1894, which, in the opinion of many experts, was a composition written by Satie in 1887 and plagiarized by Debussy. After the turn of the century the avant-garde became aware of Satie's radical views and he found a committed promoter in the all-round artist, Jean Cocteau. It was, above all, Cocteau's involvement with theater and ballet that allowed Satie to become successfully involved with the new art forms. In 1917 Satie had his breakthrough with the ballet *Parade,* gaining the acceptance of the art world. Ordinary sounds appeared in music for the first time and the public

seemed ready to accept this radical change. The "Master from Arceuil," as Satie was called in his later years, had paved the way for the development of modern music, although this did not stop him from dying in dire poverty. There are many names that stand between the two composers Debussy and Satie, as the protagonists of two decisive positions in music of the Impressionist period, including Maurice Ravel who, for instance, with his famous *Bolero,* composed one of the most frequently played orchestral pieces in the world. Based completely on the idea of atmospheric paintings of sound, with this piece Ravel developed a musical equivalent to the central term that characterized the early Modern movement: Speed. In his meticulously developed compositions, Ravel countered the shimmering iridescence of a Debussy chord with a razor-sharp contour.

Camille Saint-Saëns was a generation older. With his composition *Le carnaval des animaux* (Carnival of the Animals), which was actually created for a premier amongst a group of friends in 1886, he also created new impulses. Particularly noteworthy is the subtle critique Saint-Saëns made of his colleague, Jacques Offenbach. The cancan is danced as if in slow motion – by turtles in the company of kangaroos, cuckoos and lions, who are also among the piece's protagonists.

The freedom of form, the appropriation of foreign influences, such as gamelan music or folk dancing, were aspects of Impressionist music that were systematically expanded on in the 20th century, leading to an entirely new musical experience that would never have been possible without their role models.

Erik Satie (1866–1925),
Self Portrait,
Bibliothèque Litteraire Jacques Doucet, Paris

Locations:
Argenteuil and Pontoise

"Among the Impressionists, Pissarro is the one who represents the standpoint of the true naturalist painter. He sees nature by simplifying it. (…) As a painter of pastoral scenes and the open countryside, with his solid techniques he deals with the ploughed and harvested fields, the flowering trees and those swept bare from winter, streets lined with hedges and the dirt paths that are hidden under shrubs. He loves his subject matter. His paintings relay the greatest sense of space and seclusion."

The journalist and art critic Théodore Duret (1838–1927) in his book, "Les Peintres impressionistes" (1878).

Camille Pissarro,
The Red Roofs, or *Corner of a Village, Winter,*
1877, oil on canvas,
54,5 × 65,5 cm,
Musée d'Orsay, Paris

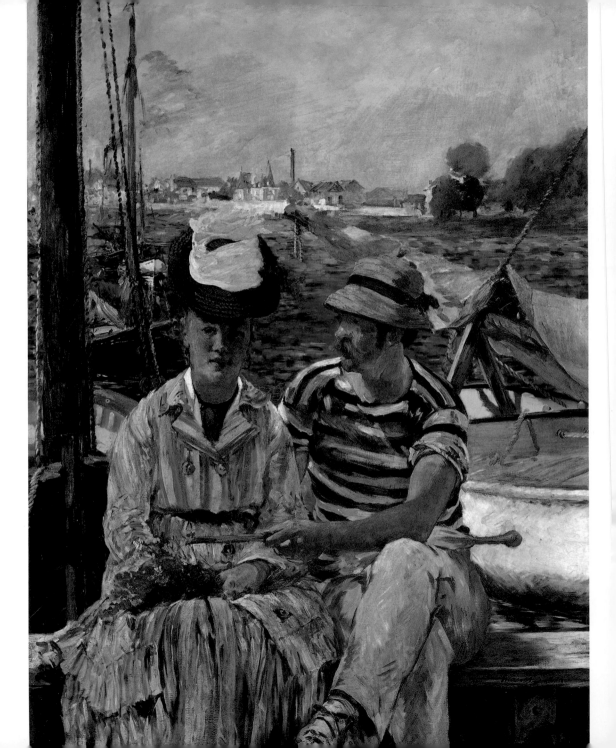

To New Shores

The Impressionists' commitment to "plein air" painting represented a lifelong search for most of the artists: a search for ever-new motifs, a particular place, a particular light; landscapes that provided the artist's eye with the inspiration he needed to paint paintings; the search for the pristine quality of the motif and for special optic and atmospheric inspirations. To this end almost all the artists traveled constantly between Paris – with its art scene, painting materials, exhibitions and gallery owners – and their actual residences in the countryside. The preferred locations were the small villages along the Seine that were easy to reach from Paris with the train line to Rouen that had been opened in 1851. Affordable living and studio spaces were available there for the usually destitute artists and their families. More important, however, was that they here lived right next to their most important subject – the countryside, with its changing seasons and weather and light conditions. No day was wasted when one could go out and set his easel up outdoors. Argenteuil, where Claude Monet lived between 1872 and 1878, and Pontoise, where Camille Pissarro lived with his large family between 1872 and 1884, were insignificant little villages in the environs of Paris that became the secret centers of Impressionist painting.

Country outings often led Parisians out to the various towns on the banks of the Seine. The Paris-Rouen railroad line made day trips to Argenteuil and Giverny possible.

Riverscapes

Claude Monet discovered the still small town of Argenteuil before the Franco-Prussian War. Then particularly popular with scullers and other water-sports enthusiasts, it was to a house with a garden near the Seine in this town of little more than 7,000 inhabitants that the artist moved with his wife Camille and their son in 1872. Sisley and Caillebotte,

Édouard Manet,
Argenteuil, 1874,
oil on canvas, 149 × 114 cm,
Musée des Beaux-Arts,
Tournai

as well as Pissarro, visited him often in the summer months from nearby Pontoise. Sometimes Auguste Renoir was also a guest, although he never was interested in living in the countryside permanently. As a portrait and figure painter, most of his subjects and clients were in Paris.

In 1874 Manet lived in Gennevilliers on the other side of the Seine, where his family had a home. Manet, who was actually still a studio painter despite a few "plein air" works he painted in 1869, most certainly allowed himself to be encouraged that summer by Monet to paint a few works outside. Remarkable is his still predominant interest in the figure – even if a light landscape replaced the dark background of the studio. The couple in *Argenteuil* have seated themselves as if for a photograph (ill. p. 114). While the woman looks straight ahead in a disciplined manner, the man has turned his head to face her. The maritime clothes characterize the two as day-trippers from the city. They are probably about to set out on a boating excursion together. The bouquet on the woman's lap was surely just picked during a stroll through nearby meadows. By the end of the 19th century the Parisian environs had already become a tourist destination and a nearby location for recreation and relaxation. Manet was one of

Angleterre

Belgique

La Manche

Berck-sur-Mer

Sainte-Adresse ● Etretat

Rouen
Pontoise

Deauville / Honfleur

Giverny

Auvers-sur-Oise

Trouville-sur-Mer

Asnières

Argenteuil

Batignolles

Port Marly

Paris

Maincy

Barbizon

Fontainebleau

Bois de Fontainebleau

the first artists to visualize the then still new perception of nature.

Monet and Renoir also worked along the riverside in Argenteuil in 1874 (ill. below and pp. 118/119). Some days they set their easels up right next to each other as they had done in 1869 in La Grenouillère (ill. p. 57). Their approach was fundamentally different from that of Manet: it was the landscape as an atmospheric realm, not the figure, that was the focus of their paintings. The course of the river with its reflections of the surrounding nature, light reflexes and the constant movement of its surface dominate the entire forefront of their paintings. The compositions have no main motif and nothing leads the viewer into the depth of the paintings, whose texture, made up of agitated brushstrokes, illustrates the shimmering of light, air and water on a hot summer's day.

Auguste Renoir,
The Seine at Argenteuil, 1874, oil on canvas, 51 × 65 cm, Portland Art Museum, Portland, Oregon

Gardens and Fields

In contrast to Argenteuil, Pontoise, situated on the Oise a good 30 kilometers from Paris, was not a day-trip destination for Parisians but rather a simple peasant's village with farmhouses, gardens and fields. Pissarro, who first visited this village in 1866, consciously chose this unspoiled place to live and work because it corresponded to his ideas of nature and authenticity. Pontoise had already been discovered by the painters of the Barbizon School, and when Pissarro came

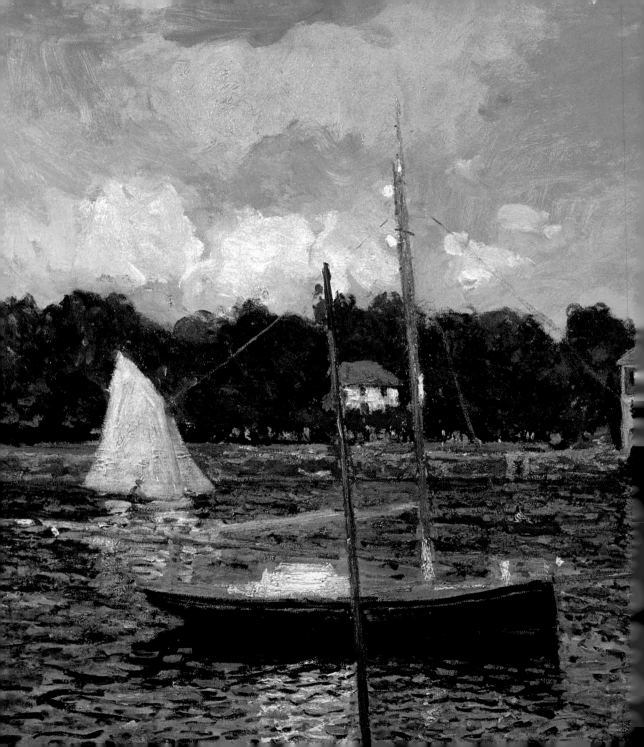

The reflection of the sky in the water is the actual theme of this painting. Monet created several versions of the bridge of Argenteuil, which had been built to accommodate railroad traffic over the Seine. The reflections of light that are thrown from the water onto the bridge's arches allow for a colorful animation of the stone and emphasize its material density.

Claude Monet,
The Seine at Argenteuil, 1874,
oil on canvas,
Private collection

Camille Pissarro,
The Little Bridge, Pontoise, 1875,
oil on canvas, 65 × 81 cm,
Städtische Kunsthalle,
Mannheim

back here following the end of the Franco-Prussian War, he became friends with the 54-year old Charles-François Daubigny. Together they worked in the rural landscape. Pissarro's ability to capture the specific character of this area was noticed even by his critics. In December 1873 Théodore Duret wrote to the painter: "You do not have Sisley's decorative talent or Monet's fantastic eye; but you do have something that others lack: a profound and deep feeling for nature and a powerful brushstroke so that a painting by you is securely grounded in itself." Pissarro's paintings of Pontoise show houses, gardens and fields. They are unspectacular subjects of a countryside that has clearly been worked by human hands. In contrast to Monet, Pissarro was not interested in the transient quality of a reflection in water, the glitter of the waves or a restless sky, but rather the quiet, peacefulness and emptiness of this austere landscape. For this reason he preferred fall with its muted colors and predominately bleak sky. His views of Pontoise, with the frequently rough atmosphere, also reflect the harshness that was part of living in the countryside. When industrialization finally made its way to Pontoise, Pissarro and his family moved to Éragny-sur-Epte in 1884.

Pissarro's particular view of nature influenced two artists who had worked with him in Pontoise at the begin-

ning of their careers, Paul Cézanne and Paul Gauguin. The cooperation with Cézanne lasted from 1872 to 1877 and was a decisive factor in the nine year younger artist's decision to dedicate his work to landscape painting (p. 121). Through his close contact with Pissarro, Cézanne's palette became permanently lighter and the type of brushstrokes, short and oblique, which are now considered so typical of the artist and which make a flat and dense painting composition possible, was developed. At times Pissarro was also an important advisor to Gauguin with regard to all artistic questions. Above all, however, Pissarro encouraged him to give up his bourgeois life as a stockbroker and exchange it for the insecure life of an artist; He also helped the still inexperienced painter to get his work included in the Impressionist's fourth exhibition in 1879.

Paul Cézanne,
Mill on the Couleuvre at Pontoise, 1881,
oil on canvas, 75.5 × 91.5 cm,
Staatliche Museen zu Berlin,
Preussischer Kulturbesitz,
Nationalgalerie, Berlin

Pissarro was not only interested in the landscape but also in the people working in it. He usually depicted farmers' wives in the field or doing handiwork, rarely in moments of frolicking, as in this watercolor drawing. The united movement of the group dancing is convincingly captured in just a few brushstrokes by the artist.

Camille Pissarro,
The Round, c. 1884,
watercolor, 41 × 61 cm,
Private collection

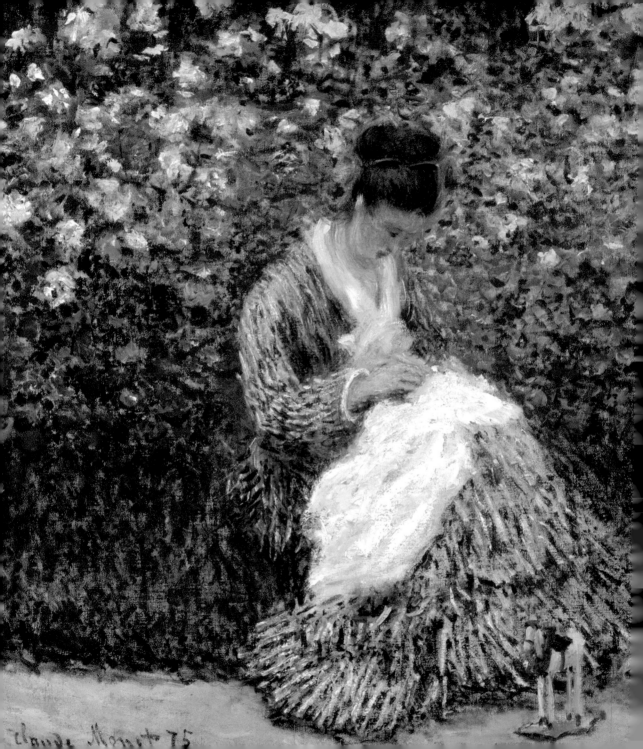

The Productive Decade

A vibrant sensation for the eye is created out of this quiet garden scene in Argenteuil. Camille Monet sits with a small child in front of a sea of flowers. She is busy doing handiwork as the child leafs through a picture book. It is a moment of absent-minded concentration, one that could be gone in the blink of an eye. Each of the figures is lost in their own thoughts, yet relishes the togetherness in the warm, sunny outdoors. Monet captures this temporary moment as a colored chord that contains harmonic sounds and bright contrasts. An animated, dynamic brush-stroke transforms the painting's entire surface into a shimmering oscillation and the figures are closely united with the natural surroundings – the dissolution of subject matter had rarely been executed more radically.

Claude Monet,
Camille Monet and a Child in the Artist's Garden in Argenteuil, 1875,
oil on canvas, 55.3 × 64.7 cm,
Museum of Fine Arts, Boston

Painting is Color

Impressionist painting only seems to know the summer: gardens overflowing with flowers, the blazing red of poppies, the incredible green of the grass in the water-rich Seine landscape and finally the blue sky with passing clouds. The landscape as an independent motif – this was nothing new. Even in 17th-century Dutch painting, landscape painting was a full-fledged genre. And in 19th-century France the painters of the Barbizon School discovered their motifs in the dense forest around Fontainebleau. The group around Camille Corot and Théodore Rousseau already experimented with painting in oils outdoors. Nonetheless, Impressionist landscape painting, which unfolded in all its facets between 1873 and 1882, yielded a whole new contribution to this theme. For the first time in the history of art, paint as a material substance became clearly visible, enabling the image to become a visual experience. Through the visualization of the painterly process the image simultaneously lost its representational power. It was suddenly no longer a window into the world but a surface designed out of paint. This quality led to Impressionist paintings' being regarded as "crude scribbling" by the public of the time and as incomplete

Berthe Morisot,
Roses Tremieres (Hollyhocks),
1884,
oil on canvas, 65 × 54 cm,
Musée Marmottan Monet, Paris

Claude Monet,
Wild Poppies, near Argenteuil,
1873,
oil on canvas, 50 × 65 cm,
Musée d'Orsay, Paris

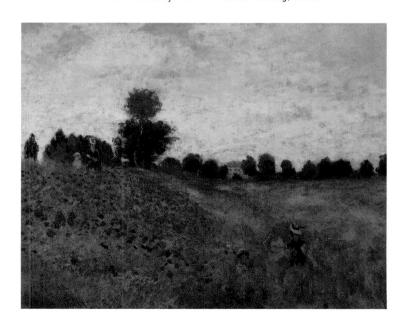

This painting represents Renoir's mature Impressionist style with his typical emphasis on soft drawing and, in this case, a particularly strong brushstroke, lending the rather peaceful, contemplative scene of the sunny meadow an enormous animation.

Auguste Renoir,
Woman with a Parasol and a Small Child on a Sunlit Hillside, 1874–76,
oil on canvas, 47 × 56.2 cm,
Museum of Fine Arts, Boston

from a compositional and technical point of view. Even well-intentioned critics demanded of Claude Monet and his comrades-in-arms that they finally create some truly finished works in the interest of artistic objectives. With this remark it is clear that they had totally misunderstood the artists for whom it was precisely not a question of a composition that had been prepared through many sketches, but rather a question of the experience of seeing in itself. The human sense of seeing was reflected in their landscapes and the appropriation of the surroundings by means of the unimpeded view into it.

Changeability as Movement

The flexible, restless eye of man, necessary for orientating himself in nature, was now addressed through painting. This factor is already apparent in the Impressionists' favored motifs: the rippling water in the rivers and lakes, the waves of the grain fields caused by the wind blowing through them, the vibrating leaves of the trees, the soaring ocean and the restless sky. The painter thus "translated" natural movements into an animated image surface, with the brushstroke "simulating" the natural phenomena. Everything material is united in doing this: there is no longer a qualitative difference between soft and hard or built structures and nature. This is why, in addition to summer landscapes in which light was responsible for the process of dissolving material things, the Impressionists were also partial to "special effects" with equalizing attributes. For this reason Sisley was intrigued by the flood disaster that occurred in Port-Marly on the Seine in 1876, which allowed him to study a watery landscape devoid of riverbanks (ill. p. 131). It was not the inhabitants' situation that was the painting's motif but rather the moving water surface that produced a colored reflection of the flooded house and row of trees. This made it possible for Sisley to reduce his palette to a

Even a natural catastrophe could become the subject matter for a painting: Alfred Sisley painted the town of Port-Marly, which had been flooded by the Seine, as a color duet in blue and ochre.

Alfred Sisley,
The Boat in the Flood,
Port-Marly, 1876,
oil on canvas, 50.5 × 61 cm,
Musée d'Orsay, Paris

fixed tonal value of blue and ochre, a combination that often pervades his work. The majority of his painting is dominated by the sky and its low-lying clouds. Sisley loved painting clouds and once claimed in a discussion with Monet that he always started his landscape paintings with the depiction of the sky.

The depiction of a snow-covered landscape also represented a special task. The snow had a similar effect to that

of sunlight: it created a bright atmosphere and therefore a light impressionist palette. Contrasts of light and dark were included in the work, as were the material and color qualities. The blanket of light reflecting snow covers the landscape in a unified white. The eye can and may lose sight here of what is in front and what is in back, what is up and what is down – everything seems to melt into the impression that gave this art its name.

Landscape as an Aesthetic Experience

Although the landscape had been understood as a visual space for centuries, a space that opened up to the viewer as a stage, that had a main motif and that could be accessed via a perspective that ended near the picture frame, the Impressionist landscape usually seems to be a radically chosen and arbitrary excerpt (ill. p. 133). These are views that could ramble on, frequently without a resting point and finding no moment of concentration. This kind of abandonment of a compositional image direction was regarded as a loss by viewers at the time. Why the artist chose to "crop" the scene this way and not in another or why he selected a simple well or a flower meadow as a motif is not revealed at length (ill. pp. 136/137). What did these paintings actually want to convey? What gave the painter the right to reproduce this? How was this landscape to be interpreted?

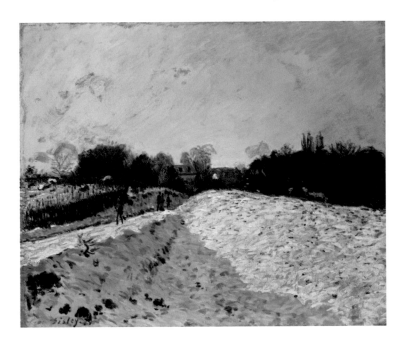

Alfred Sisley,
Effect of Snow at Argenteuil,
1874,
oil on canvas, 54 × 65 cm,
Private collection

Apparently a purely aesthetic form of perception moved into the world of images that was new in its radical character and that stood in contrast to the demand for idealism that had always been delegated to art. In place of the staging of reality now stood the painter's subjective visual perception of reality, at least this is how the Impressionists formulated their aspiration. "The treatment of a theme not for the sake of its motifs, but rather for its tonal value, is

Claude Monet,
The Banks of the Seine or, *Spring through the Trees,* 1878,
oil on canvas, 52 × 63 cm,
Musée Marmottan Monet, Paris

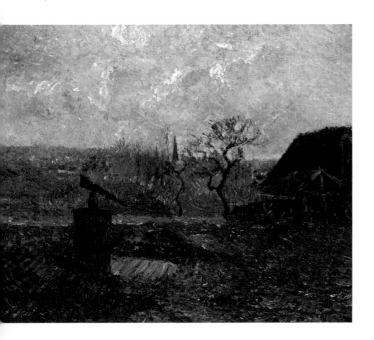

Camille Pissarro,
A Brick-Works Eragny, 1885,
oil on canvas, 38 × 46 cm,
Ashmolean Museum, University
of Oxford

what distinguished the Impressionists from other painters," are the words Georges Rivière wrote in 1877 in his review of their third exhibition. The artists also continually emphasized that their painting was about capturing the first impression, about concentrating completely and utterly on an object's appearance, to reproduce nature as it actually appears to the human eye. "Plein air" painting, spontaneous and without a preparatory drawing, placing the oil paint directly from the tube onto the canvas, is what was to become the Impressionist creed. This did not always correspond with the actual way the artists worked: paintings were still produced in the studio – something that can be concluded from the large-format works – and there are often compositional drawings under the layer of paint (these have been revealed through x-ray photographs); visible revisions allow one to conclude that not every painting was successful at the first go. The defined goal, however, remained clear: the visualization of a natural view with the changing conditions of light was the focus of these paintings. This led to a new color arrangement on the palette and, above all, the elimination of pure black, as well as to a new application of paint that attempted to adjust to the ever-changing relation of light by means of loose and fast brushwork. The local color, meaning the best possible imitation of the natural colors, became less important and subordinate to the atmospheric effect that tied the painting together in a harmonic color tone. "One always lies outdoors," Renoir once admitted with a wink.

The Landscape in the Period of Industrialization

The Impressionists' view of nature was the product and reflection of great upheavals in the 19th century. Human living conditions changed fundamentally as a result of increasing industrialization and urbanization. An enormous acceleration in all spheres of life became noticeable – this affected many things including traffic, the pace of work, the manufacture of technical products and the turnover of merchandise in the new department stores. City and countryside, public and private life differed from each other in new and unfamiliar ways. These develop-

ments also had an effect on how people perceived nature, which now was seen as an alternative to the city, as a place of recreation and relaxation from urban hustle and bustle. This was connected with the desire for things simple and pristine, for freer life styles beyond bourgeois concepts of values and morals. Impressionist landscape painting was the first to reflect this fundamental change in the notion of nature. Signs of industrialization were not hidden in doing this; in many Impressionist landscape paintings smoke pours out of factory chimneys (ill. pp. 68, 142), railroad bridges span rivers (ill. pp. 62/63) and the city edges its way into the countryside (ill. p. 89). More and more, nature itself appears to be a manipulated and designed space for humans. Its mystical fierceness, primitive and unpredictable qualities that had been expressed in paintings of the Barbizon School had been largely lost. Not the dark forest of Fontainebleau, but rather the bright meadows along the

Auguste Renoir,
The Path through the Long Grass
(preceding double spread:
detail),1875,
oil on canvas, 59 × 74 cm,
Musée d'Orsay, Paris

Auguste Renoir,
The Path through the Long Grass,
1875,
oil on canvas, 59 × 74 cm,
Musée d'Orsay, Paris

From 1882, Seurat, who had been a graphic artist until then, dedicated himself more intensely to painting. His color spectrum was based on the three primary colors, blue, red and yellow, plus green, and their interme-diate tones that were mixed with white, but never with each other: he employed these colors to create a particular bright-ness and intensity. While the *The Stone Breaker* is still a small format study, the following year Seurat began working on his complicated composition, *Bathers at Asnières* (ill. pp. 232/233).

Georges Seurat,
The Stone Breaker, 1882,
oil on panel, 17 × 26 cm,
Phillips Collection, Washington

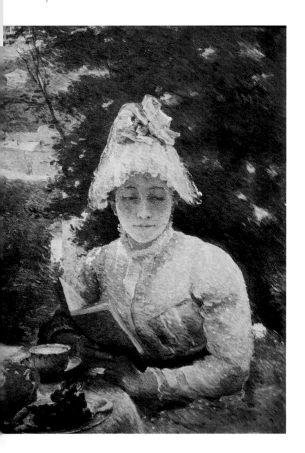

Marie Bracquemond,
Afternoon Tea, 1880,
oil on canvas, 81.5 × 61.5 cm,
Petit Palais, Musée des Beaux-
Arts de la Ville de Paris, Paris

riverbanks of the Seine, which even the elegantly dressed Parisian with a shielding parasol could effortlessly cross, provided the Impressionists with their motifs for paintings (ill. p. 137). Even today we can still relate to this modern, one might even say touristic view of nature's beauty.

Impressionism as a Group Style

The peak of Impressionist painting in France can be dated to the years between 1874 and 1882. During this period, seven of the total of eight group exhibitions took place (even if these included different participants) and the artists involved were in close contact with one another, if only to deal with organizational issues. Collaborations were established in places such as Argenteuil and Pontoise, as well as shared studios, and friendships. Even early on, obvious tension existed between the "plein air" painters (Monet, Renoir, Pissarro, Sisley, Morisot and Braquemond), who primarily painted and promoted landscape paintings "en plein air," and the "realists," with Edgar Degas as their most important protagonist with his figurative interiors that remained dedicated to drawing and urban society as their main subject matter. A few exceptions were Manet and his student Eva Gonzalès, who never participated in a group exhibition but who, nonetheless, still had a close personal and artistic connection to the Impressionist group.

In all these years an artists' group was never established, in the sense of a union under the formulation of a common program or at least a fixed goal. Clear differences are also visible in the way they practiced their trade:

Caillebotte's realism, which was strongly influenced by photography, has little to do with the "soft drawing" quality of a Renoir; the dark studio tones in many of Manet's paintings stand in strong contrast to the light paintings of Monet; Pissaro's simple rural landscapes seem strangely ingenuous next to the mysterious paintings of Degas. Nonetheless, in the short period of about eight years they all worked – often under extremely difficult personal and financial conditions – persistently and continuously on a fundamental renewal of painting. In reaction to their exclusion by the official art market, the "Indépendants" tried to be pro-active and to mount their own exhibitions. Because the artists enjoyed very different financial possibilities, they often helped each other

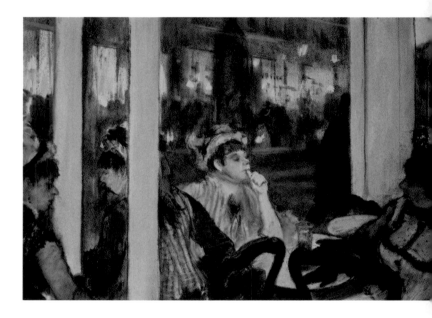

out. The well-off Caillebotte thus bought works by his friends on a regular basis and the even wealthier Bazille helped other artists, until his untimely death, by, for instance, allowing Renoir to share his studio or paying off Monet's oppressive debts. Even if one absolutely cannot speak here of an artists' group and certainly not of a group style, these painters felt an alliance with each other because of their common position as outsiders. Around 1881, however, the bond between them fell apart more and more: The issue of whether participation in the Salon could be agreed to without question by the "independ-

Edgar Degas,
Women on a Cafe Terrace, 1878, oil on canvas, 77 × 83 cm, Museum Stiftung Oskar Reinhart, Winterthur

ents" divided the group as much as the different ways they dealt with the new artistic impulses that came from the younger generation of artists. Manet's death (1883) also left a painful void. The artists retreated emotionally and physically.

Armand Guillaumin,
Setting Sun at Ivry, c. 1873,
oil on canvas, 65 × 81 cm,
Musée d'Orsay, Paris

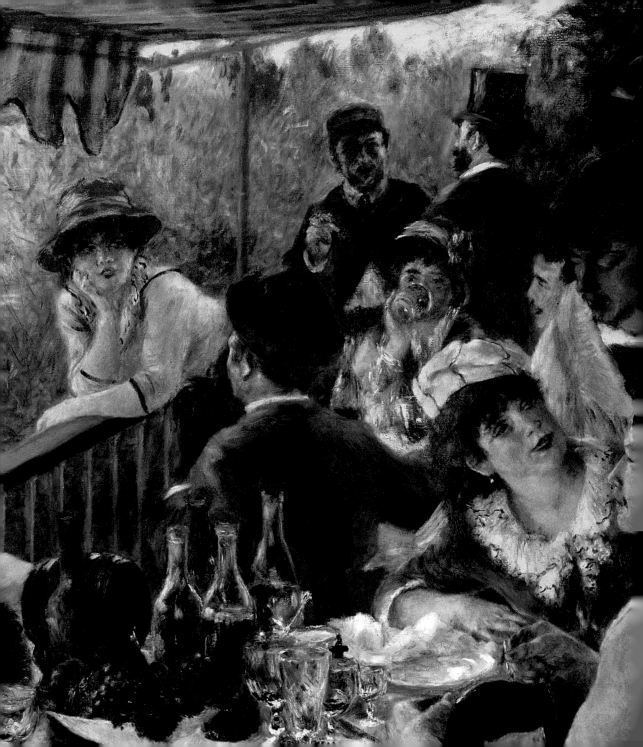

Protagonists:

Renoir and the Happiness of the Moment

People gathered under the shadow of the awning at midday. The meal is now over, people enjoy a final glass of wine, drinking, smoking and enjoying the relaxed atmosphere for a bit longer – the rowers in their simple undershirts as much as the established gentlemen in their tails and top hats, the small girl in the straw hat as much as the elegant society women. In the cheerful Sunday gathering social differences seem to suddenly have been forgotten. Everyone speaks with everyone on the terrace of this excursion restaurant on the Seine. A freedom and casualness is born that even seems to abolish class differences. A visionary thought hidden in this harmless scene on the riverbank.

Auguste Renoir,
The Luncheon of the Boating Party, 1880/81,
oil on canvas, 130 × 175 cm,
Phillips Collection, Washington

Renoir – Chronicler of his Age

Renoir's painting focus on people, on the one hand within the framework of his many portraits (ill. pp. 86, 94 and 98), on the other in the form of complicated, figure-rich compositions that portrayed Sunday pleasures in the dance and excursion establishments in and around Paris (ill. pp. 144, 154). These works depict young people in a cheerful mood, dancing, laughing, talking and kissing in the shade of the trees. Glances meet or miss each other, people connect or turn away. These scenes are characterized by an incredible lightness and casualness – both in the togetherness of the people and in their painterly representation. A soft brushstroke, which avoids all decisive contours, and a unification of color by means of the dominating blues and yellows, characterizes the harmonious impression of these paintings. Nature becomes a diffused stage-set, a homogenized backdrop that, above all, can be understood as an atmospheric space full of summer's warmth. It is both the warmth and the sunlight that create and reflect "Renoiristic" sentiments about life. The people in these paintings

Auguste Renoir,
The Swing, 1876,
oil on canvas, 92 × 73 cm,
Musée d'Orsay, Paris

Auguste Renoir,
The Sleeper, 1880,
oil on canvas, 49 × 60 cm,
Private collection

retain their individuality and remain recognizable in their uniqueness.

Beginnings

Pierre-Auguste Renoir came from a modest family. His father was a simple and not very successful workman who had difficulty feeding his wife and five children. At 13 Auguste was sent to become an apprentice to a porcelain painter in order to earn money for the family. He proved himself to be so agile and talented in the workshop that he was soon given the task of developing new decorative motifs. He found models for these in the Louvre, whose extensive art treasures were to enrich his entire life. Already paralyzed by a major illness, he had himself carried through the halls of the museums in 1919, just weeks before his death. And when the important German art critic, Julius Meier-Graefe (1867–1935), asked him – while researching a monograph on the artist published in 1911 – where the roots of his paintings were, Renoir spontaneously answered: "Au musée, parbleu!" (In the museum, of course!) This was a strange answer against the backdrop of a then-often discussed debate about the meaning and use of museums, in the context of which Cézanne later came up with the idea that

Pierre-Auguste Renoir
**(25 Feb. 1841 in Limoges –
3 Dec. 1919 in Cagnes)**

Following his training as a porcelain painter, Auguste Renoir began his studies in art and met Monet, Sisley, Bazille and Pissarro.

From **1867** he lived with Bazille in a studio- and flat-share; in **1869** he worked closely with Monet.

After the war (**1870/71**) the gallery owner Durand-Ruel was the first to buy Renoir's paintings; the artist participated in three group exhibitions in subsequent years.

In **1883** he had his first solo exhibition at Durand-Ruel's gallery, followed by a comprehensive retrospective in **1892**.

In **1890** he married his lover of many years, Aline Charigot, with whom he already had a five-year-old son Pierre, who was followed by Jean (**1894**) and Claude (**1901**).

In **1894** he became afflicted with a painful arthritic disease causing him to go on frequent cures in southern France. After 1900 he experienced international exhibition success in cities such as Berlin, London, New York, Venice and Zurich.

the Louvre should be burnt down. In addition to Rococo painting, which provided him with inspiration for his porcelain designs, Renoir's declared heroes were, above all, Delacroix (1798–1863), as well as the Spanish painter Velázquez (1599–1660). Members of the older generation who were especially important to him were Gustave Courbet and Camille Corot. He also had a close personal friendship with the Spaniard, Narcisso Virgilio Díaz de la Peña (1807–1876), 26 years his senior, who, like Corot, was one of the Barbizon School, and had also been a porcelain painter in his youth.

Renoir became an independent artist because of a crisis in porcelain manufacturing. With the discovery of the mechanical printer for porcelain at the end of the 1850s, the tedious and costly hand work became more and more obsolete. There were massive layoffs. Renoir's workshop director, who had discovered the young worker's talent, presented himself to the young artist's family and made efforts to convince Renoir's father to allow his son to study art. Thus it came to be that, in 1861, Auguste Renoir enrolled at the École des Beaux-Arts and the private academy run by Charles Gleyre (1806–1874), where he soon met Claude Monet, Alfred Sisley and Frédéric Bazille. Monet later introduced him to Camille Pissarro. During the summer months they all went out into the forest around Fontainebleau to work in the tracks of the Barbizon painters they so admired. With these men, the most important protagonists

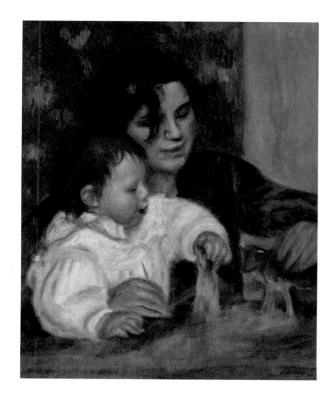

Auguste Renoir,
Gabrielle and Jean, 1895,
oil on canvas, 65 × 54 cm,
Musée de l'Orangerie, Paris

"I have neither rules nor methods. Anyone may examine what I use or watch me paint – he will see that I have no secrets."
Auguste Renoir

of the future exhibition group had been found. In the friendship portrait painted by Henri Fantin-Latour in Manet's studio in 1867, the 26-year-old Renoir was already a member of the "Batignolles painters" circle (ill. p. 15).

The Impressionist Phase

Renoir, in his typically pragmatic way that rejected every heroizing of the artist, described the beginning of Impressionist painting in the following way: "In 1874 we wanted to express joy in our paintings, a life without literature. One morning one of us did not have anymore black and used blue instead. That is when Impressionism was born." And, in fact, in 1874 an extremely productive phase in Renoir's artistic development began. He painted his masterpieces, which are still regarded as the epitome of French Impressionism between 1874 and about 1881. Renoir's style is characterized by his particular kind of "soft drawing" and his subtle brushstroke that outlined the motif and that clearly differed from Monet's pointed commas and Pisarro's solid pictorial construction. The direction of light additionally increases the recognizability of his paintings; no one else could so masterfully set a spot of sun to capture the diffuse light conditions of light filtered through the trees (ill. p. 146). "The brush touches the canvas like the sun the dancing crowd beneath the trees," wrote Meier-Graefe while looking at Renoir's *Ball at the Moulin de la Galette* from 1876 (ill. p.154). And then, looking at the work more closely, it can be seen that the supposedly forbidden color black had, in fact, been used here. In reality it was less a question of a strict color code than of a fundamental loosening up of the composition, style and color that – and this not just in relation to Renoir's work – characterized Impressionist painting. The work shows a view into a garden restaurant in Montmartre in which outdoor balls were held on weekends. With the financial backing of the wealthy

publisher, Georges Charpentier (1846–1905), Renoir was able to rent a small house with a garden near Rue de Cortot in 1875. Some of his friends served as models for this complex and figure-rich composition that was presented to the public in the third Impressionist exhibition in 1877. In the foreground we can recognize the painter's two sisters, the seamstresses Estelle and Jeanne Margot, at the table, as well as Renoir's friend and later biographer, Georges Rivière. Next to him are two painters, Franc Lamy and Norbert Goeneutte. The dancing couple on the left are the Spanish painter, Vedel de Solares y Cardenes, and his girlfriend, Margot. As later in *The Luncheon of the Boating Party* (ill. p. 144), in this painting Renoir already has designed the ideal of a young, casual society that manages without stiff poses and propriety and without exclusive self-representation rituals. It is nothing less than the opposite image of the then-prevalent bourgeois Parisian elite that celebrated itself nightly in front of the backcloth of the Neo-baroque Opéra. In Renoir's alternative design the craving for recognition and hierarchies plays no role; it is the boundless, fraternal camaraderie of French youth at the beginning of the Third

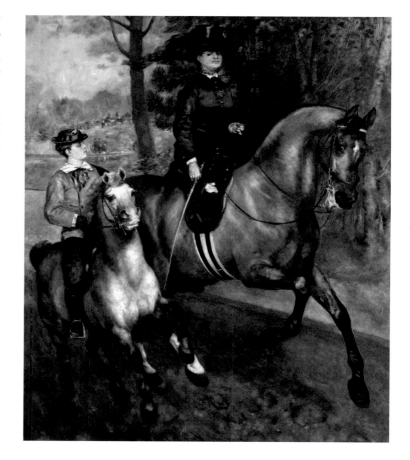

Auguste Renoir,
Horsewoman in the Bois de Boulogne, 1873,
oil on canvas, 261 × 226 cm,
Kunsthalle, Hamburg

Republic – still without doubt an ideal, but a less naïve one than may appear at first glance.

Dancing continued to be a theme in Renoir's work: in 1883 the art dealer Durand-Ruel commissioned a pair of large paintings that depicted a couple dancing the waltz (ill. pp. 156/157). In both cases Renoir's friend Paul Lhote, who had traveled with the artist to Provence the previous year on a painting trip, probably served as the model. For *Dance in the Country* Dance Renoir's future wife, Aline Charigot, was the model; in *Dance in the City* it was Suzanne Valadon (1865–1938), who was one of the most colorful personalities of Montmartre. Valadon, who came from a simple background, had an intimate relationship with many of these artists, serving as a model and lover. Encouraged by Edgar Degas, she later worked as a painter herself. Her illegitimate son, Maurice Utrillo (1883–1955), also became a painter and is primarily known today for his street scenes of Montmartre.

Renoir staged the two identically sized canvases as allegories on life in the city and in the country; the graceful city couple, he dressed in elegant tails and she in an elaborate ball gown, move with perfect pose through the sophisticated hall, suggested by a stately columned structure and exotic palm trees, while the county pair twirl outside beneath the trees. The man looks as if he wants to steal a kiss and, breaking all dancing rules, holds the woman

Auguste Renoir,
Ball at the Moulin de la Galette (preceding double spread: detail), 1876,
oil on canvas, 131 × 175 cm,
Musée d'Orsay, Paris

tightly in his arms. Even a few of the details, such as the skew tablecloth or the straw hat on the ground, relay the casual ease of the situation. Corresponding to this is the open gaze of the woman dancing, whose smile and red cheeks are a direct expression of her happiness. In contrast to life in the city, which was dominated by social conventions, socializing in the countryside was cheerful and full of an immediate lust for life. This easy interaction of people, especially between the sexes, was Renoir's ideal and he conveys this in all his works.

Turnaround

Renoir's break with Impressionism had already begun when he made the two dance paintings; "it came as a real break in my work around 1883," was how he described it later to the famous art dealer, Ambroise Vollard (ill. p. 182) "I followed the path of the Impressionist to its end and had to establish that I could not draw or paint. In a word, I had reached a dead end." A trip to Italy (1881/82), where he studied antiquities and the Renaissance, brought new impulses, which were manifested in the two dance paintings. In place of the bubbling and

Auguste Renoir,
Dance in the Country, 1883,
oil on canvas, 180 × 90 cm,
Musée d'Orsay, Paris

vibrating colors in the *Luncheon of the Boating Party* fresco-like coloring appears, despite the painting's colorful quality. Clear changes in the relationship between the figure and space also are obvious; the couple disengage more intensely from the background and the dense atmospheric interweaving observable until now is lifted in favor of a stronger plasticity. Even the brushstrokes seem more restrained. Renoir obviously is trying to achieve a fundamental simplification and consolidation. His late work will demonstrate this in a more varied, often contradictory manner. Renoir participated in the Impressionist exhibitions in 1874, 1876 and 1877 with larger groups of his own paintings and even started the magazine *L'Impressioniste* together with Georges Rivière. After this, however, his involvement ceased altogether. Instead, he participated again in the official Salon as of 1878. In 1879 he was represented there with four paintings, including the portrait of Madame Charpentier and her children (Ill. p.98). That same year he had his first solo exhibition in the rooms of the magazine, *La Vie Moderne,* published by Georges Charpentier. His participation in the seventh Impressionist exhibition (1882) occurred unintentionally; his

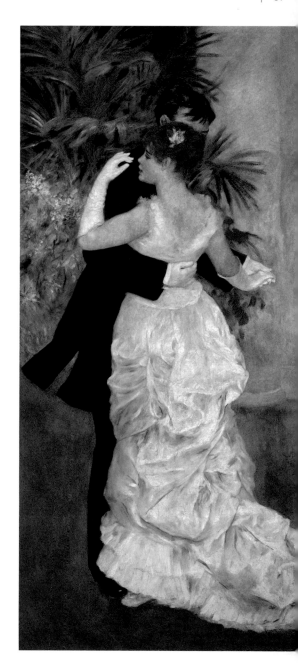

Auguste Renoir,
Dance in the City, 1883,
oil on canvas, 180 × 90 cm,
Musée d'Orsay, Paris

art dealer Durand-Ruel contributed 25 of the paintings he owned to the show. For Renoir, however, Impressionism as a theme was already a closed case. From this point on his interest was in a monumental painting that was obviously inspired by Raphael. Voluptuous nude women populated his late, Arcadian landscapes – the "bathers" became his most important motif. Contemporary life, in contrast, seemed to be as good as forgotten. Future generations were left with paintings that were met alternatively with boundless admiration, as well as the accusation of being a "confectioner's aesthetic." After 1945 the art world also punished him with disdain. Yet Renoir's Impressionist paintings are not only to be understood as a naive homage to color but also as a witness to an alternative awareness for life. By capturing the dreams and utopias of his generation in paintings, he became a chronicler of his era.

Auguste Renoir,
Two Sisters, or *On The Terrace,*
1881,
oil on canvas, 100 × 80 cm,
Art Institute of Chicago

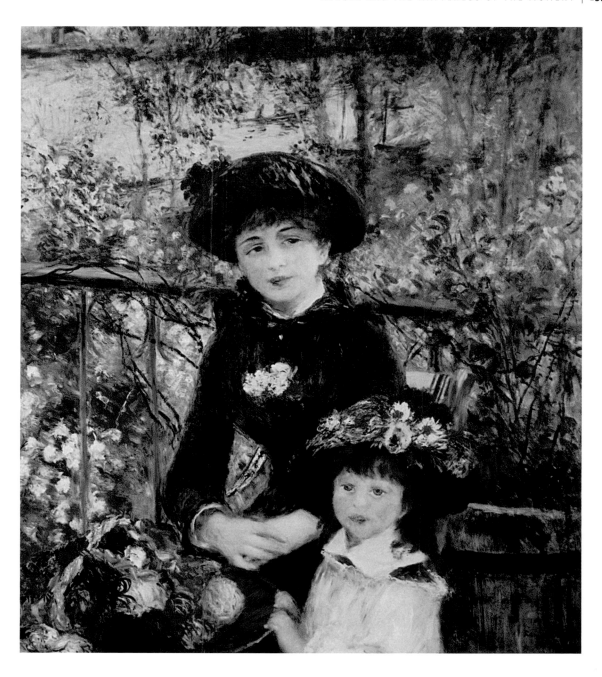

Brief Study of Techniques –
Impressionist Paint Application and Palette

Claude Monet,
The Terrace at Sainte-Adresse
(detail of p. 42), 1867,
oil on canvas, 98 × 130 cm,
Metropolitan Museum of Art,
New York

Artistic work also has a technical aspect. The realization of artistic concepts is, therefore, always dependent on the technical methods and devices available at the time the works are executed – sometimes they are even triggered by technical innovations. This is more than obvious today in the age of digital image processing. But this was also already the case in the second half of the 19th century: The image conception of the Impressionists, as well as the outdoor painting and their quick, sketch-like painting technique would not have been conceivable were it not for fundamental discoveries in the chemical and paint industries. This is because the industrial production of pigments and, even more importantly, the availability of ready-to-use oil paint in tubes simplified the artists' preparatory work and painting process in a completely revolutionary way. Before this a stockpiling of valuable and expensive pigments in the studio and a complicated process of grinding and mixing colors had been necessary; now, however, painters could employ a ready-to-use paint in no time at all. In 1840 the London-based company, Robertson, brought the first, but still familiar, zinc tube onto the mar-

ket, followed just one year later by Winsor & Newton; by 1850, these kinds of tubes were available in a specialty store in Paris for about 10 centimes. Not only was the work process simplified, but the cost of making a painting fell substantially. It was no wonder then that artists were more willing to experiment with paint, directly and without preliminary sketches – at least the financial risk of working this way was easier to calculate under such conditions. Additionally during this period the artist's palette expanded thanks to more and more industrially produced and mixed colors.

Another fundamental way to save work was the mechanically primed canvas that was available in standard sizes after the mid-19th century. The dark primer that had predominately been used by painters was now replaced by a lighter primer and helped create the distinctly brighter overall impression of Impressionist paintings. Until then the stretching of canvas on stretchers and priming the canvas was one of the laborious but unavoidable workshop tasks an artist had to perform, but now work could begin immediately. Dealers had different canvas sizes available, some of which were already ascribed to specific genres of paintings, such as portrait or landscape. This, however, led to a standardization of painting sizes and it became the dealer and no longer the painter who determined the usual painting sizes.

Once canvas, paint brush, palette and paint had been bought, for instance in the specialty store of the famous dealer Blot, on the Rue de Saint Honoré, or at "Père" Tanguy's on the Rue Lafitte, not only could the artist begin work at any time but also in any place because all the necessary painting materials were transportable and ready to be used anywhere. This made it easier, even possible, to paint outdoors. It would have been virtually impossible to work with expensive pigments and various painting materials in the field and forest or on the beach. Initial experiments with glass containers, as well as parchment and oilcloth bags, proved this.

Max Slevogt,
Francisco D'Andrade as Don Giovanni (detail of p. 256), 1912, oil on canvas, 54 × 45 cm, Kunsthalle, Hamburg

Marie Bracquemond,
Afternoon Tea (detail of p. 140),
1880,
oil on canvas, 81.5 × 61.5 cm,
Petit Palais, Musée des Beaux-
Arts de la Ville de Paris, Paris

Now, however, artists could and did paint outside, everywhere and even under adverse conditions. When Claude Monet was staying on the Breton island Belle-Île, he virtually had to fight the rough conditions of the Atlantic Ocean. The art critic Gustave Geoffroy, who visited the artist on the island and was enthusiastic about the work he had made there, which depicted dark and dramatic landscapes, commented: "Claude Monet works from his cathedral of Port-Domois [meaning the cliff formations, N.B.] in wind and rain (...) The gusts of wind knock the palette and brush out of his hands His easel is kept upright with ropes and stones." Many of the paintings that he made there, however, remained unfinished or were totally repainted later on. And this certainly took place in the studio. Monet's claim that he never had or needed a studio – since his studio was nature – has to be understood as a rhetorical confirmation of the Impressionist dogma of "plein air" painting. Naturally, particularly large works – rather an exception in Impressionism – could not be worked on outdoors, despite all the possibilities of the new painting technique.

Limitations also existed with regard to the demanded and practiced speed and spontaneity of the painterly process; Degas, Caillebotte and Renoir often used photographs as an aid for their image conceptions. Recent x-ray examinations prove that painstaking preliminary drawings done with quick brushstrokes are often underneath the picture surfaces. Gustave Caillebotte and Paul Gauguin, as well as Vincent van Gogh, prepared their compositions with the help of perspective frames, as well as pencil and ink drawings. The application of paint that the Impressionist had revolutionized became a bone of contention; more than anything else, the open structure of the brushstrokes placed next to one other offended the previous viewing habits and conventional demands placed on a finished painting. Instead of the smooth transition from one color to the next, which contributed to a unified overall picture and emphasized the imitating charac-

ter of painting, the work process of the painter could now be clearly recognized in the visible and permanent brushwork. The painting's surface was restless, even vibrant, and sometimes even crudely handled and rough. Gustave Courbet had already used a palette knife instead of a brush in order to lend the surface of his paintings an especially intense structure; Vincent van Gogh sometimes squeezed the paint directly from the tube onto the canvas in order to visually exaggerate the paint's material quality. Paint increasingly led a life of its own in Impressionist painting and it soon "emancipated" itself more and more from the object it represented. Supported by scientific findings, it was examined and employed with regard to its interdependencies. How colors intensify or mute each other, how they glow more the purer they are and how they lose their luminosity as compound colors – all this interested the Impressionists beyond all measure. In this sense they had an effect far beyond their own era, into the 20th century.

View of Paul Cézanne's Studio
in Aix-en-Provence

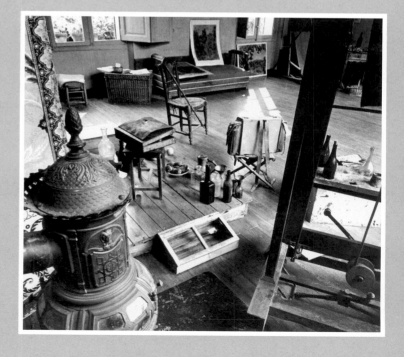

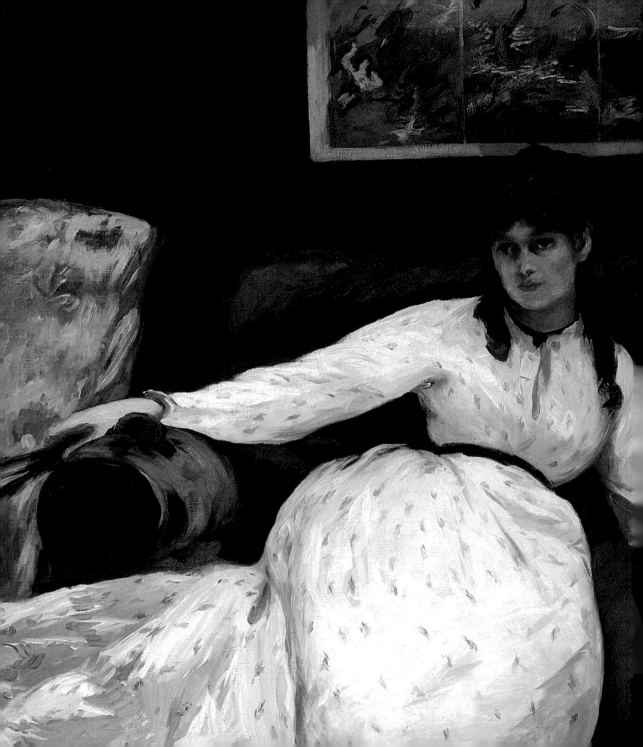

Protagonists:

Female Impressionist Artists

"I do not believe that there has ever been a man that has treated a woman as his absolute equal, and that is all that I have ever demanded – because I know that I am just as good as the men." This sentence, which sounds just as self-confident as it does resigned, comes from Berthe Morisot's personal diary from 1890. She was 49 years old at the time and a successful painter, as well as one of the main artistic and social figures of the Impressionist scene. It was not only Berthe Morisot but also Mary Cassatt, Marie Bracquemond and Eva Gonzalès who were responsible for the development and success of Impressionism. Their contribution, however, was long ignored by art historians.

Édouard Manet,
The Rest, portrait of Berthe Morisot, 1870,
oil on canvas, 150 × 114 cm,
Rhode Island School of Design Museum of
Art, Providence, Rhode Island

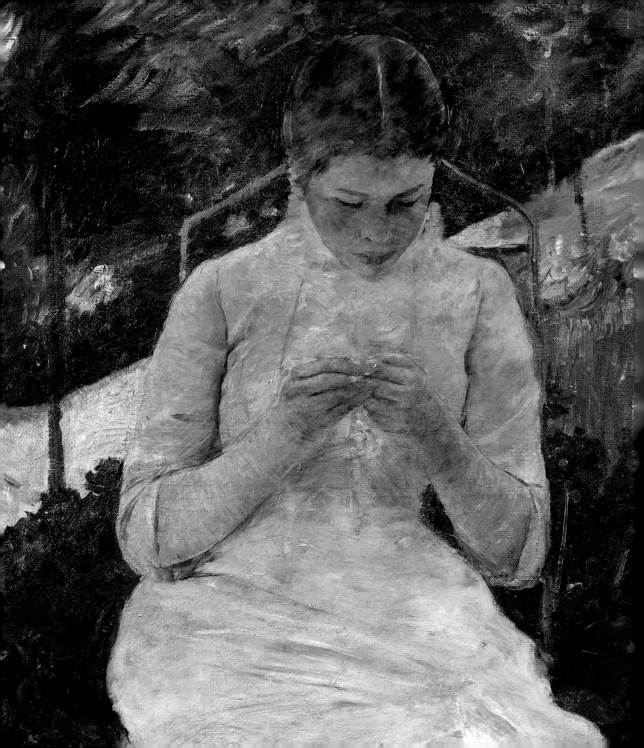

Caught between the Creative Urge and Convention

In the 19th century, and up into the 20th, Paris was the only place in Europe where women were able to receive an art education and practice their trade. Although they did not have access to a state education at the École des Beaux-Arts, numerous private academies offered women artistic training in women's classes. Although the quality of this education was extremely varied and depended, above all, on the personal commitment of the respective teachers, it did offer women the environment and opportunity to deal seriously with painting and sculpture. It is, therefore, no wonder that the French capital became a melting pot for an international community of female students: the latest research assumes that 300 American women alone went to Paris to study art every year at the end of the 19th century. Many of them remained in Paris after completing their studies and tried to establish themselves on the art market there. It was, however, very difficult for a woman to distinguish herself as a serious artist. Often women were only regarded as talented dilettantes who occupied their time with art until they found a suitable husband. Additionally, women were primarily typecast to the "lesser genres," such as portraiture, still lifes,

Mary Cassatt,
Young Woman Sewing in the Garden, 1880–82,
oil on canvas, 92 × 63 cm,
Musée d'Orsay, Paris

Berthe Morisot,
The Butterfly Hunt (detail of p. 170), 1874,
oil on canvas, 46 × 56 cm,
Musée d'Orsay, Paris

animals and genre scenes. Since women were usually completely excluded from taking life classes during their studies, they could only study human anatomy from clothed models or by drawing plaster casts of Classical sculptures. They were, thus, not believed capable of coping with large-format figure compositions and were therefore barred from public commissions. Additionally, social and private restrictions limited artists' personal freedom tremendously; visits to cafes, restaurants and even cabarets were considered inappropriate for women of a bourgeois background. It follows, then, that their participation in the evening gatherings of the Impressionists in the Café Guerbois or Nouvelle-Athènes was unthinkable. Their activities were focused instead on the domestic realm. Berthe Morisot, for instance, had a dinner party every Thursday at her home and invited her artist friends Renoir, Degas, Caillebotte and Monet, as well as the writers Charles Baudelaire, Émile Zola and Stéphane Mallarmé.

"Holding on to Something that Drifts By"

Women artists also found their subject matter and motifs within this relatively tight-knit private framework. *The Cradle* (ill. p.172), an important early work by Berthe Morisot, illuminates brilliantly how the intimate world of mother and child reflects

Marie Bracquemond

(1 Dec. 1840 in Argenton/Bretagne – 17 Jan. 1916 in Sèvres)

Marie Quivoron, who was brought up under difficult family conditions, met the famous painter Jean-Auguste Ingres while studying drawing. He helped her early on to get official commissions. She exhibited her works in the Salon for the first time in **1859**, participating in their shows often after this. In **1866** she met the painter and printmaker, Félix Bracquemond, whom she married in **1899**. A year later their son Pierre was born.

Félix was appointed director of the porcelain manufactory in Sèvres in **1871** and he later headed a branch of Haviland in Auteuil. Marie Bracquemond helped her husband develop designs.

Her contact to Edgar Degas led to her participation in Impressionist exhibitions (**1879, 1880** and **1886**). Pressured by her husband, she gave up painting in **1890**. She lived her last years in Sèvres in seclusion.

the female existence in the bourgeois society of her time. Delicately formulated with regard to both color and composition, this painting, with its soft pastel tones, material transparency and often free application of paint, corresponds perfectly with the conceptions of Impressionist painting and was exhibited in the first group exhibition in 1874. The image focuses on a young mother who pensively looks upon her sleeping child. The peaceful atmosphere in the child's bed room seems to be overshadowed by a faint melancholy. The room does not just seem homey and comfortable but cramped and shut off from the outside world. This might refer to the situation of Morisot's sister, Edma, who was the model for the painting. Probably just as talented an artist as Berthe, in the 1860s Edma studied and worked together

Marie Bracquemond,
On the Terrace in Sèvres, 1880, oil on canvas, 88 × 115 cm, Musée du Petit Palais, Geneva

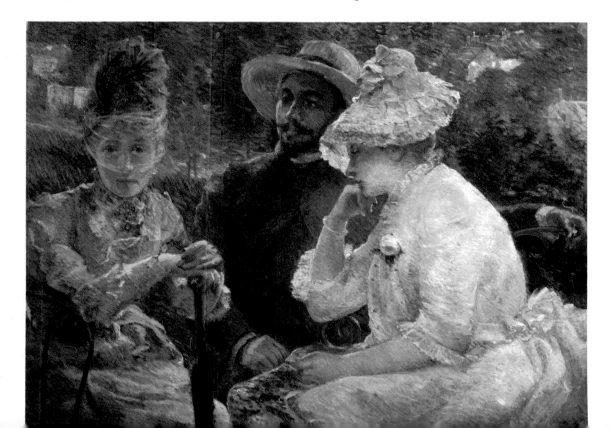

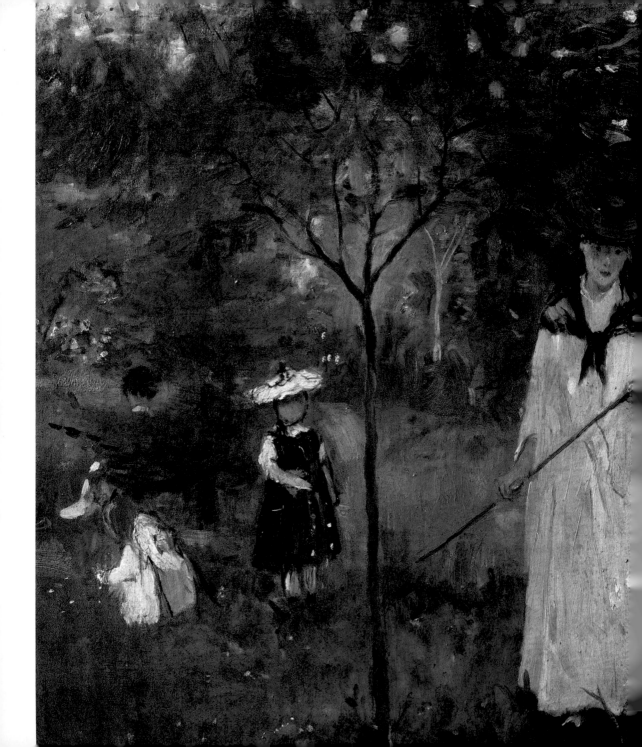

As she had in *The Cradle,* Morisot's sister Edma also was the model for this painting, this time with both her children. The striking sketch-like character of the entire painting is also used to depict the figures. Portrait-like qualities are avoided. The tendency to abolish perspective and towards painterly abstraction on the left half of the painting display Morisot's radical modernity.

Berthe Morisot,
The Butterfly Hunt, 1874,
oil on canvas, 46 × 56 cm,
Musée d'Orsay, Paris

with her sister. The girls' parents kindly encouraged the artistic education of their daughters and even had a studio built for them in the garden of their Paris home. After marrying (1869), however, Edma gave up painting and had two children. Just how painful and how much of a loss this step was felt to be is documented by a letter Edma wrote to Berthe: "(…) and I wish I could slip away, even if only for a quarter of an hour, to breath the air in which we lived for so many years." Following her participation in the first Impressionist group exhibition, Berthe Morisot married Eugène Manet, the painter's younger brother, in December 1874. Four years later she became a mother. She continued to work unabatedly, however. Self-assured, she painted a self-portrait as a 44-year-old in her painter's smock and a suggestion of a palette (ill. p.173). "Working is the only purpose of my existence (…) Idleness of an undefined extended period of time would be fatal to me in every way," she wrote to Edma. She saw her task in painting as "holding on to something that drifts by." This included a woman's own reality of life in the late 19th century.

Berthe Morisot,
The Cradle, 1872,
oil on canvas, 56 × 46 cm,
Musée d'Orsay, Paris

Typically Female?

The world of men does not find any significant expression as a motif in the works of Berthe Morisot, Mary Cassatt, Marie Bracquemond or Eva Gonzalès, who died early. Instead, young girls and women populate their paintings. These are depicted in elegant dresses, at tea with a friend or doing handiwork, on a boat excursion, in the park, at the opera or in their private realm at the morning toilet or with their children. To derive a specifically female perspective of the world from this choice of motifs is, however – a projection, though often found in literature. This is confirmed by a comparative look at the work of these artists' male colleagues; Auguste Renoir also often chose mother and child as a motif (ill. pp. 98, 149 and 159) or painted portraits of young women in the countryside; Claude Monet also preferred women and children when he painted a garden scene or a stroll through a summer meadow (ill. p.137). More decisive than a gender-specific assignment, however, is the realization that Impressionism led to a fundamental leveling of valid generic hierarchies. In demarcating themselves from the academic art market, with its

Berthe Morisot,
Self-portrait, 1885,
oil on canvas, 61 × 50 cm,
Musée Marmottan Monet, Paris

The narrow detail, the uncompromising demarcation of the individual elements to one another and the contrast-rich shining color surfaces refer to the influence of Japanese woodblock prints in Cassatt's painted works. Together with Berthe Morisot, she visited a major exhibition of Japanese prints at the École des Beaux-Arts in 1890.

Mary Cassatt,
The Boating Party, 1893/94, oil on canvas, 90 × 118 cm, National Gallery of Art, Washington

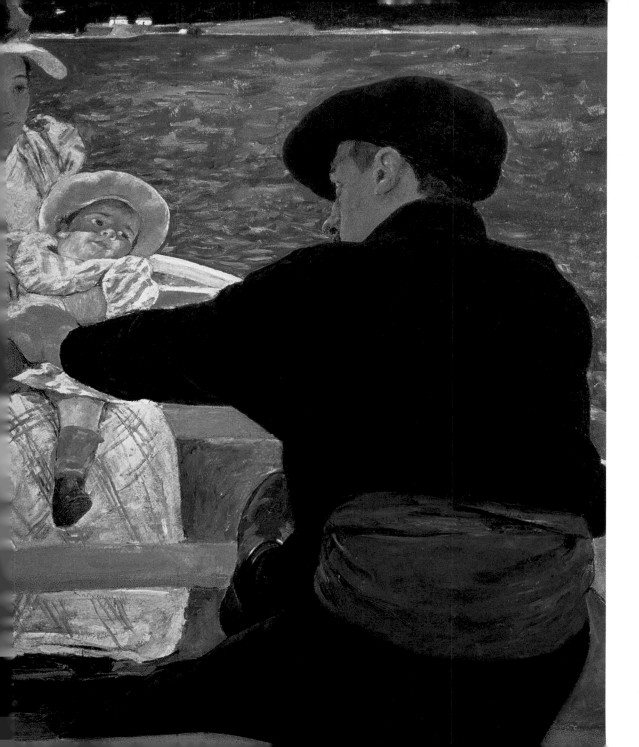

emphasis on historical and mythological subject matter, the Impressionists turned more intensely to the private and everyday realm for their motifs. Their contribution to the Modern movement lay in the uncompromising discovery of their own present day – for both female and male artists.

Opportunities for Personal Development

The relatively open circle of Impressionists presented women with the opportunity, which had hardly existed before, to make a contribution with their artistic potential. Berthe Morisot and Mary Cassatt in particular were able to develop their own work independently. Morisot had already helped organize the first Impressionist group exhibition in 1874 and continued in subsequent years to exhibit her work together with that of those in the circle around Pissarro and Monet. Her close friendly relationship with Édouard Manet, which is mistakenly often seen as a teacher-pupil one, could not change anything regarding her exhibition activities in this circle, although Manet is known to have refrained from becoming involved in their matters. "I will only achieve (my independence) through perseverance and by expressing my intention to emancipate myself

Mary Cassatt

(22 May 1844 in Pittsburgh, Pennsylvania – 14 June 1926 at Château Beaufresne, Mesnil-Théribus)

After her studies in art at the Pennsylvania Academy of Fine Arts, Mary Cassatt moved to Paris in **1865**. Together with Eva Gonzalès she studied in the women's classes given by the painter Charles Chaplin; later she became a student of Jean-Léon Gérôme.

Between **1868** and **1876** she was a regular participant in the Paris Salon.

Following a stay in the United States in **1871**, she went to London, Italy and Spain. In **1877** she met Degas and became friends with Pissarro and Morisot.

In **1878** she exhibited her work in the American pavilion at the World's Fair and in **1879** she participated for the first time in an Impressionist exhibition.

From **1881** on, she had several solo exhibitions at Durand-Ruel, and was represented in his first exhibition in the United States in **1886**. Influenced by Japanese color prints, she began to make etchings. In **1894** she bought Château Beaufresne. In **1910/11** she journeyed to Egypt and from **1914** to **1918** she lived in Grasse in Southern France. An eye disease blinded her.

openly," were the words she wrote to her sister in 1871. Morisot's painting technique consistently developed in the analysis of the figure in the landscape. Even early on, in *The Butterfly Hunt* (Ill. p.170– 171), she demonstrates dynamic brushwork that exhibits an emphasized sketch-like character in many parts of the surface treatment. Interestingly, several works were prepared with watercolors and completed later in the studio. The spontaneity of the painterly realization is, thus, not inevitably tied to working from nature.

Mary Cassatt was already a rather successful painter when she was brought to the attention of Edgar Degas, who asked her to participate in the group exhibitions. This relationship was not in any way one between a student and a teacher, either, as it is often described to be in writings on art. At the end of the 1870s Mary Cassatt had already completed a comprehensive art education and had undertaken numerous study trips. In 1874 she may have exhibited her work in the Paris Salon – it is here that she came to Edgar Degas' attention. In the years that followed the two developed a friendly relationship that was founded, above all, on the emphasis of drawing and their common interest in graphic techniques. At the end of his life, Degas possessed several paintings by Mary Cassatt and had painted numerous portraits of her. The artist did not serve as an explicit model who embodied a certain role, as Berthe Morisot often did in the dozens of paintings that Manet made of her (ill. p.164).

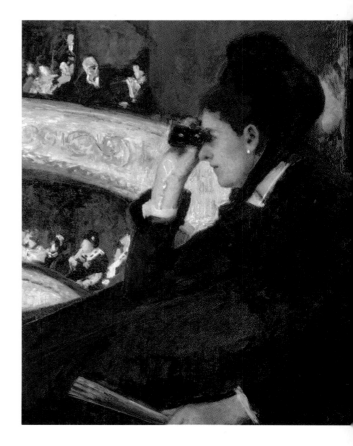

Mary Cassatt,
In the Loge, 1879,
oil on canvas, 81.3 × 66 cm,
Museum of Fine Arts, Boston

The works of Cassatt, who never married or became a mother, also focused on the world of women. In contrast to Morisot, she created more monumental formulations that placed the figure as a body more in the foreground. Not the dissolution of a person in his or her surroundings but rather the placement of a person in the field of vision was one of the formulations that she examined over many years and in a variety of ways. The strong impression left by a visit to an exhibition of Japanese color woodblock prints in 1890 was reflected not only in a whole series of etchings (ill. pp. 78/79), but also in several paintings (ill. pp.174/175).

While Morisot and Cassatt had a public presence thanks to their participation in exhibitions and contact with important collectors, as well as the opportunities they had to develop their artistic style thanks to their external and inner independence, their colleagues Marie Bracquemond and Eva Gonzalès (1849–1883) were not destined to succeed to this degree. The recently re-acknowledged artistic potential of Eva Gonzalès (ill. p.103), who was Manet's only pupil and who was already represented in the Paris Salon when she was just 23, could not develop her talents because of her premature death after the birth of her only child. In the case of Marie Bracquemond it was, rather, the influence

Berthe Morisot

(14 Jan. 1841 in Bourges – 2 Mar. 1895 in Paris)

Together with her sister, Edma, Berthe Morisot had a private art education. She often copied works in the Louvre, met Camille Corot and painted directly from nature with him. She was represented with two landscape paintings in the Salon when she was just 23. Between **1865** and **1873** she exhibited her works there regularly.
In **1868** Morisot met Manet; they worked together and influenced each others painting. Together with Monet and Pissarro she organized the first Impressionist exhibition in

1874 and she married Eugène Manet, the painter's younger brother, in December.
Until **1886** she participated in all group exhibitions, with one exception (**1879**).
1878 saw the birth of her daughter, Eugénie Julie, the establishment of a friendship with Mary Cassatt, trips to Italy, Belgium and Holland and exhibitions in New York, Brussels and Paris.
1892 death of the artist's husband.
1895 death of the artist following a severe bout of influenza.

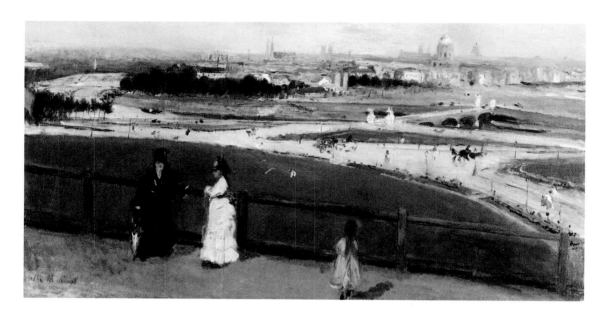

of a dominant husband that caused her to become estranged from her artistic work. Like Morisot and Cassatt, she accepted Degas's invitation and participated in the Impressionist exhibitions in 1879, 1880 and 1886. Her main Impressionist works from this period, *On the Terrace in Sèvres* (ill. p.169) and *Afternoon Tea* (ill. p.140), reveal the rich range of her colors and characteristic style: a lively, dynamic brushstroke that renders the painting's background into an abstract green space and that juxtaposes a rhythmic painting style made of little layers of lines that understands both figure and landscape as light and air phenomena.

Berthe Morisot,
View of Paris from the Trocadero,
1871/72,
oil on canvas, 45.9 × 81.4 cm,
Santa Barbara Museum of Art,
gift of Mrs. Hugh N. Kirkland,
Santa Barbara

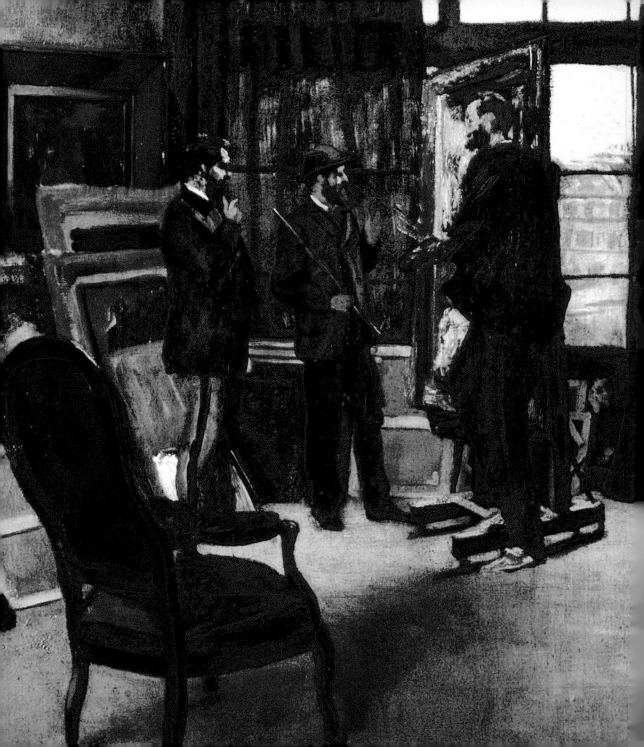

Institutions:
Art Critics and the Art Market

The first – and sometimes hardest – criticism of a painting usually took place in the studio when fellow artists and friends visited. Here it is the strikingly tall Frédéric Bazille who presents Édouard Manet and Zacharie Astruc with a freshly framed painting in his studio in the Rue de la Condamine. The guests look attentively at the easel. Manet comments on the work and Astruc and Bazille listen eagerly. Because the art market excluded Impressionist paintings, the artists, their well-inclined critics, collectors and gallery owners developed their own criteria for judging art. New paths, techniques and results were discussed with great seriousness and a certain amount of vanity.

Frédéric Bazille,
Studio in the Rue de la Condamine (detail of p. 188), 1870,
oil on canvas, 98 × 128.5 cm,
Musée d'Orsay, Paris

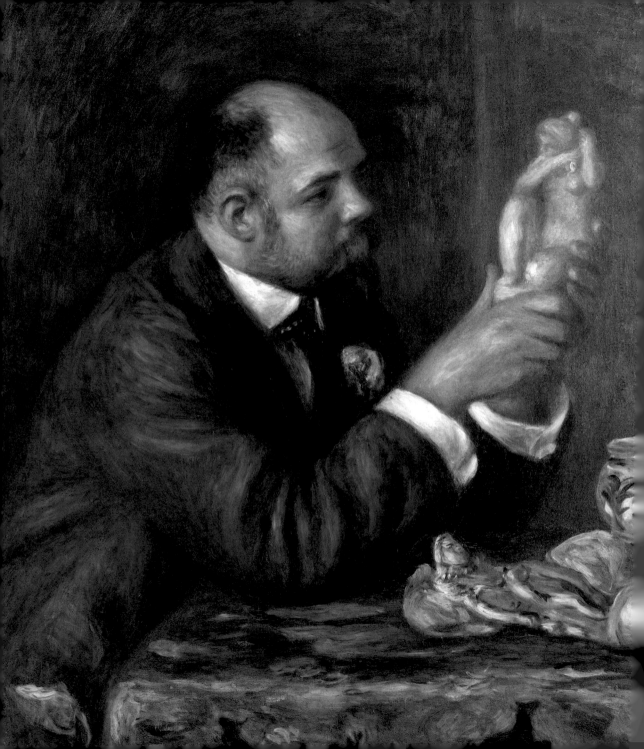

Private Art Production – Public Art Market

In the second half of the 19th century artists increasingly produced works according to their own ideas for potential private buyers rather than for the church and aristocracy. Such buyers had to be enthusiastic about the work and had to be able to judge the asking price and the corresponding value of the painting or drawing. Selling art thus entailed imparting art from the beginning. There were various possibilities of orientation to this end on the expanding art market. The large exhibitions, above all the annual Salon, showed contemporary art creations – albeit chosen by a jury that was increasingly coming under criticism. Many paintings and sculptures were hung or placed closely next to and above one another, all competing and trying to win the favor of the collectors. Specialized art dealers and galleries developed parallel to this and either sold works from the previous century or contemporary art.

Gallery Owners

The risk of interceding on behalf of young, completely unknown and even controversial artists was not something many gallery owners seemed interested in doing in the second half of the 19th century. It was, above all, Paul Durand-Ruel (1831–1922) who committed himself at his own risk to promoting and marketing the Impres-

Auguste Renoir,
Portrait of Ambroise Vollard, 1908,
oil on canvas, 82 × 65 cm,
Courtauld Institute of Art, London

Mihail Orlov,
Gallery Sergei Shukin, 1913,
photograph,
The Hermitage, St Petersburg

At the end of the 19th century art dealers gave way to modern gallery owners. They discovered, promoted, advised and marketed their artists, whose commercial success on the private art market depended on the galleries' clever exhibition and sale policies.

sionists. Financial success evaded him long after the opening of his gallery on the Rue Lafitte at the corner of Rue Le Peletier (1869), although he created totally new standards for presenting art with his hanging and lighting concept. In place of the so-called "Petersburg hanging" style, in which paintings were hung neck to neck and from floor to ceiling, Durand-Ruel only exhibited a few works in a loose succession at eye level with spot lighting, thereby lending the individual work far more significance; it could and should be perceived as an individual artistic achievement. The artists he promoted received little more than scorn and ridicule in the press and from the public. For years the establishment of a wealthy customer clientele was hardly conceivable after the biting reviews in the Parisian newspapers.

An attempt during the Franco-Prussian war to establish himself in London also failed. Nonetheless, Durand-Ruel was already buying works regularly at his own expense from Monet, Pissarro, Morisot and others, thereby guaranteeing often completely destitute artists a modest livelihood. It was also Durand-Ruel who made his rooms available for the group's second exhibition (1876). Albert Wolff commented at the time in *Figaro:* "The Rue Le Peletier has bad luck. Following the burning of the opera a new disaster has befallen her. At Durand-Ruel a new exhibition of so-called paintings has opened. (...) Driven by ambition, five of six lunatics, including one woman, have exhibited their works here. Many fall into fits of laughter from these miserable efforts; my heart contracted. (...) I know a few of these rebellious Impressionists; they are irritating, deeply convinced young people, who are deeply sure that they have found the way. This drama is extremely distressing." Despite these harsh lines the sales figures improved in the early 1880s and the first well-heeled collectors invested in the "so-called paintings." With this, however, the Impres-

sionists also became interesting for the competitors and since Durand-Ruel had not signed an exclusive agreement with his artists, they transferred to other galleries, time and again. His most severe competitor, the rather conservative and cautious gallery owner Georges Petit, was thus able to get the increasingly established Claude Monet to commit to several exhibitions in his gallery. Only Mary Cassatt's good contacts in the United States finally saved the passionate art dealer from ruin in the mid-1880s. The American buyers helped themselves to the pickings and Durand-Ruel's commercial success finally began when he opened his branch in New York. In the meantime a young colleague of his, Ambroise Vollard (1865–1939), also opened his gallery in the Rue Lafitte in 1893. Eccentric and moody, but with an enormous feeling for art, Vollard was able to sign the next generation of artists on in good time; in 1895 he showed, for the first time in 20 years, works by Cézanne in Paris; a year later his was the only gallery to offer Gauguin's South Sea paintings; in 1901 he exhibited the works of Picasso, who was just 20 at the time; and three years later he organized the first show of Matisse's work. There is no doubt that Vollard made art

Claude Monet's sales statements from the Galerie Durand-Ruel, 1891,
ink on paper, 27 × 21.4 cm,
Musée Marmottan Monet, Paris

Excerpt from: Recollections of a Picture Dealer: Ambroise Vollard, (Paris 1937)

"I remember another visitor who came by daily in the evening. He began by looking at the window, where the painting, 'Poppy Fields' of Arles was ablaze, then he entered the shop and looked around. (...) One day I did not see him at the usual time. He returned only the following week. 'I was not able to come all this time. My wife gave birth to a little girl. We ... have decided to secure a dowry for the child, to buy objects that will increase in value ... Paintings, for example. I saw my 'Poppy Field' already sold. (...) 'If I had the money, that painting would already be mine,' he said. 'But understand that I now have a great responsibility. We want to get the advice of a cousin who is a professor of drawing.' Some time passed without my seeing the man again. But one day he was there and carrying a box under his arm. 'At last the time has come,' he said, tapping on the box. 'The dowry of my little girl is in here.' He pulled out a 'Fantasia' by Detaille (= Edouard Detaille, a French Academy painter, 1848–1912). 'My cousin was able to buy the watercolor for 15,000 francs. In ten years it will be worth at least 100,000 francs.' I did not think it fitting to disagree. About 25 years later the same man appeared with his watercolor at my gallery in the Rue Martignac. 'Now it is time to part from this,' he said melancholically. 'My daughter wishes to marry.' I asked him if he remembered the Van Gogh exhibition and the 'Poppy Field' that he seemed to like so much back then. 'Do I remember? Fortunately, I could resist the temptation; How much would I get for it today?' 'My friend, you could sell it for more than 300,000 francs.' 'Then...What will my Detaille fetch me?' 'Your Detaille! His masterpiece, 'The Battle of Hüningen,' was burnt in the attic by the director of the [Palais du] Luxembourg.'"

history by separating the wheat from the chaff with his unerring gaze and his ability to recognize the future potential of an artist in his early works.

Art Criticism

Not only the art market, but also art criticism, experienced an enormous impetus in the 19th century. In the daily newspapers, and even in the more popular gazettes, regular columns were established in which current exhibition events were reported on. The major Salon exhibition was even accompanied by daily coverage. Because of the tremendous circulation, a bad review could have awful consequences for the artist in question, while a euphoric write-up could mean a sudden commercial breakthrough.

At the time, critics usually worked at such as a sideline to their normal jobs. They were literary figures, such as Émile Zola, artists, such as Zacharie

Astruc, poets, such as Charles Baudelaire, and sometimes even art-interested politicians. The conservative advocates of Salon art and the committed supporters of the young Avant-garde often carried on hefty exchanges in the media. A clearly formulated opinion by the reviewer was desired and yet quite risky; when Émile Zola, who worked on the newspaper, *L'Événement* (The Event), delivered frontal attacks against the jury, their selection and the patronage of the Academy members when he was reporting on the Salon in 1866, he lost his job on the spot.

Artists

Not only their works, but the artists themselves received more public attention at the end of the 19th century. This was manifested in the new kind of artist novel, the most famous example of which is Émile Zola's work, "L'œuvre" (The Masterpiece), which was published in 1886 and unfortunately led to a deep break in his longstanding friendship with Cézanne. Zola presented, in a nasty manner, an artist figure who, caught between a totally exaggerated opinion of his own abilities and profound doubt, finally commits suicide. Many commentaries and reports in Parisian gazettes of the time, however, also examined the highs and lows of an artistic career, as did biting caricatures and graphic series. Many of these contributions imparted a stereotyped idea of the artist, which, nonetheless, had its counterpart in reality; in addition to

Edgar Degas,
Portrait of Edmond Duranty,
1879,
pastel and tempera on paper,
100.9 × 100.3 cm,
Museums & Art Galleries, Burrell
Collection, Glasgow

the celebrated Salon painter was the completely misunderstood avantgardist, who single-mindedly and relentlessly went his own artistic way – even if this meant personal sacrifice and social exclusion. The artistic way of life and work developed into a liberal alternative to bourgeois existence. This was regarded by the public both critically and with interest. The artist served as a projection surface for individual and unfulfilled wishes. Bazille's studio interior can also be understood with this in mind; we see a vast, scantily furnished room in which painter, musician and writer have come together. Auguste Renoir and Alfred Sisley are absorbed in conversation, Edmond Maitre plays the piano, and Manet and Astruc turn their attention to Bazille's painting on the easel. The artist's own artworks, already in impressive gold frames or as half-finished "work in progress," hang on the walls. The studio proves itself to be a place of many possibilities, of discourse and freedom. Paris looks with fascination at it through the window.

Frédéric Bazille,
Studio in the Rue de la Condamine,
1870,
oil on canvas, 98 × 128.5 cm,
Musée d'Orsay, Paris

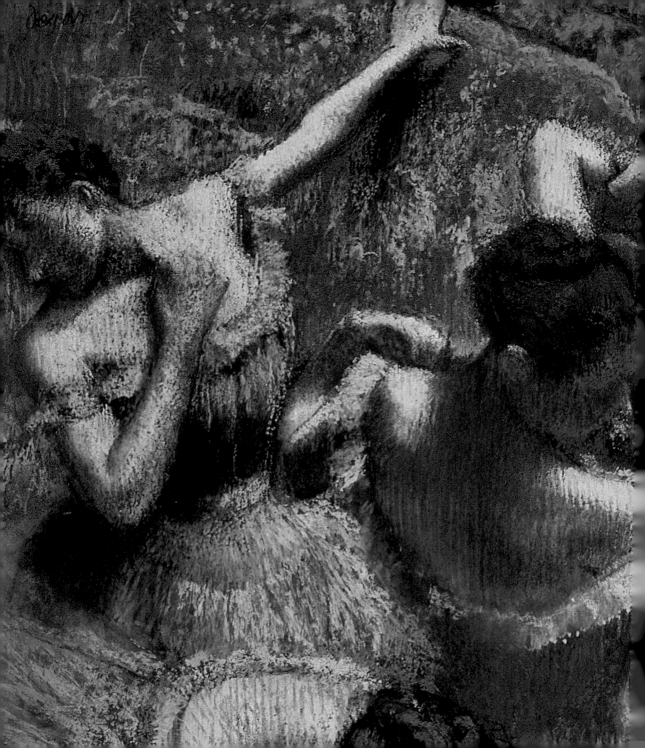

Protagonists:

Edgar Degas and the World of the Stage

Repetition of the same steps and turns over and over again: creating the grand illusion that the dance is playful and light takes hard work. To understand the true nature of ballet – the body's total subordination to a choreographed idea – it has to be seen in the rehearsal room, not on the stage. In the 1870s Edgar Degas was a permanent backstage guest at the Paris Opéra. In numerous paintings and pastels he captured better than anyone the dancers' strain during class and their grace and elegance on the stage. His famous paintings give an unembellished view of the poorly-paid yet highly-motivated young women who were willing to exert themselves to the very fullest in the knowledge that the "Corps de Ballet" offered them the chance at a modest career.

Edgar Degas,
Blue Dancers, 1899,
pastel, 65 × 65 cm,
Pushkin Museum, Moscow

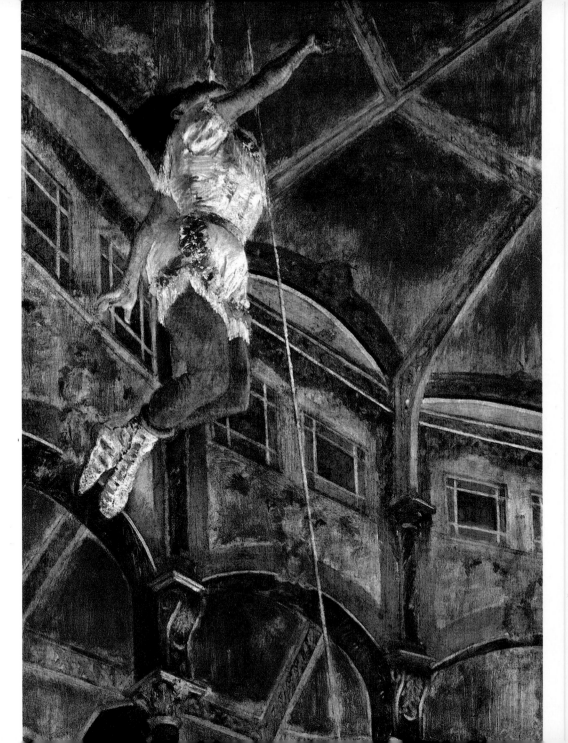

A Director of Highs and Lows

Degas was a painter of the stage. This is clear from his many paintings and pastels of ballet dancers on and behind the stage which show the same mastery as his other preferred subjects – public urban areas with people on the street, in cafés (ill. p. 141) and at the racetrack (ill. p. 90/91). Unlike any other Impressionist painter, Degas's work expresses a fascination with life in the big city.

"Miss Lala is a mulatto with a young man's figure and the uncontested talent of being able to hang with her teeth from the ridgepole of a variety theater. Degas depicts her in this poetic act with her frizzy head of hair thrust forcefully backward, her curved spine and lightly crossed legs dangling as she slowly spins in the flickering light of the arched ceiling at the bottom of the rope amidst a loud festive atmosphere," wrote the critic Armand Silvestre about a painting that caused a great sensation when Degas presented it in the fourth group exhibition in 1879 (ill. p. 192). This breathtaking depiction of an acrobat is matched by an equally exciting picture composition. The figure, seen from below – the perspective of the audience – is totally isolated within the arch of the theater ceiling, leaving no room for a spatial arrangement. The woman's life, illuminated from

Edgar Degas,
Miss Lala at the Cirque Fernando, 1879,
oil on canvas, 117 × 77.5 cm,
National Gallery, London

Edgar Degas,
Waiting, 1882,
pastel, 48.2 × 61 cm,
Norton Simon Museum, the
J. Paul Getty Museum, Pasadena

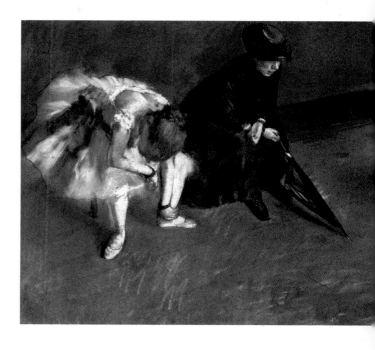

below, seems literally to "hang from a thread" and the precariousness of the situation she is in is strengthened by the diagonals of the dome construction that dominate the composition. The figure of Lala, is the central motif, but it does not mark the center of the picture detail. She is instead positioned in the upper left side of the painting, reinforcing the impression that the observer is witnessing the figure being suspended upward: her body, held only by her clenched teeth, swings and sways. This brief, suspenseful moment, perhaps accentuated by a drum roll during the performance, is reflected visually by an intentionally asymmetrical composition.

Degas and Photography

Edgar Germain Hilaire Degas (originally: de Gas)

(19 July 1834 Paris – 27 Sept. 1917 Paris)

After studying law, Degas completed an academic art degree, after which he traveled to Italy.

In **1855** he met Ingres, whom he came to greatly admire. Following his early historic paintings, Degas discovered new contemporary subjects such as the horse-races (from **1862**) and the washerwomen (from **1869**). He began painting scenes of opera and theater life in the **1860s**.

After serving in the Franco-Prussian War (**1870/71**), Degas visited his brother René de Gas in New Orleans.

He painted mostly dancers and female nudes in the **1870s**. By **1878–80** he preferred working with pastel.

His chronic eye ailment worsened in the **1890s**, which is why he turned to sculpture in **1898**, creating approximately seventy statuettes of female nudes, dancers and horses in wax.

Degas was a master of developing new perspectives and vantage points: dramatic details, aligned space, a view from great heights, the clash of foreground and background. These details suggest a spontaneous observation when in fact the picture had been planned carefully in advance. The new technical possibilities created by photography inspired Degas and he used them heavily to prepare and examine the draft of his composition. "M. Degas thinks only about photography," noted Julie Manet, the daughter of Berthe Morisot, in her

journal in 1895. In particular, the camera's increasingly shortened exposure time made him more sensitive to unusual composition details, to the concept of overlapping images and the snapshot character of his subject. An example of this is provided by the dancer bending over to fix her shoe (ill. p. 193). Has she just been called to audition? This would explain why she is accompanied by the woman dressed in black – her teacher or maybe, her mother – who is drawing a pattern on the floor with her umbrella to pass the time. The picture composition, full of contrasts, increases the tension in a discreet but effective way. The two women seated so close to each other without exchanging a glance or word are presented as opposites, particularly through their clothing – the juxtaposition of black and white, the one costume rigid, completely enshrouding the body, the other transparent, accentuating the figure. Their isolation in the empty room reinforces the diffuse impression of a constrained situation. And finally, there is a disparity established by the triviality of the scene and the effort that has gone into presenting it: Degas had to stand on a ladder in order to capture this perspective.

Edgar Degas,
The Rehearsal, 1873–78,
oil on canvas, 45.7 × 60 cm,
Fogg Art Museum, Harvard

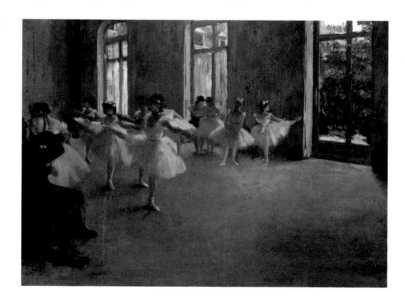

Degas and Ballet

Degas discovered ballet in the 1870s and it would remain his main subject for twenty years, a kind of long-term study during which he explored it in its entirety. Using soft pastel

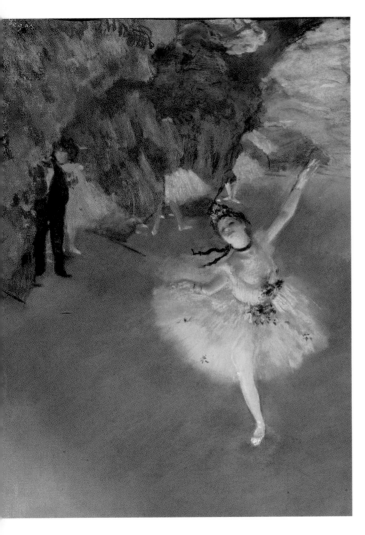

Edgar Degas,
The Star, or *Dancer on Stage,*
1878,
pastel, 58 × 42 cm,
Musée d'Orsay, Paris

tones applied with a light filmy coat, he ingeniously translated the pleasure derived from the beauty of the dance and the elegance and grace that was achieved through continuous hard training. He was interested equally in the repeated synchronized movement of the dancers in the room and in the illusion, which, unraveling like a story, was slowly revealed on the stage. Degas often chose a perspective that connected the events on the stage with a surreptitious glimpse backstage. His decentralized compositions tended to create a latent atmosphere of instability and confusion. An example of this is provided by the prima ballerina who, while presenting herself to the audience on an empty stage, appears to be about to fall over in the wide-open pose of an "attitude." (ill. p. 198) The view from a perspective high above her also incorporates the dancers waiting offstage. A fragment of a darkly clothed man subtly introduces an aspect of the ballet dancers' reality that was rarely spoken about: the dancers of the Paris Opéra were often doubly exploited. Self-appointed "protectors" took advantage of the young women's precarious social and financial situations by "selling" prestigious members of the "Jockey Club" access to their dressing-rooms and hence to the dancers' amorous services. These reputable men also used their high-standing in society to assure that every opera per-

formance included ballet scenes. These scenes, however, never took place during the first act when these men were still enjoying their dinner!

Degas and the Theme of Violence

The artist only alluded to the dangerous circumstances of the dancers' loss of autonomy over their own bodies, but in another work, titled *Interior*, which Degas painted in 1868/69, he created a more drastic presentation of a violent unequal relationship between a man and a woman (ill. p. 198). The painting depicts a diffusely lit bedroom reminiscent of a theater stage. A man leans against a door with his legs spread wide apart and protruding into the room while a young girl, dressed only in a shift, is crouched on a chair. An ambiguous situation is suggested by the various objects in the room – an open suitcase with a salmon-red inner lining, a corsage lying on the floor, the man's gloves and coat on the bed. What has just happened or is about to happen? Is the blood stain on the pale blanket the result of vio-

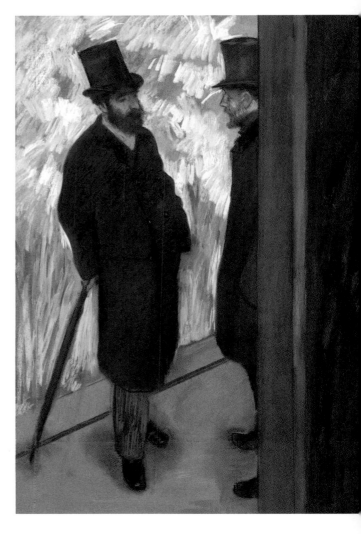

lence? How does that fit with the orderly room and the untouched bed? The painting holds a special position in Degas's work. He never returned to this subject in his work, nor was the piece ever exhibited or sold during his lifetime. Even the debate over whether Degas actually gave it the title *The Rape* or the more neutral *Interior* has never been

Edgar Degas,
Friends at the Theatre, Ludovic Halevy and Albert Cave, c. 1878, pastel, 79 × 55 cm,
Musée d'Orsay, Paris

resolved. By using the effect of subtle lighting and by positioning the man with the sinister shadow in the sphere of darkness while the woman and the bed radiate in illuminating white, Degas, without really telling a story, created an atmosphere of fear and aggression.

Degas and Impressionism

Degas held a special position within the loose circle of Impressionists. He was not interested in landscape motifs or in the process of "plein-air" painting. His most important role model was Jean-Auguste-Dominique Ingres, who had from the very beginning focused his attention instead on the line and drawing. Unlike Monet and Renoir, Degas stopped submitting pictures to the annual official salon exhibition after 1873, although he had successfully exhibited there in the 1860s. Instead he participated regularly in the Impressionist group exhibitions.

Edgar Degas,
Interior, or *The Rape, c.* 1870,
oil on canvas, 81 × 116 cm,
The Philadelphia Museum of Art,
Philadelphia

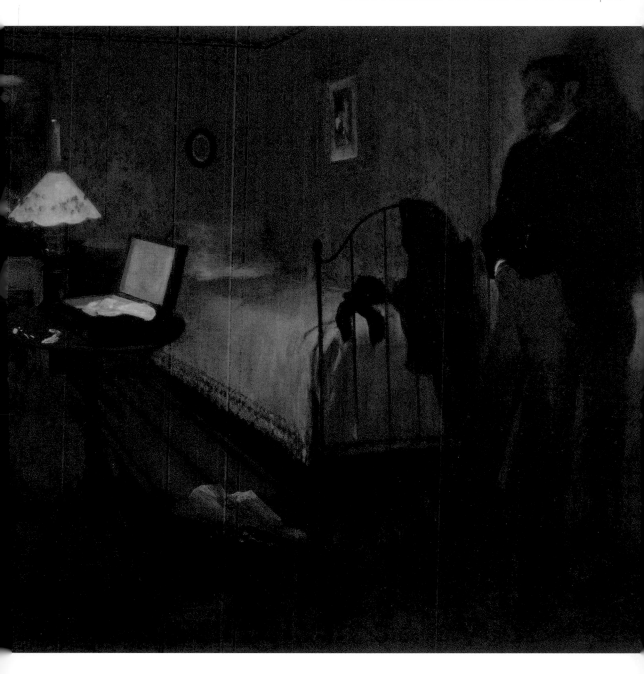

Degas turned almost obsessively to depicting nudes in the 1880s, which he exhibited for the first time in 1882 under the title *Series of female nudes bathing, washing, drying, rubbing, combing or being combed.* In this radical sectional drawing that is typical of Degas's work, he creates a tension through the vast three-dimensional presence of the body and the surrounding space created purely out of color.

Edgar Degas,
Woman at Her Bath, 1895,
oil on canvas, 71.1 × 88.9 cm,
Art Gallery of Ontario, Toronto

Émile Zola – Novelist and Art Critic

Édouard Manet,
Émile Zola, 1868,
oil on canvas, 146 × 114 cm,
Musée d'Orsay, Paris

In his novel *L'Assommoir,* published in 1870, Émile Zola portrays the 15-year-old Nana, daughter of the washerwoman Gervaise Macquart and the worker and alcoholic Coupeau. Thanks to her mature beauty Nana soon gains fame in her neighborhood. Émile Zola (1840–1902), a great narrator of the third French republic and founder of literary Naturalism, describes Nana's appearance with great precision – her rounded edges, her rosy mouth and the coquettish glance of her glowing eyes, "with which the men would have just loved to light their pipes."

Édouard Manet completed a painting titled *Nana* the very same year that Zola's novel was published. A short glance at the painting confirms that it has more than just a name in common with the author's work. Manet's *Nana* seems practically to have sprung from the novel, or perhaps it is the other way around: as if Zola had been looking over Manet's shoulder while he wrote the Nana passages. Both figures possess the same female allure, but they also share many other qualities: Manet placed his Nana in a pose and surroundings that would allow any contemporary observer to recognize her coquettishness. The picture caused a predictable scandal and the bourgeois public was shocked – as they often were with Manet's work. Two years later Émile Zola published another novel titled *Nana,* in which he made the young girl from *L'Assommoir* the main protagonist, recounting her rise and fall as a prostitute.

The symbiosis between the painting and the novel are, in fact, not a coincidence. Émile Zola and Édouard Manet had known each other for many years and shared the same aesthetic ideals. The two artists' acquaintanceship began after 1858, when Émile Zola moved away from Aix-en-Provence,

where he had grown up, to settle in Paris. Until he was able to live from his writing, Zola managed to scrape by in the big city with odd jobs here and there. He often visited the art academies and artist studios where he met a group of young men who called themselves "paysagistes" (landscape painters). The group's members included Édouard Manet, Claude Monet, Auguste Renoir and Alfred Sisley. Zola attended their meetings and was exposed to their work, an experience that was seminal in shaping his own creative development. Consequently, he turned away from the artistic ideas represented by Neoclassical painting with its historical and mythical motifs and joined the representatives of modernism. He shared the Impressionists' preference for contemporary subjects, exemplified by Degas's ballerinas and Monet's train stations. In his articles, Zola, who began to work regularly as a journalist in 1865, repeatedly expressed his support for the Impressionists, although they were widely rejected by the broader public. In his commentaries on the Paris salons he often stressed the importance of Édouard Manet, whom he greatly admired and saw as a forerunner of the Impressionist movement. His painter friends were pleased to have such an eloquent advocate and thanked him in their own way: Manet made a portrait of the writer. Edgar Degas painted a watercolor, inspired by themes in *L'Assommoir*.

His contact to the Impressionists also influenced Zola's literary development. In the foreword of the second edition of his novel *Thérèse Raquin*, published in 1868, Zola outlined his own program for the first time in his theory of Naturalism. Zola demanded of art, at least of literature, an exact description of its subject. He applied to literature the basic principles of scholarly Positivism that had emerged in the late 19th century. In Positivism, metaphysical explanations are not accepted; it accepts as valid only that which is true and can be proven through experience.

This view is the basis for the assumption that as the observation process becomes sharper

Henri Fantin-Latour,
The Studio at Batignolles (detail from p. 15), 1870,
oil on canvas, 204 × 273.5 cm,
Musée d'Orsay, Paris

Zola uses just a few words to sum up Impressionist painting: "A piece of artwork is a part of nature seen by a powerful temperament."

and more complex it ultimately allows us to comprehend the propelling forces and principles of biological and social life. Zola made this understanding of Positivism the guiding idea of his literary creativity. In 1880 in *le roman expérimental* (The Experimental Novel), Zola explained that the Naturalist novel analyzes the "natural man in his dependence on physical and chemical laws and as he is determined by the influences of his milieu." According to these notions, man is doubly pre-determined: first by his biology – today we would say genetic makeup – and secondly, by the environment in which he lives.

In his novel cycle *Les Rougon-Macquart,* with the sub-title: *The Natural and Social History of a Family under the Second Empire,* and in *La Fortune des Rougon* (The Fortune of the Rougons), which was published in 1871, Zola began to investigate the determinism of his main characters by focusing mostly on people at the bottom of the social spectrum: petty bourgeoisie, workers, small merchants, businessmen, and also outsiders: prostitutes, murderers, priests and artists.

Zola dedicated the 14th volume of the Rougon-Macquart cycle, "L'œuvre" (The Masterpiece), published in 1886, to the subject of artists. In it he describes the life and failure of the painter Claude Lantier and develops the experiences and observations that he was able to gather during the time he shared with the Impressionists. The experiment was not received fondly by his painter friends and ultimately led to a break with his one-time companions. In truth however, when "L'œuvre" was published, Zola and the Impressionists had already become estranged from one another. Paul Cézanne, who also grew up in Aix- en-Provence and with whom Zola had been friends as a child, reacted strongly to the novel. He mistakenly recognized himself in the novel's main character and was so infuriated that he broke off contact to Zola.

There were, however, other objective reasons for the process of disaffection that developed between Zola and the Impressionists. It began where the original mutual interests drifted

apart. Zola had always been interested in a presentation of the contemporary milieu that satisfied scientific claims of substance. The creative aim of the Impressionists, however, was to create an adequate rendition of light and color reflections. Where Zola remained oriented towards historic content, the painters were focusing on surface design and questions of technique. Disappointed, Zola turned away from his longtime companions. The man who had once defended the Impressionists expressed his disappointment with them in 1880 when he wrote: "Le grand malheur, c'est que pas un artiste de ce groupe n'a réalisé puissamment et définitivement la formule nouvelle qu'ils apportent tous, éparse dans leurs oeuvres. La formule est là, divisée à l'infini; mais nulle part, dans aucun d'eux, on ne la trouve appliquée par un maître. Ce sont tous des précurseurs, l'homme de génie n'est pas né." ("The great misfortune lies in the fact that none of the artists in this group effectively and conclusively realized this new method that they all carried within themselves and scattered throughout their work. The method is there, divided to infinity, but nowhere did any of them apply it masterfully. They are all mere pioneers; the genius has yet to be born.")

Édouard Manet,
Nana, 1877,
oil on canvas, 150 × 116 cm,
Kunsthalle, Hamburg

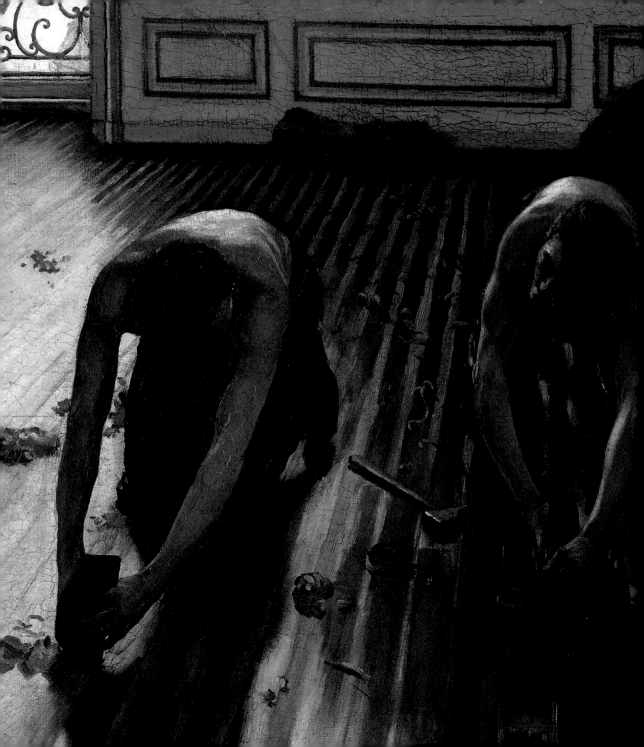

Caillebotte and the View into the Room

A distinguished family will soon be moving into the attractive salon with the different color paneling and the wrought-iron railing in front of the large balcony window. Before they arrive, however, the workmen will have to labor and sweat to polish the parquet floors. Caillebotte's lighting and composition transforms a simple subject into an exciting picture: in an empty room in which only the lower base area is visible, two men work side by side in the same rhythm. Their upper bodies shine dramatically in the back light, echoing the old varnish they are working hard to strip. Rarely has labor been presented so vividly as a mechanical performance. The painter's perspective also makes subtle reference to the upper and lower social classes.

Gustave Caillebotte,
The Parquet Planers, 1875,
oil on canvas, 102 × 146.5 cm,
Musée d'Orsay, Paris

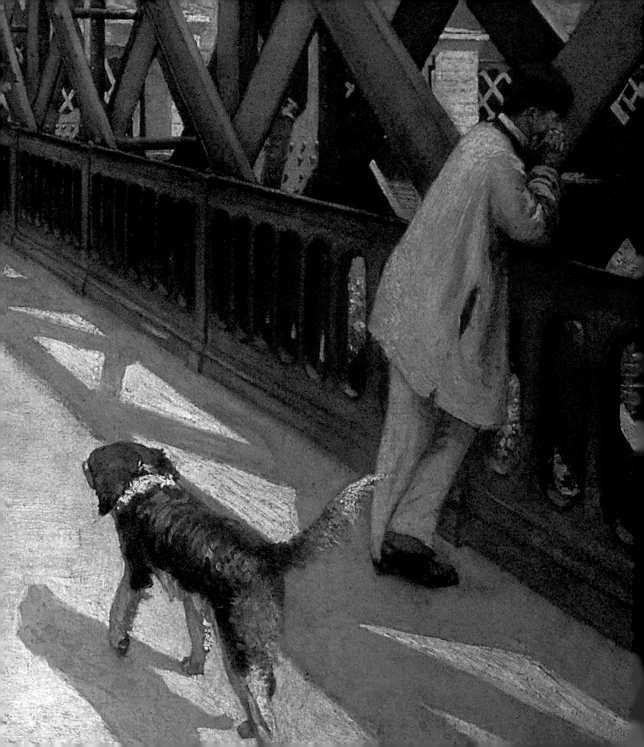

Caillebotte – The Painter

This chapter heading is necessary: too often in the past Caillebotte has been honored solely as a patron. Only in the last 15 years has attention been paid to his own artistic work, despite the fact that Caillebotte discovered new and surprising expressions for two subjects in particular, both of which encompass modern big-city life: the public space of the street and the intimate space of an interior.

Gustave Caillebotte,
Le Pont de l'Europe, 1876,
oil on canvas, 124.7 × 180.6 cm,
Musée du Petit Palais, Geneva

Urban Space – Interior Space

Unlike the boulevard paintings by Monet and Pissarro (ill. p. 82, 85), Caillebotte focused closely on events taking place on the street. He presents streets, plazas, and railroad bridges, not from a balcony set high above, but directly from the sidewalk below. His works are devoid of any important landmarks, well-known memorials or famous perspectives, making it impossible to locate his city views. His architecture remains anonymous, but its structural form is typical of the new Paris that emerged after Haussmann's "great transformation." Caillebotte deals similarly with passersby: Although they face the observer directly, they appear uniform as a result of their clothing and manners, all typical of modern bourgeois urban dwellers (ill. p. 84). The street itself is above all a place of motion. Take for example *Le Pont de l'Europe* (ill. p. 209):

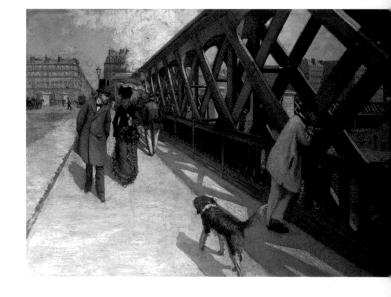

Here a couple are crossing the bridge while a man wearing a simple worker's jacket looks over the railroad balustrade to the trains on the tracks below. The dog appears to have just wandered into the picture. Will its owner follow in the next moment?

Like Degas, Caillebotte worked with strong overlapping motifs at the edge of the painting and with dramatic perspectives: close-ups from above or strongly aligned in-depth spatial views, zooming in closely on a subject or viewing it as if through a wide-angle lens. These distortions have a slightly unsettling effect on the observer. The spatial fabric seems disrupted. The fact that something here is not quite right becomes tangible.

Unlike his artist colleagues within the group of Impressionists, Caillebotte applied an almost photographic realism to his painting technique that underscored the (supposed) realistic subject of his painting. The view into the Caillebotte family dining-room (ill. p. 213) suggests, for example, that the painter, or rather the observer, is also seated at the table, peering into the room over the edge of the plate that is jutting into the detail from below. The artist's brother has just turned his attention to his food; Caillebotte's widowed mother is about to be served at her place. Various glasses and carafes set on

Gustave Caillebotte

(19 Aug. 1848 Paris – 21 Feb. 1894 Gennevilliers)

In **1872**, after passing his law exams, Caillebotte began his studies at the École des Beaux-Arts.

By **1874** he was in close contact with the circle of Impressionist painters.

He exhibited his work with them for the first time in **1876**, and over the next few years worked hard to prepare additional joint exhibitions while expanding his own extensive collection of Impressionist painting. An enthusiastic sailor, he often painted on the banks of the Seine and on occasion with Monet, Renoir and Sisley in Argenteuil.

He began spending his summers on the coast of Normandy in **1880**.

He did not participate in the eighth and final exhibition of the group in **1886** because of a dispute he had had with Degas in **1882** over the acceptance of more painters into the exhibition.

He lived an increasingly reclusive life in his country house in Gennevilliers and died in **1894** at the young age of 45 from the effects of a stroke.

the dark wooden table create points of light in the other-wise gloomy-looking dining room. There is a silent, depressing atmosphere in these rather comfortable, even luxurious surroundings, an impression strongly reinforced by the distorted perspective of the table top. The artificially long distance between the people accentuates the inner distance between them and creates an unusual contrast to the otherwise accurate spatial proportions.

Caillebotte – an Impressionist?

Gustave Caillebotte came from a prosperous Paris family and inherited a fortune after his father died (1874), making it possible for him to work as a painter without any financial worries while at the same time supporting his colleagues

Gustave Caillebotte,
Boaters Rowing on the Yerres,
1877,
oil on canvas, 81 × 116 cm,
Private collection

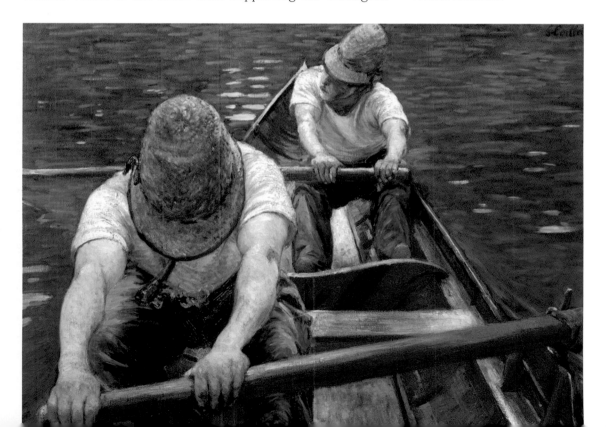

Building on photography, Caillebotte's paintings reveal distortions and alienation. Seemingly harmless subjects unsettle and surprise the viewer.

generously by purchasing their work. When Caillebotte died suddenly from a stroke in 1894 at the young age of 45, he left behind 67 high-quality paintings by Cézanne, Degas, Manet, Monet, Pissarro, Renoir and Sisley, all of which he bequeathed to the French state on condition that they be exhibited in appropriate surroundings. Pierre-Auguste Renoir, the executor of his will, had the difficult task of overcoming the enduring public reluctance to have the Impressionists' work displayed publicly. Influential academic artists threatened to resign from the École des Beaux-Arts if the state accepted the gift. It took two years of tough negotiations before 40 works from Caillebotte's collection were selected for presentation in a separate room of the Palais du Luxembourg.

Caillebotte's dedication as patron and his early death have resulted in an unbalanced view of his own work over a long period of time. Until recently, even experts on Impressionist painting were still dubbing Caillebotte a "Sunday painter" who only dabbled in painting in his free time. This view overlooks Caillebotte's professional training from the École des Beaux-Arts, and more importantly, the breadth and quality of his work. Caillebotte showed no less than eighty paintings in the five Impressionist exhibitions that he participated in between 1876 and 1882. He left approximately five hundred paintings of his own on his death. In many ways, however, Caillebotte's artistic method does not coincide with the ideas of Impressionist painting: instead of applying a visible brushstroke, engaging in a fast, spontaneous paint act or placing emphasis on lighting and atmospheric conditions, Caillebotte adopted an almost old-master painting style, using many studies to prepare for the final work that he ultimately completed in the studio. His use of perspective, local color, materiality and drawing accuracy convey a strong realistic impression that shows the subject as it was. Only at second glance does the observer

recognize that Caillebotte's photographic precision is accompanied by altered perspectives and depictions of the city and living space that reveal what they really are: places of modern life.

Gustave Caillebotte,
Luncheon, 1876,
oil on canvas, 52 × 75 cm,
Private collection

A man has just climbed out of the bathtub and is drying off his left leg somewhat awkwardly. Depicting this kind of intimate moment was itself a taboo, but the fact that Caillebotte's protagonist is a man, and not a female nude as was usually the case in the works of Degas and Renoir, is very unusual, and a radical break from the understanding of gender roles that existed at that time.

Gustave Caillebotte,
Man Drying his Leg, 1884,
oil on canvas, 100 × 125 cm,
Private collection

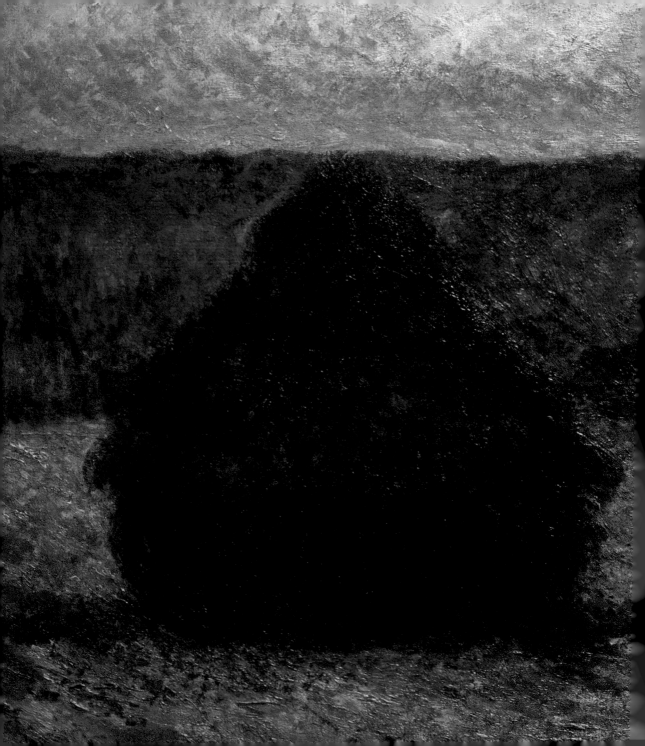

The Series as a Work Principle

"And suddenly, for the first time, I saw a picture," wrote Wassily Kandinsky in 1895 at the age of 29, when he saw one of Claude Monet's *Haystacks* at an exhibition in Moscow. "I learned from the catalogue that it was a stack of hay. I had not been able to recognize it as such and this lack of recognition embarrassed me. I felt that the artist had no right to paint so unclearly. I felt dimly that the object of the picture was missing. Yet I later noticed with surprise and bewilderment that the picture not only seized me, it had engraved itself indelibly in my memory and constantly floated unexpectedly down to the last detail before my eyes (...) – this was the unforeseen force of the pallet that had previously been hidden and which went beyond all my dreams. The painting acquired a fairytale like quality and magnificence."

Claude Monet,
Haystack, Hazy Sunshine, 1891,
oil on canvas, 65 × 100.5 cm,
Private collection

From Picture to Pictures

The process of creating a picture had remained practically unchanged for a century. An artist began work on the composition of a subject of his choice or one he had been commissioned to do by creating a number of studies and sketches. He then sketched the placement of individual motifs of his picture and began testing different color combinations in an oil sketch. Only then did he embark on the final work. A completed painting was hence the final stage of a long process. Ideally, the final work was a mature masterpiece whose completion had depended on many journeyman pieces.

But over time the Impressionists developed a very new understanding of a picture, which also entailed an inevitable change in the work process. The artists left their studios and began drawing directly from nature, making the draft sketches superfluous. Lengthy conceptual considerations were replaced by the fast, spontaneous act of painting. A composition in the classical sense no longer existed—what mattered now was where the artist carried his easel and which vantage point or detail he selected. The object of the painting had also lost significance. A picture was no longer supposed to tell a story. Now the most important task was to use color and color application to reflect the visual "impression." It became a mirror of optical phenomena: atmosphere and light, weather conditions and time of day motivated and dramatized the presentation.

Rouen Cathedral

By the end of the 1880s Claude Monet began painting the very same motifs over and over again. The result was a number of extensive series of paintings, first of haystacks,

Claude Monet,
Rouen Cathedral at Sunset
(detail from p. 220), 1892–94,
oil on canvas, 100 × 65 cm,
National Museum and Gallery of
Wales, Cardiff

A picture had long been regarded as the final product of many studies. Now a subject was "encircled" by many equally important paintings.

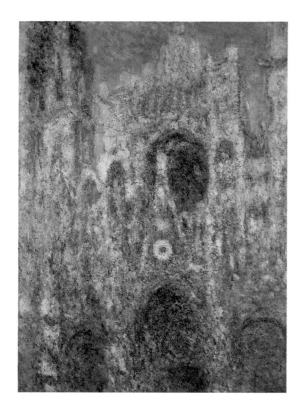

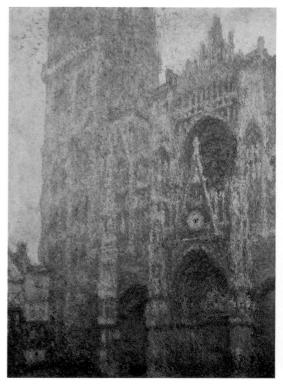

Claude Monet,
Rouen Cathedral at Twilight,
1892–94,
oil on canvas, 100 × 65 cm,
National Museum and Gallery of
Wales, Cardiff

Claude Monet,
Rouen Cathedral, the west portal,
dull weather, 1894,
oil on canvas, 101 × 73.5 cm,
Musée des Beaux-Arts, Rouen

later of poplar trees. By the early 1890s he had turned his attention to the façade of the Rouen Cathedral (ill. pp. 218, 220/221). The water lilies in his garden pond in Giverny were one of his last important subjects which he continued to paint until the end of his life (pp. 224/225). Monet focused on optical phenomena in his painting for over three decades and the serial structure of his later work was a logical continuation of this interest. It allowed him to carefully examine the effect of changing weather, seasons and light conditions on a single object. The fresh cold air of a light summer morning, the wet foggy mist of autumn, the flickering heat of the afternoon sun or the slow falling darkness after sunset not only changed the color scale and light

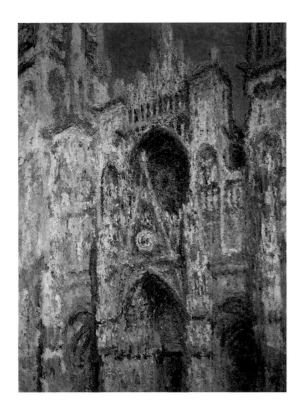

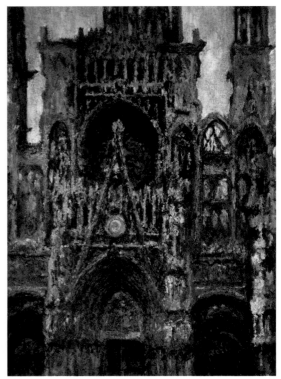

values, it also directly influenced how Monet treated the picture surface. A painting detail shows a thick coating of color collected on the canvas (ill. p. 218). Monet described this as the "intractable incrustation of color." These were no longer just "paintings": as the object of the painting disappeared, it became the canvas surface that posed the challenge to the artist. His letters suggest that for his cathedral series Monet had entered into a competition with light. "I am drudging through, concentrating on a series of various effects, but with the changing season the sun sinks faster and I cannot keep up...I have become a very slow worker, which depresses me, but the farther I get, the better I come to understand how much I have to do if I want to achieve

Claude Monet,
Rouen Cathedral in Full Sunlight: Harmony in Blue and Gold, 1893, oil on canvas, 107 × 73 cm, Musée d'Orsay, Paris

Claude Monet,
Rouen Cathedral, Evening, Harmony in Brown, 1893, oil on canvas, 107 × 73 cm, Musée d'Orsay, Paris

what I have in mind: the instantaneousness, this above all – the very same light everywhere." Monet worked on different canvases simultaneously in order to be able to immediately react to the changing light – a complete transformation of the artistic painting process. For so long the finished picture had been considered the ideal final product, the product of numerous preparatory efforts. Now a subject was "encircled" by many equally valuable paintings. Terms like "unique" and "original" inevitably lost their significance. Monet's principle of serial work opened a door to the 20th century, and would be repeated often.

From Space to Surface

Monet experienced a breakthrough in his work in the early 1890s, after struggling for many years to make ends meet. His paintings were suddenly in great demand internationally and being bought for acceptable prices. When he exhibited 15 paintings from his extensive *Haystack* series at the Galerie Durand-Ruel in May 1891, they were sold within three days and went for between 2,000 and 4,000 francs each. This growing income made it possible for him to buy a house in Giverny with a Japanese-style garden with a water-lily pond, exotic water plants, thick bushes, weeping willows, and a

Claude Monet,
Nympheas at Giverny, 1918,
oil on canvas,
Private collection

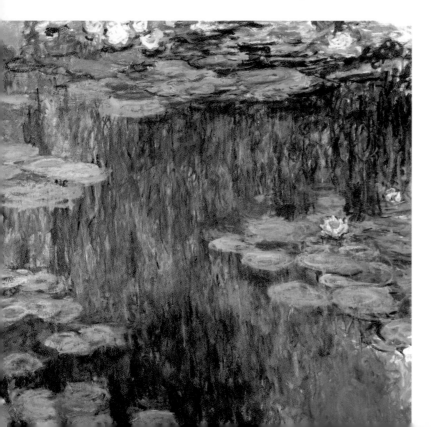

bridge. A whole crew of gardeners helped the aging artist create a world into which he increasingly withdrew after 1900. First the garden, then later the water lilies became his most important motif. Towards the end of his life he painted them on large canvases, creating something close to a memorial to them. The concept of space increasingly disappeared from his paintings. Monet's focus narrowed to the water surface as it reflected the vegetation, leaves and blossoms growing on it. A spatial orientation is no longer possible in these paintings; above and below melt into the surface. The motif of the plants is born out of the color only to disappear into it. The effect that Kandinsky observed when he encountered *Haystacks* became even more distinct: the steps towards abstraction were not only being prepared, they were being carried out.

Next two doueble spreads:
Claude Monet,
Water Lilies,1919–22,
oil on canvas,
Private collection

Claude Monet,
Nympheas at Giverny, 1908,
oil on canvas, 100 × 200 cm,
Private collection

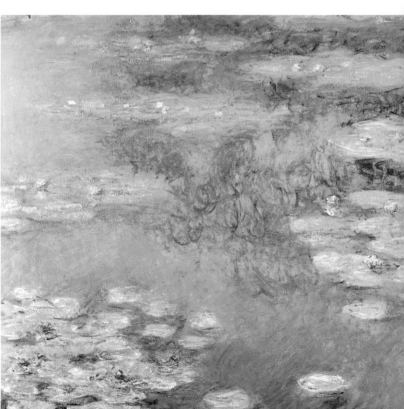

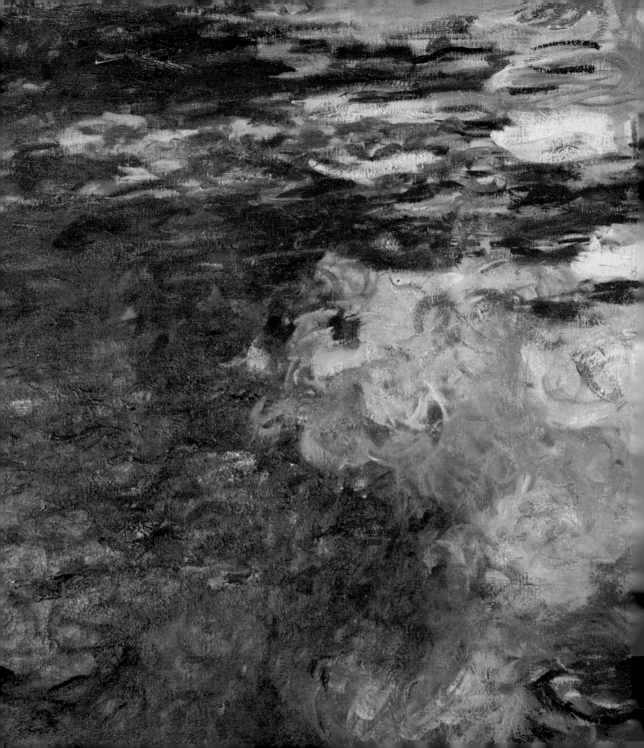

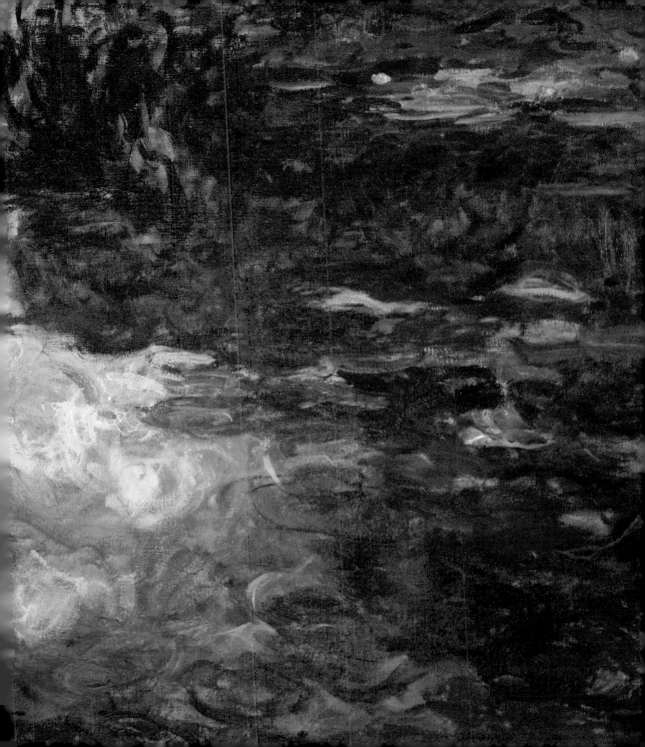

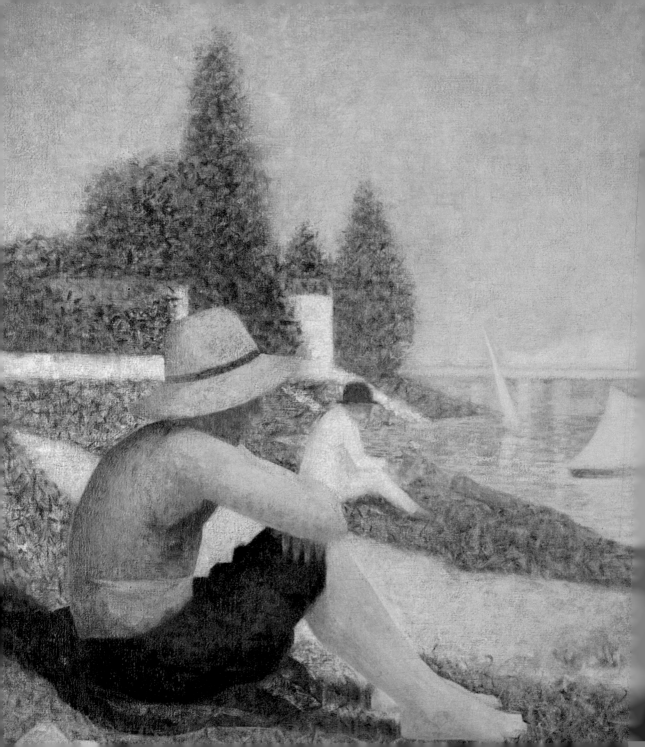

The Last Exhibition in 1886

"At the last exhibition of the Impressionists in Paris in 1886 (…) pictures were shown for the first time that were painted solely with pure fragmented, finely balanced color and which through a carefully plotted method evoked an optical fusion. (…) The unusual luminance and the harmonious mood of these innovators' paintings – although not received warmly – jumped out at you (…) In recognition of this effort and to characterized their shared aim of 'light and color,' albeit through different methods, the painters called themselves (…) Neo-impressionists."

Paul Signac, "From Eugène Delacroix to Neo-Impressionism," 1899

Georges Seurat,
Bathers at Asnières (detail from p. 233), 1884, oil on canvas, 200 × 300 cm, National Gallery, London

To Pastures New – Neo-impressionism

After a long and difficult period of preparation entailing many disputes, the eighth and final group exhibition opened in 1886 in the rooms above the Café Maison Dorée on the Boulevard des Italiens. One painting in particular, by the 27-year-old Georges Seurat, triggered a heated discussion (ill. left and below). Titled *Sunday Afternoon on the Island of La Grande Jatte,* the work stood out because of its large format, unusual for Impressionist painting. The subject itself – people strolling along the river bank of the Seine on a summer day – was fully in line with the canon of Impressionist subjects, but the painting style was completely new. Instead of using the loose brushstroke typical of the Impressionists, the artist covered the entire canvas with evenly distributed colored dots. The pallet was limited to the three primary colors red, yellow and blue and the complementary colors green, violet and orange. Instead of mixing them together the artist simply used black and white to create lighter and darker tones. Visitors and critics immediately recognized the novelty of this painting method. Seurat's understanding of painting was no longer spontaneous. It was a systematic, long and drawn-out undertaking, demonstrated by the 33 oil studies that he made in preparation of the final painting.

Georges Seurat,
Sunday Afternoon on the Island of La Grande Jatte, 1884–86, oil on canvas, 206 × 306 cm, The Art Institute, Chicago

Georges Seurat,
Model from the Back, 1886/87,
oil on wood, 24.5 × 15.5 cm,
Musée d'Orsay, Paris

Painting as Science

The critic and publisher Félix Fénéon (1861–1944) coined the term "Neo-impressionism" in his review of the 1886 exhibition to make the connection between color and light in the painting and to underscore the novelty of this style of painting, which allowed the object of the picture to dissolve into colored dots that blend together as they are being viewed. Today, this process continues to be referred to as "Pointillism" ("point" being French for "dot"). This form of painting was based on an intensive confrontation with scientific research findings on the perception of color, in particular the writings of the physicist Charles Blanc (1813–1882) and the chemist Michel Eugène Chevreul (1786–1889). The idea that certain colors, when placed next to each other, affect each other and how they are perceived (simultaneous contrast) was important to Seurat. The Pointillists began to define art as something close to a scientific discipline with a precise system of rules. The conflict that this posed for a painter like Claude Monet, who created his pictures out of an intuitive process of perception, was irreconcilable. Seurat's painting was not aimed at capturing a moment of reality. Instead he created a composition that based its authority beyond time and space. The void, cool atmosphere of his painting, inhabited by constructive, "molded," stylized figures that are motionless and devoid of contact is no longer a reflection of reality. It is the depiction of an artistic reality captured within the painting.

The End of the Independents

Monet was not the only one to withdraw from the exhibition project. In the end he was joined by Renoir, Sisley and Caillebotte. Even the painters who remained, in particular Degas, Bracquemond, Cassatt, and Morisot, had their problems with Seurat and Signac's participation and demanded that the two of them, along with the much older Pissarro, who had adopted their painting technique (ill. p. 231), show their works in a separate room. Pissarro had always been open to new impulses and thus spoke out strongly on behalf of painters like Cézanne and Gauguin, but he too turned away from Pointillism in 1888. "After experimenting for four years, and after a long inner struggle, I gave up this theory to regain what I had lost and to not lose what I had learned," he later wrote in a letter to the Belgian Art Nouveau designer Henry van de Velde. Pissarro sensed that his Neo-impressionist painting lacked life and movement and that he personally had lost his intuitive spontaneity for nature.

Seurat died of diphtheria in 1891 at the young age of 32. The method of painting that he invented and developed was not carried on by anyone directly, but the illuminating color effects of his painting did inspire the young "Wild Beasts, the "Fauves" led by Henri Matisse. Seurat's scien-

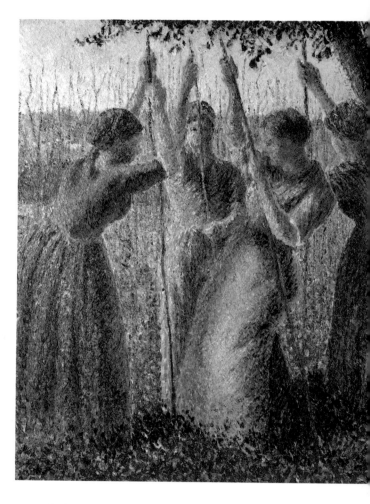

Camille Pissarro,
Women Planting Peasticks, 1891,
oil on canvas,
Sheffield Galleries and Museums
Trust, Sheffield

A few women and men have gathered on the edge of a beach of the Seine. The factory in the background disturbs the otherwise idyllic setting. A matt atmosphere devoid of illusion hangs over the summer scene. When the picture was rejected by the jury of the Paris Salon in 1884, Seurat and other "rejected artists" founded the Société des Artistes Indépendants, which organized a spectacular exhibition with 450 artists the very same year.

Georges Seurat,
Bathers at Asnières, 1884,
oil on canvas, 200 × 300 cm,
National Gallery, London

An Overview of the Impressionist Exhibitions
A Selection of the Participants

	1874	1876	1877	1879	1880	1881	1882	1886
Zacharie **Astruc**	●							
Felix **Bracquemond**	●			●	●			
Marie **Bracquemond**				●	●			●
Gustave **Caillebotte**		●	●	●	●		●	
Mary **Cassatt**				●	●	●		●
Paul **Cézanne**	●		●					
Edgar **Degas**	●	●	●	●	●	●		●
Paul **Gauguin**				●	●	●	●	●
Armand **Guillaumin**	●		●		●	●	●	●
Claude **Monet**	●	●	●	●			●	
Berthe **Morisot**	●	●	●		●	●	●	●
Guiseppe **de Nittis**	●							
Camille **Pissarro**	●	●	●	●	●	●	●	●
Lucien **Pissarro**								●
Auguste **Renoir**	●	●	●				●	
Emile **Schuffenecker**								●
Georges **Seurat**								●
Paul **Signac**								●
Alfred **Sisley**	●	●	●				●	

tific approach was also continued in 20th century abstract, Constructionist painting.

Paul Signac,
The River Bank, Petit-Andely,
1886,
oil on canvas, 65 × 81 cm,
Musée d'Orsay, Paris

Lakes and harbor scenes play an important role in the works of Signac. This composition showing a sailing regatta off the coast of Brittany is dominated by the elements of rhythm, contrast and harmony, not the archaic strength of wind and water.

Paul Signac,
Breeze, Concarneau, 1891,
oil on canvas, 56 × 82 cm,
Private collection

Against the Light – Impressionism in Photography

Honoré Daumier,
Nadar elevating photography to the level of art, published in May 1862 in *Le Boulevard* newspaper. Nadar had already made his first attempts at aerial photography in 1858.

"Monsieur Degas thinks only about photography. He has invited us to dinner next week and plans to take our picture in artificial light." Julie Manet, the daughter of Eugène Manet and Berthe Morisot, was right when she wrote this entry in her journal in 1895. Edgar Degas's interest in photography was at its peak. But he was not the only one experimenting with the camera. Other artists such as Edvard Munch, Pierre Bonnard, and Henri de Toulouse-Lautrec were also enthusiastic amateur photographers. And like Degas, Claude Monet began frequently to substitute photos for his painting sketches. There is a reason for this enthusiasm: rarely were two cultural phenomena to emerge at the same time and be so closely connected as was the case with Impressionist painting and the emerging medium of photography. Their shared history is one of ongoing mutual influence and inspiration. By 1870 Degas was already experimenting with picture details and spatial views reminiscent of the perspective provided by a camera lens; two decades later photographers like Robert Demachy and Gertrude Käsebier were choreographing their subjects to resemble a Degas ballet scene or a Renoir landscape. After all, making pictures was exactly what their photography was about. They were not simply copying reality: photography was an autonomous artwork with its own composition and statement. The conscious reference to Impressionist painting served to legitimate the photographers' understanding of their work in the way they wanted to see it: namely, as art.

Originally celebrated for its ability to reproduce nature and life "truthfully" without the use of chisel or paintbrush, photographers from the very beginning investigated new ways to employ the medium. As early as

1853 the English photographer William J. Newton characterized the mere act of copying the environment as "unartistic." But the higher artistic claims of photographers were ridiculed. The Paris photographer Nadar, who experimented with unusual perspectives and even tried to make the first aerial photographs in 1858, is depicted by the cartoonist Honoré Daumier in a hot-air balloon with the deriding caption: "Nadar elevating photography to the level of art." The young technology was regarded by contemporaries as too limited to create valuable art. Photographers ultimately turned to Naturalist painting and later Impressionism out of a pressing desire to bring their images closer to art. This early photography, after all, shared so much in common with the paintings of the 1860s and 1870s: In both cases the artist tried to employ light adeptly to create unusual pictures that seem to capture an atmospheric moment. As early as the 1850s the photographer Gustav Le Gray enthralled audiences with his distinctly choreographed atmospheric photos of the ocean in sunlight – almost twenty years before Monet had created his painting *Impression, Sunrise*. Photographs were exhibited for the first time in the Paris Salon in 1859, albeit in a separate wing of the building.

Impressionistic photography experienced its zenith between 1880 and 1910. During this period, known as "Pictorialism," photographers declared their aim to be the creation of "beautiful pictures" that satisfy artistic claims and are unique. As Impressionist painting slowly fell out of fashion, its motifs and design principles were carried on in artistic photography. Advanced technical developments made it possible to adapt the Impressionist form of presentation to photography. Shortened exposure times made it easier to take pictures and new techniques answering to the special needs of artistically ambitious photographers became available. Different methods of fine print processing, beginning with a glass negative exposed under an arc lamp onto different laminated printed sheets, were especially popular. Oil and rubber printing plates,

Edgard Degas,
Portrait of Auguste Renoir and
Stephan Mallarmé, 1895

later also brometching, are typical of art photography at the turn of the century. The repeated and varying lengths of exposure to the color-coated printing sheets made it possible for a photographer to achieve the exact tonal value that he desired for his picture in order to create a certain light, a certain surface of a very specific atmosphere. Pencil, chalk and ink were also often employed in fine print processing as a way to manipulate the photography and add an "artistic" touch. The stipple process of 1907 allowed for the photograph to be broken down into pointillist grain structures. The development of "picturesque lenses" in 1910 intentionally produced blurry, sketchy pictures. These were the last technological advances of pictorial photography. Art photographers often established alliances and groups based on similar interests and were joined by other artists struggling with similar developments in painting. Photo clubs existed in every major European city. Alfred Stieglitz founded the "Photo Secession" in 1902 and organized an exhibition

room for the group with Gallery 291 just three years later. Photo artists such as Edward Steichen, Alvin Langdon Coburn, Gertrude Käsebier, Clarence H. White and Stieglitz showed their work there. Stieglitz also published "Camera Work," an important magazine that existed until 1917.

The period during which Impressionist painting motifs lived on in photography is impressively long. In 1906 Edward Steichen photographed the Flatiron Building in New York City in rainy twilight – with shiny wet streets and illuminated lanterns that recall Camille Pissarro's boulevard paintings. But by about 1910 this kind of photography was no longer regarded as contemporary. Photographers were now criticized for the very thing that had first made them so popular: the close relationship of their work to painting. After the First World War, and especially during the period of "New Visions" in the 1920s, photography developed its own new aesthetic way of perceiving the world through the camera.

Clarence H. White,
Fountain, c. 1906/07,
Royal Photographic Society,
Bath

Gustave Le Gray,
Sun on the Sea, No. 23, 1856

Pioneers of the 20th Century

The picture resembles an explosion: A major
cosmic event has occurred in an evening land-
scape. Stars and moon are surrounded by huge
illuminated aureoles; a bright milky way is seen
in the background; the entire sky is over-
whelmed by a tremendous undulating move-
ment. Something dark is flickering in the
forefront, probably the outline of a cypress. A
village lies nestled in a valley, light glows through
a few windows. Are the people aware of what is
happening around them? Is something hap-
pening? Or did Vincent van Gogh's visionary
image transform a starlit night into a spectacular,
supernatural painting?

Vincent van Gogh,
The Starry Night, 1889,
oil on canvas, 73 × 192.2 cm,
The Metropolitan Museum of Art,
New York

New Picture Concepts

After an exhausting marathon of eight exhibitions, realized between 1874 and 1886 and accompanied by numerous external and internal difficulties, most of the participating artists left Paris. They stayed in contact, but after 1886 no new attempts were made to exhibit together. Instead many of the artists withdrew to the countryside to reap the first benefits of an artistic life that had been characterized by deprivation. At the same time Impressionism was replaced by a new avantgarde art movement as a younger generation of artists established themselves. Alongside the Neo-impressionists who had a brief yet intense interlude between 1886 and 1891 (the year Seurat died), three dominant artists in particular continued to inspire through their work, well into the 20th century: Paul Gauguin, Vincent van Gogh and Paul Cézanne. Today they are still considered the "Fathers of Modernity." Each of them completely re-defined the relationship between nature and painting. "Do not copy nature too much, art is an abstraction; take this from nature by dreamily observing, and think more about creating than about the

Paul Gauguin,
*The Vision after the Sermon
(Jacob wrestling with the Angel),*
1888,
oil on canvas, 73 × 92 cm,
National Gallery of Scotland,
Edinburgh

In search of new methods of expression through painting, many artists withdrew into isolation – to Brittany, Arles, the South Seas or Provence.

end result," wrote Paul Gauguin in August 1888 to his painter friend Émile Schuffenecker. The same month Vincent van Gogh wrote in a letter to his brother Theo: "Instead of trying to recreate what I see before me, I employ color quite arbitrarily as a way to express myself more effectively." The Impressionist doctrine of a direct, unfalsified rendering of the painter's perceived impression of the natural world had lost validity. Now artists were looking for new ways of "expressing themselves." Creating anew instead of re-creating became the declared goal of the artist – a fundamentally new concept with a far-reaching impact.

Paul Gauguin – A New Primitivism

Paul Gauguin's (1848–1903) journey to art is well known. After a few years of being a successful stockbroker with a wife and five children, he became destitute. He was a passionate painter who risked his entire existence for a life with art. In the beginning, encouraged and instructed by Pissarro in particular, he participated in the 1879 Impressionist group exhibition. In 1886 he withdrew to Pont-Aven in Brittany and stopped working in nature as Pissarro had taught him to do. Two years later, when Gauguin returned to Pont-Aven after a visit to the Caribbean Island of Martinique, he developed his early characteristic work titled *The Vision after the Sermon (Jacob wrestling with the Angel)* (ill. p. 245). The scene from the Old Testament is set in Brittany with Breton peasants witnessing the unequal wrestling match which, set in the upper right quarter of the painting, could almost be overlooked. It was not enough that the return to a biblical subject suggested a break from the Impressionist canon – the Impressionists after all typically took their motifs from their own perceived reality – but Gauguin's implementation was also completely new. His picture shows no natural space. Instead he presents a signal red surface and a stylized tree. The proportions

between foreground and background are distorted and the close up and distant views are strangely intertwined. Gauguin's painting is practically a manifesto against the "fetters of natural representation," which he felt the Impressionists were bound by. "They research within the circle of their vision and not in the secretive center of their thought," he noted polemically. His painting was not intended to imitate. More importantly, it was to bear a symbolic character and be real, authentic and original. He was inspired by folk art and techniques used in the applied arts such as glass painting with its clearly outlined surfaces.

In search of new impulses and an alternative way of life that could infuse new energy into his art, Gauguin discovered the South Seas. He traveled to Tahiti for the first time

Paul Gauguin,
The Birth of Christ, 1896,
oil on canvas, 96 × 128 cm,
Neue Pinakothek, Munich

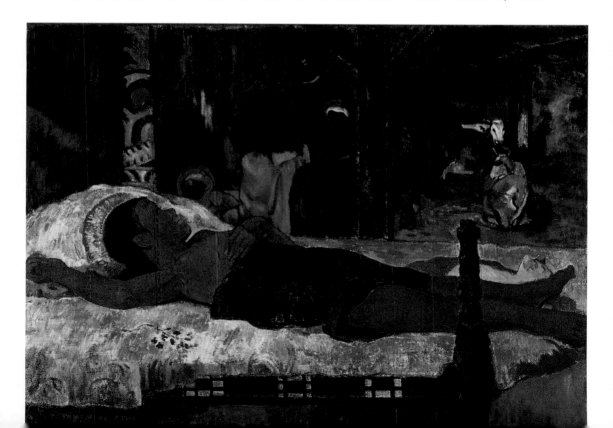

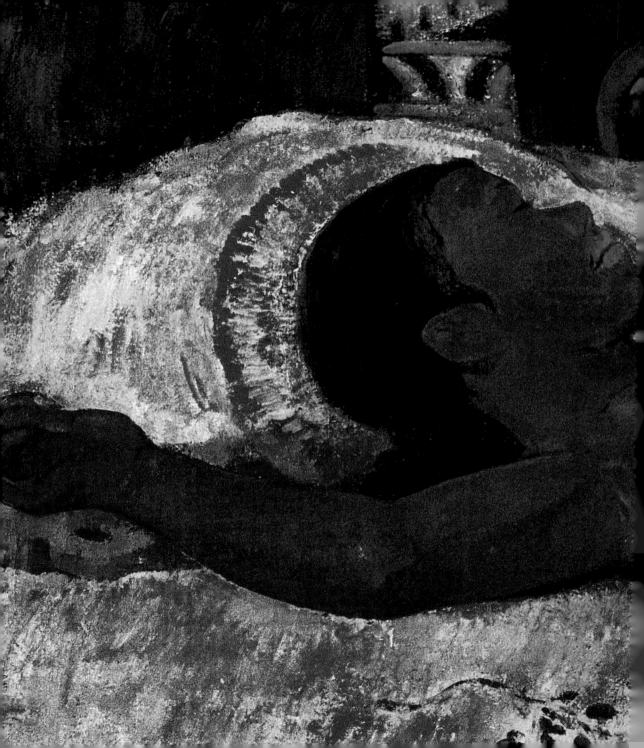

In his presentation of the birth of his son, Gauguin intentionally returns to Christian iconography, interpreting the event as an act of salvation. The heads of mother and child are enveloped by halos. An ox and donkey are visible in the background. The child, born to Gauguin's young mistress Pahura, died just a few hours later.

Paul Gauguin,
The Birth of Christ (detail from p. 247), 1896,
oil on canvas, 96 × 128 cm,
Neue Pinakothek, Munich

Vincent van Gogh,
*Self Portrait with Bandaged Ear
and Pipe,* 1889,
oil on canvas, 51 × 45 cm,
Private collection

in 1891 and ended up settling there permanently in 1895. Although the living conditions of the islanders had long been influenced by French colonization, the paintings he created there show a fictitious, timeless paradise (ill. p. 247). Gauguin was less interested in exotic subjects. He wanted his painting to reflect the (supposed) reality of an anti-civilizing form of existence, not one that had been denaturalized.

Van Gogh – a New Expressiveness

Vincent van Gogh (1853–1890) also left Paris in search of sun and light and ended up settling in Arles in southern France. He was hoping to work with other artists in a group and invited Gauguin to join him. The experiment not only failed, it ended in disaster. Van Gogh's self-mutilation in December 1888 (ill. above) was a clear sign of a developing mental illness that caused him to be increasingly isolated from his artist colleagues. It is also what presumably led to his suicide in July 1890. Despite all these afflictions and difficulties, including his lifelong financial dependence on his brother Theo, during the few months after he left Paris on February 19, 1888 and before his death, van Gogh developed powerfully expressive work that is distinctive and unique. With an unprecedented color intensity and an unmistakable brushstroke, he broke away from the Impressionist style practiced until then. Like Gauguin, van Gogh strove towards a fundamental simplification which was to

give his art a stronger, almost existential expressive quality. His painting language, raw and brute coloring and application, had an extraordinary influence on the next generation of artists.

Paul Cézanne – a New Nature

Just as early 20th-century Expressionism remains unthinkable without the work of van Gogh, Paul Cézanne (1839–1906) played an essential role in developing Cubism. To go by his age, Cézanne belonged to the generation of Impressionists, but his work developed well beyond

Paul Cézanne,
Still Life of Peaches and Pears,
1888–90,
oil on canvas, 61 × 90 cm,
Pushkin Museum, Moscow

this style. As early as 1877 he broke away from the group and left Paris to return to his home in Aix-en-Provence in southern France. Cézanne did not return to the French capital for almost 20 years. Isolated from colleagues, gallery-owners and critics, he developed a new spatial concept in his painting that broke with the traditional rules of perspective and anatomy and with the atmospheric fragmentary style of the Impressionists. In his extensive *Bathers* series (ill. p. 253), heavy, voluminous figures populate a landscape that does not open to depth but instead is tightly interlocked into the foreground and background by color. The aim is evidently no longer to capture a moment but to create a calculated composite picture design that is "parallel to nature," to translate Cézanne's own words. The constructive character of his painting is apparent in his still lifes as well (ill. p. 251). His pictures seem to be built of color and form, thus claiming both autonomy and universal validity at the same time. When Ambroise Vollard showed about 150 of Cézanne's pictures in his Paris gallery in 1895, a generation of young artists experienced a revelation. Painting had even – or especially – been liberated from the ephemeral quality of nature itself.

In a letter dated April 15, 1904, Cézanne offered advice to the younger painter Émile Bernard (1868–1941): "May I repeat what I told you here: treat nature by means of the cylinder, the sphere, the cone, everything brought into proper perspective so that each side of an object or a plane is directed towards a central point."

Paul Cézanne,
Three Bathers, 1879–82,
oil on canvas, 52 × 55 cm,
Musée du Petit-Palais, Paris

Impact:

Impressionism as Revolutionary Style

"Cola Rossi has his academy in the small Rue de la Grande Chaumière (...), small, rumbling, dirty, funny barracks with no lack of poetry. Next to Julien, Cola Rossi is the best academy (...) And in these holy halls I draw nudes (...) There are some fantastical characters here. Actually no one here resembles anything like the reasonable people that we know from home. Velvet suits, long hair, shirt sleeves, hand towels for ties, and other peculiarities are donned by these spiritual brothers of Apollo. Gala presentation: bombardments with bread crusts, screeching hens, cat cacophony and general brawling. Lots of Yankees, lots of Spaniards, English and a few French and Germans."

Letter sent by Paula Becker to Otto Modersohn on February 2, 1900 from Paris

Denis Miller Bunker,
Chrysanthemums, 1888,
oil on canvas, 90.2 × 121.9 cm,
Isabella Stewart Gardner Museum, Boston

From Paris into the World

By the end of the 19th century Impressionism had developed into an international style. In Scandinavia, Holland and Germany, all the way to Italy, Spain, Eastern Europe and the United States and Australia, even in Japan and China, artists were adapting the accomplishments of their French colleagues or turning, independent from them, to open-air painting. The decisive components shared by these artists around the world included an interest in the contemporary experience as a subject of painting, a brightened pallet of colors, the spontaneous loose brushstroke and the intense preoccupation with light as a central element of the painting. Variations were derived from local interpretations, regional singularities and an affiliation with the national painting tradition of the artists' respective countries. Despite these differences, however, Impressionism, having captured the spirit of the times, was by end of the 19th century clearly the style of the age.

Artists from all over the world traveled to Paris at the end of the 19th century as the city was considered the cultural center of Europe. The École des Beaux-Arts and the many private academies offered excellent educational opportunities and the city's superb public collections, most notably in the Louvre, provided an unparalleled pool of original historic art for study. Moreover, Paris, as the site of the Universal Expositions in 1855, 1867, 1878, 1889 and 1900 had a magical allure. But life was not always easy for artists from abroad who chose to reside longer in the French capital. German artists there encountered a wide range of resentments as a consequence of the Franco-Prussian war of 1870/71 and found themselves excluded not only from conservative groups, but also from liberal

Max Slevogt,
Francisco D'Andrade as Don Giovanni, 1912,
oil on canvas, 54 × 45 cm,
Kunsthalle, Hamburg

Joaquín Sorolla y Bastida,
Mending the Sail, 1896,
oil on canvas, 220 × 302 cm,
Museo d'Arte Moderna, Galleria
Internazionale Ca' Pesaro,
Venice

French artist circles. In general, a xenophobic atmosphere dominated France at the end of the 19th century and in response, foreigners joined forces with their fellow countrymen, frequenting different Paris cafés and meeting in various artist locations on the Seine or in Normandy to pursue their open-air studies. Some artists chose only to remain a few months. Others, however, such as Mary Cassatt and Guiseppe de Nittis (ill. p. 262), made Paris their second home.

The special situation created by French avantgarde art made it rather difficult for young students to establish direct contact with contemporary painting. Not a single Impressionist painting was on view in a public collection in Paris before 1895. To be able to see an Impressionist work, artists had to have access to one of the few Paris private collections. In order for them to even be aware of the newest developments in French painting, they had to know about the group exhibitions taking place or be acquainted with an important participant. Young artists in the École des Beaux-Arts and in the larger private academies, such as Julien or Colarossi, usually encountered conservative salon painters teaching courses there. Despite these difficulties, Paris still provided new perspectives for rising young artists who had distanced themselves from their previous living and working arrangements in their native countries and who had come to Paris to extend their horizons, to achieve a

new sense of freedom and engage in experimental painting. Women especially found more favorable conditions in Paris as professional artists than anywhere else in the world. The Paris art scene was generally regarded as open and liberal. Impressionism, the style of the "independents," broke away from traditional conventional subjects and embraced the immediate world, thereby embodying to a large degree the freedom of art. That's why it particularly fascinated the younger generation and became successful internationally.

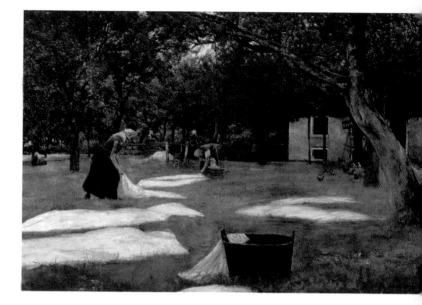

Max Liebermann,
The Bleaching Ground, 1882, oil on canvas, 108 × 173 cm, Wallraf-Richartz-Museum, Cologne

America in Paris – Paris in America

The Americans made up a rather large group among the foreigners living in Paris. The first Impressionist among them was without a doubt Mary Cassatt, who had already worked with Edgar Degas in 1877 and was participating in the group exhibitions by 1879. She also established contact with collectors and buyers in the United States, which culminated in a large exhibition of 290 paintings by the French Impressionists, organized by the gallery owner Durand-Ruel in the spring of 1886 in New York. Works by Claude Monet and his artist colleagues were soon being displayed in any number of American galleries, museums and private exhibitions.

John Singer Sargent (1856–1925) was extremely important to the reception of Impressionist painting in the

The Impressionists were so successful with American collectors that Durand-Ruel opened a branch of his gallery in New York in 1888.

United States. He had already made the acquaintance of Claude Monet in the 1870s and visited him in Giverny in 1887. Giverny subsequently became a small American artist colony – a fact that did not especially please Monet. Sargent, who had become one of the most sought-after portraitists of his time, adopted the Impressionist pallet and technique in the following years. His figures, particularly those set in landscapes, reveal his close connection to Impressionism (ill. p. 263).

Not only New York, but Boston too became a center of Impressionist art. The artists working there included Childe Hassam (1859–1935) and Dennis Miller Bunker (1861–1890), who, despite his early death, was an important contributor to Impressionist painting. Bunker changed his style while working with Sargent. His work *Chrysanthemums* (ill. p. 254), portraying flowers in a Boston winter garden in 1888, displayed the essential characteristics of Impressionist art: long, succinct brushstrokes of bright color that make the selected detail appear especially random and fragmentary.

"London Impressionists"

This was the title of an exhibition of ten English artists shown in December 1889 in the London branch of the Paris gallery Goupil. The artists' work was clearly influenced by Monet and Degas, but also by the American-born, but British-based, James Abbott McNeill Whistler. The paintings exhibited did not follow the rules of established Victorian art at all. Many young artists experienced their exposure to Impressionism as a liberation from the limits of their own traditions. This was true of Philip Wilson Steer (1860–1942), who greatly admired the works both of Monet and Sargent. He worked for many years in Walberswick, a small seaside resort on the coast of Suffolk (ill. p. 265) and developed a far-reaching form of the picture in dis-

solution. Wind, light and air are the main components of the ocean scenes that he painted in soft pastel tones.

Although Impressionism was initially rejected by the older academy members, by the 1890s it had established itself in the Royal Academy.

The "Macchiaioli"

Unlike many other Europeans, Italian painters developed

Tom Roberts,
A Break Away!, 1891,
oil on canvas, 137.2 × 168.1 cm,
Gallery of South Australia,
Adelaide, Elder Bequest Fund

open-air painting relatively independent of their French forerunners. A group of painters trained by regional academies and active foremost in Naples and Tuscany in the early 1860s were painting "all'aperto" (outdoors). Although they occasionally completed a painting in a studio, reproducing light and materiality as they had been trained to do remained important to their work. Great emphasis was placed on a special chiaroscuro background called "Macchia." This harmonic distribution of different tones was designed to increase the poetic quality of the work and "is the result of the first fleeting impression of nature," explained the art historian Vittorio Imbriani in 1868, accentuating its impressionistic quality. One important representative of the 1860s "Macchia" movement was Silvestro Lega (1826–1895). Although his brightly illuminated portraits clearly bring to mind similar paintings by Frédéric Bazille (ill. p. 267), he rarely left his Tuscan home, preferring to depict the well-to-do country life where he lived.

Guiseppe de Nittis, already mentioned here, and Federico Zandomeneghi (1841–1917) took a quite different route, choosing to settle for a longer period in Paris and maintaining close contact to the Impressionists. Encouraged by Degas, Zandomeneghi was represented in four of the Impressionist group exhibitions. He showed a total of fourteen works in the eighth exhibition in 1886. Although de Nittis, who died young, only exhibited with the Impressionists in 1874, he had great commercial success working in a moderately Impressionist style. Although they had many contacts, the artistic status of the two Italians in Paris was difficult. In their letters and journal entries they expressed their feelings

Giuseppe de Nittis,
The Place des Pyramides, Paris,
1875,
oil on canvas, 92 × 74 cm,
Musée d'Orsay, Paris

John Singer Sargent,
Paul Helleu Sketching with his Wife, 1889,
oil on canvas, 66.3 × 81.5 cm,
Brooklyn Museum of Art,
New York

of loneliness and isolation.

The Spanish Path: Tradition and Open-Air Painting

The art scene in Spain, as in Italy, was strongly character-ized by regional diversity. Moreover, a confrontation with Spanish tradition, especially with important role models such as Goya and Velázquez, provided a significant influ-ence. Both trends are reflected in the works of the Spanish Impressionists who discovered open-air painting in the 1880s and 1890s. These included artists working in Valencia and Madrid such as Joaquín Sorolla y Bastida (1863–1923), who spent a few months in Paris in 1885 after completing his studies, but who was oriented mostly towards the work of Velázquez. Sorolla, more than anyone else, was a great success in America. An exhibition in New York in 1909 drew 150,000 people, an unheard of number of visitors for that time. His paintings are often dominated by the southern sun, with bright colors and an almost blinding white enlivening the scenery. (Ill. S. 258).

The Birth of Impressionism in Holland

The reception of open-air painting between France and Holland was not a one-way street. A fruitful exchange existed between Barbizon and The Hague, between artists such as Josef Israëls, Anton Mauve, Johan Barthold Jongkind and Charles Daubigny. The Dutch and French were equally inspired by the Old Masters of the northern Netherlands, especially Salomon van Ruisdael, Rembrandt and Frans Hals, and consequently they developed new ways of dealing with light in their works.

Many Dutch painters moved to Paris at the end of the 19th century, including the most famous of all, Vincent van Gogh, who resided in the French capital from 1886 to 1888 and went "through the school of Impressionism" before finding his own distinct style in Arles. But Van Gogh's friend

By the end of the 19th century, Impressionism had developed into an international style that reflected the spirit of the times.

George Hendrik Breitner (1857–1923) chose to remain in Holland and consequently, his pallet does not demonstrate the lightness and illuminating strength of the south. Instead his rich ornamentation and elegant lines are clearly influenced by the current Japonism of the time. (ill. left).

Munich – Paris – Berlin

These were the important stations of many German artists during their educational period. Max Liebermann, for example, studied at the progressive Munich Academy, and went from there to the Académie Julien in Paris in the fall of 1884. In 1898 he founded the Berlin Secession and formed the "triumvirate of German Impressionism" with Max Slevogt and Lovis Corinth. In addition to a rather delayed reception of French Impressionism, the early, mostly private oil sketches by Adolph Menzel and Carl

Philip Wilson Steer,
Children Paddling, 1894,
oil on canvas, 64.2 × 92.4 cm,
Fitzwilliam Museum, Cambridge

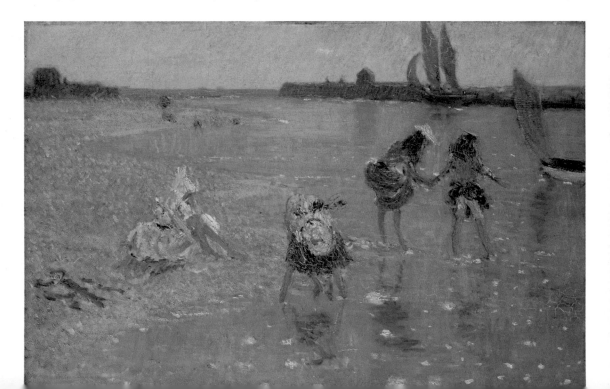

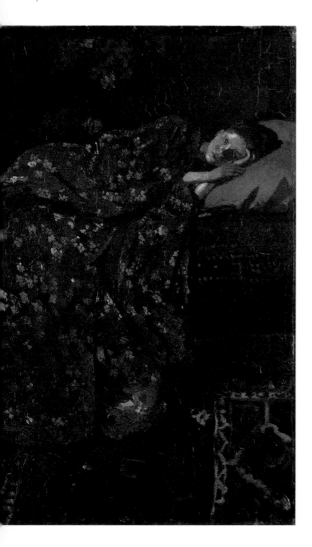

Georg-Hendrik Breitner,
The Red Kimono, c. 1893,
oil on canvas, 85 × 52.5 cm,
Haags Gemeentemuseum, The
Hague

Blechen, who had already experimented with "plein air" in the 1830s and 1840s, provided inspiration on the path to outdoor painting. The nearness of Holland brought Germans into contact with the Hague School, which is how Liebermann met Josef Israëls and Anton Mauve in the early 1880s. This influence finds expression in his works of country villages. His paintings reveal a masterful atmosphere of air and light while maintaining a focus on people and their reality. (ill. p. 259). By the turn of the century, German painting had also discovered typical Impressionist subjects – street and café scenes as well as industrial and railroad landscapes. Artists such as Lesser Ury, Friedrich Kallmorgen and Gotthardt Kuehl deserve mention in this context. Impressionist painting in Germany continued to make its mark after the turn of the century as well, but the powerful brushstroke motion in the late work by Corinth and Slevogt reveals the first echoes of Expressionism. (ill. p. 256).

Impressionism Down Under

At the end of the 19th century, Australia was still a developing country in regard to art. A hundred years after the whites had settled there, there was still not anything resembling an established art scene or a national school on the continent that at that time consisted of six British colonies. Three artists in particular, Tom Roberts (1856–1931), Charles Conder (1868–1931) and Arthur Streeton (1867–1943) tried to establish an Impressionist-style Australian painting in this

open terrain. They showed their work together in 1889 in Melbourne and declared in a manifesto that they published for the occasion: "Each impression lasts only a short time which is why an Impressionist must try to capture it as quickly as possible." Open-air painting also became the preferred working method in Australia. It was adopted from the immigrant painters who had been in contact with the Barbizon School. Life in the countryside provided the appropriate motifs. Roberts, for example, created a powerfully dynamic depiction of a herd of sheep breaking away while the shepherd, running after them, tries to cut them off (ill. p. 261).

Silvestro Lega,
The Folk Song, 1868,
oil on canvas,
Palazzo Pitti, Galleria d'Arte
Moderna, Florence

Glossary

Absinthe (Gk. *apsínthion,* "wormwood"), green, bitter spirit distilled from herbs including wormwood.

Academy (Lat. *academia;* Gk. *akademia*), institution or society to support artistic or scientific studies and education. The first significant academies were founded during the Renaissance in Milan and Florence and modeled after schools of Antiquity. The Accademia di San Luca, founded in Rome in 1599, marks the introduction of the first painting schools. Under Absolutism, the idea of the academy spread across all of Europe. The Académie Française, founded in 1635 and the Académie Royale de Peinture et de Sculpture, founded in 1648, served as models. The name goes back to a gymnasium in Athens dedicated to the Attic hero Akademos. Plato named the philosophy school that he established in 387 BC after his favorite sport.

Academicism, a term derived from the academy in the art-college sense, referring to an aesthetic view that is oriented to a set body of rules for artistic representation, for example the reproduction of anatomy or perspective. In addition to regimented training, the academic doctrine encompassed an exact idea of the artistic "ideal picture," model composition rules and picture topics with a clearly outlined hierarchy of categories ranging from the historical painting to genre. Found to be rigid and dogmatic, it has been increasingly rejected by art critics since the 19th century.

Allegory (Gk. *allegoría,* from *allegorein,* "to speak figuratively"; the pictorial presentation of an abstract term, idea or association, often influenced by literature. Allegorical representation can include figures (personification), action and symbols and was often applied as ornamentation on buildings and monuments in the 19th century, sometimes with political references.

Antiquity (Fr. *antique,* "ancient"; Lat. *antiquus,* "old"), the classical Greco-Roman world. It conventionally begins with the earliest Greek artifacts and literature in the 8th century BC and ends in the West in AD 476 with the abdication

of the Roman emperor Romulus Augustus, and in the East in AD 529 with the closing of the Platonic Academy by Emperor Justinian (AD 482–565). Aspects of Antiquity underwent revivals in later centuries, for example in the Renaissance, in Neo-classicism and in Post-modernism.

Barbizon School, gathering of several Parisian landscape painters in the town of Barbizon located on the edge of Fontainebleau forest. Around 1830 Théodore Rousseau, Jean-François Millet, Jules Dupré and occasionally Camille Corot met here regularly during the summer months to paint outdoors. Subject matter included simple country life, farmers and the surrounding countryside. Despite a general rejection of the elevation of certain motifs, as practice by Romantic landscape painters, painters, such as Millet and Corot, lend their subject matter a deeper meaning by, for instance, glorifying simplicity. The group's approach to painting had a stimulating affect on Realism in the natural portrayal of the image, as well as on Impressionism in the creation of painting en plein air.

Batignolles Group, a contemporary term used to describe the early representatives of Impressionism around Édouard Manet, Auguste Renoir, Claude Monet and Henri Fantin-Latour, who made a portrait of the group in his famous studio painting of 1870. The name refers to the Parisian neighborhood of Batignolles, in the north west of the city, in which famous artist meeting places, including the Café Guerboi, were located.

Cenotaph (Gr. *kenos,* "empty" and *taphos,* "tomb"), already existent in prehistoric times, a cenotaph commemorates one or more deceased, but does not contain any bodies. A famous example is the Cenotaph in London, commemorating the war dead

Cloisonné (Fr. *cloisonner,* "to partition; separate with partitions"), the term is based on a technical process in enamel painting in which the liquid enamel is pored into small elements made of metal wire; It is the description of a painting technique in which juxtaposed bold and flat colors are separated by strong dark contour lines; The technique was particularly prominent during the late Impressionist period and practiced by Émile Bernard and Paul Gauguin, protagonists of "synthetic" painting.

Complementary contrast, contrasts created by using complementary co-

lors (red – green, blue – orange, yellow – purple) that have a very decisive effect on a painting's overall color atmosphere.

Daguerreotype, named after the man who invented the process, Louis Jacques Mandé Daguerre (1787–1851), it is the oldest photographic technique in which a silver-plated copper plate is developed into a light-sensitive photograph base by means of iodine or bromine vapors. Each daguerrotype is a one-off. In 1839 the patent was bought by the French government and made available for public use.

Divisionism, see *Pointillism.*

Eclecticism (Gk. *eklegein,* "to select"), in art and architecture a term that is usually used with negative connotations and describes the adoption, often arbi-

trary, of various existing forms of representation, motifs and structures in the style of earlier art works and periods employed because of the artist's lack of creativity.

Expressionism, early 20th-century art movement ("Les Fauves," "Die Brücke," "Der blaue Reiter") that found its expression primarily in paintings and prints rather than in sculpture; established as a counter-reaction to the Impressionist manner of seeing, which had already been cast into question in the late 1880s, and as a reaction to naturalism and academicism. Members of the Expressionist movement strove for intellectualization and objectification while abandoning the faithful reproduction of reality. Bold, undiluted colors, which were not in keeping with natural ones, served the subjective expression of represented reality and the

illustration of essential qualities.

Fauvism (Fr. *fauves,* "wild animals"), a trend in French painting founded in the first decade of the 20th century by Henri Matisse (1869–1954) and a group of post-Impressionist painters that renounced plasticity and three-dimensionality and based their work on pure vivid colors.

Genre painting (Fr. *genre,* "kind, sort; manner"), paintings whose subject matter included typical scenes and events from the everyday life of specific professional groups or social classes. The representations were, therefore, also referred to as genre pictures, scenes or views. Genre painting reached one of its high points in 16th and, above all, in 17th century Netherlandish art, when the subject matter became more sophisticated and independent genre

forms evolved, including depictions of soldiers and conversation pieces. In the 18th century courtly genre painting appears with scenes depicting shepherds, gallant celebrations and cheerful rural scenes. The form also became characterized by a satirical and sentimental expression. The 19th century also gave genre painting new subject matter and significance with its depictions of laborers and farmers at work.

Gouache (It. *guazzo;* Fr. *gouache*), a painting technique using water soluble paints that, however, unlike watercolor painting, uses very opaque colors. The pigments are mixed with a bonding agent (gum arabic or dextrose) and whitener, which gives the gouache its flat-colored, "chalky" appearance; It had been used in miniature portrait painting since the 15th century because the paint became lighter after drying

and sculptural effects could be created with it.

History painting (Lat. *historia,* "knowledge; story"), an academic painting form that had been held in high esteem since the 17th century and had motifs from human history as its subject matter. In addition to mythological tales, actual events also became established themes (including Napoleon's campaigns). History painting replaced Christian themes in the hierarchy of genres. Universal principles, which were derived from the representation of historic events, were also supposed to be valid for the present time. With the dissolution of the academic tradition in the 19th century a slow decline of history painting took place, accompanied by the emergence of realistic and naturalistic movements; Thomas Couture (1815–1879) and Jean Léon Gérôme (1824–1904) were the last major history painters in France.

Illusionism (Lat. *illusio,* "irony, mockery, deception;" Fr., *illusion,* "illusion, delusion"), using perspective and other artistic methods, it creates the impression of a three-dimensional representation on the two-dimensional image or relief surface.

Japonism, the term used in France from 1860 to describe the imitation of picturesque Japanese objects. Primarily imparted by the world fairs in Paris and Vienna at which Japan presented itself on a grand scale for the first time to the Western public, resulting in an increased interest in Japanese art that occasionally served artists, such as Edgar Degas, Félix Vallotton and Gustav Klimt, as a source of inspiration.

Les Vingt (Fr. "The Twenty"), also Les XX, an artists' community founded in 1883 by 20 Belgian artists, sculptors and critics

in order to stage jury-free exhibitions because the members were dissatisfied with the selection processes of the Brussels Academy and the Paris Salon. The group did not represent a unified style, but rather presented Realism, Impressionism, Symbolism and Art Nouveau next to each other. The artist group Les Vingt had a decisive effect on the modernization of art in Belgium, inviting foreign artists, such as James Abbott McNeill Whistler (1834–1903), Claude Monet (1840–1926) and Auguste Renoir (1841–1919), to participate in their shows. The frequent participation of Paul Signac (1863–1935) and Georges Seurat (1859–1891) led to the development of a Belgian Neo-impressionist style with an international presence. Important Les Vingts members included James Ensor (1860–1949), Fernand Khnopff (1858–1921), Theo van Rysselberghe (1862–1926), Félicien Rops (1833–1898) and

Henri van de Velde (1863–1957). The group broke up in 1893 after mounting 126 exhibitions.

Lithography (Gk. *lithos,* "stone" and *graphein,* "to write"), the oldest form of flatbed printing, it was developed between 1796 and 1798 by Aloys Senefelder in Munich. Widely used in later years, the process involved drawing an image on a limestone with an oil-based ink or chalk. Acid that was then applied to the slab ensuring that the printing ink adhered only to the drawing and that only this was transferred to the paper in the ensuing printing process.

Nabis (Heb. "prophets, enlightened"), an artists' group headed by Paul Sérusier that met in 1888/89 in Paris and, led by Paul Gauguin (1848–1903), distanced itself from the Impressionists by pro-

moting expression, concentrated forms and colors and a strong interested in emotional values as essential traits of a new artistic truth. Artists such as Pierre Bonnard, Edouard Vuillard, Félix Vallotton, and Henri Toulouse-Lautrec developed a new style of illustration with lithography that was to point the way for modern book design.

Naturalism, the collective name for scientific positions based on a natural understanding of things. From approximately 1870 to 1900 Naturalism attempted to represent reality, which was perceived by sensory experience, as realistically as possible, meaning without idealizing the object and to depict this reality with scientific precision. In contrast to Realism, which was also based on the exact description of natural circumstances, Naturalism was concerned with the sensory dimension of observation; the moral

and socio-critical question was of the most immediate importance. The spokesman of literary Naturalism was Émile Zola (1840–1902), who credited artistic methods as being cogent to human existence.

Neo-impressionism, an emerging art movement at the end of the 19th century that became a revival movement in Impressionist painting. Georges Seurat (1859–1891) made the method of applying short brushstrokes placed next to each other, which created the impression of a surface that first became recognizable in the viewer's perception, the highest principle of painting. Seurat wanted to give the spontaneous, Impressionistic painting process a scientific foundation; studies in physical, optical and color theories by E. Chevreul, Ch. Blanc and O.N. Rood substantiated his theories. Closely set and continuous points of paint ("Pointillism,"

"Divisionism" or "Chromoluminarism") do not just reproduce the color value of the represented object but also the color of light as a reflection of the object. Seurat experimented with his "scientific Impressionism" for the first time in his painting, "Bathers at Asnières"(1884, London, National Gallery), which was initially presented to the public in 1884 at the first Salon des Indépendants. Other Neo-impressionist painters included Paul Signac (1863–1935), Camille Pissarro (1830–1903) and Henri-Edmond Cross (1856–1910).

Œuvre (Fr. "work"), an artist's body of work.

Oil paints, light-resistant, mixed paints made of dried oils, various admixtures and insoluble pigments (colored powder) in the oil itself. The binding agents used for the pigment were usually linseed, poppy and walnut oils.

Orientalism, a special form of general exoticism in European art. Oriental trends, promoted by travelogues as well as by the academic and growing tourism-related development of the Middle East and Egypt, reached a high point in 19th century French painting. Subject matter included everything from genre paintings to realistic and imaginary landscapes and scenes from ordinary life.

Pastel (Iz. *pasta,* "dough"), a painting and drawing technique using soft colored sticks made of compressed pigment. These are known to have been used before 1500 in France and initially were only employed for making drawings in the way that silverpoint, charcoal and red chalk were. Soft, toned and natural paper usually serves as the picture support. This technique was used in the 16th and 17th centuries in Italy, the Netherlands and

France, where it experienced its heyday in the 18th century.

Paysage intime (Fr. "intimate landscape"), a variety of landscape painting that emerged in mid-19th century France that cultivated simple, atmospheric and intimate landscape details rather than imaginary, heroic or idealized landscapes. Among its founders were members of the Barbizon School surrounding Théodore Rousseau (1812–1867) and Jean-François Millet (1814–1875).

Pigment (Lat. *pigmentum,* coloring substance, from "pingere", to paint), a coloring substance; most pigments are dry powders, which can then be combined with a neutral binding agent, e.g. oil, water or resin. When creating frescoes (wall paintings on wet plaster), the pigments were only mixed with water.

Plein air painting, (Fr. *en plein air,* lit. "in full air", i.e. outdoors), in contrast to studio painting. Its task became the realistic representation of the natural conditions of a landscape and its atmosphere, as well as of the changing conditions of light. In the mid 19th century many French painters, above all those who belonged to the Barbizon School, began painting their works outdoors following the example of English landscape painters, such as John Constable (1776–1837) and Richard Parkes Bonington (1801–1828). Impressionist painters declared plein air painting to be an implicit principle of the painterly process.

Pointillism (Fr. *point,* "dot"), a painting movement that emerged towards the end of the 19th century in France. The Neoimpressionist process of juxtaposing pure colors, so that the color tones were first

recognizable by means of optical blending in the eye when viewed at a certain distance, became the movement's overriding principle, promoted and resolutely developed by Georges Seurat (1859–1891) who created his works by juxtaposing his point and comma-like brushstrokes of unmixed paint in a strict schematic manner. This new painting technique, which Seurat referred to as "Divisionism" was first presented to the public in 1884 in Paris in an exhibition of the Indépendants.

Pont-Aven, School of, a loose artists' association that began meeting in the Breton town of Pont-Aven in 1888; The group's initiator was Paul Gauguin (1848–1903), who rejected the conception of nature promoted by Naturalism, for instance the Barbizon School, in favor of the idea of something that emerged from personal sensation and that put the transformation

of this independent image vehicle into the forefront. So-called Synthetism became the preferred means of representation used to convey the natural way of life and immediate impressions of nature. Les Nabis and the Symbolists evolved out of the Pont-Aven School. The group's leading figures included Gauguin, Émile Bernard, Paul Sérusier and Armand Seguin.

Portrait (Fr. *portrait;* Lat. *protrahere,* "to draw forth"), the portrayal of a specific person through the rendition of his/her individual features. A similarity with the person thus represented (the "sitter") should be recognizable but must not necessarily correspond to the naturalistic appearance. In the case of a more idealized portrait the sitter is rendered in more detail by means of name, professional status, attributes, symbols or coat of arms. The main purpose of a portrait is the representation of the absent person (possibly because deceased), personal memory and reverence, which is why, after religious art, this genre had the most important status in the fine arts. A distinction is made between individual, double and group portrait depending on the number of figures represented.

Realism, a painting and literary style prevalent, above all, in the second half of the 19th century. One of the movement's main spokesmen and leaders was the painter Gustave Courbet (1819–1877). In an attempt to come to terms with a way of representing reality, Realism rejected the idealizing and classifying tendencies in painting. In his publication "Le Réalisme" from 1855, Courbet made a plea in favor of topicality and the relevance of the present in painting, whose true task was to design real portrayals of the " social milieu." This representation made a reflection of political, social and ideological of contemporary phenomena possible that was of use to both the represented figures and society in general. Courbet's solo exhibitions in 1855 at the Exposition Universelle and in 1867 were programmatic highpoints of the Realism movement.

Salon (Fr., It. *salone,* originally "large hall"), a term applied in everyday usage in 18th and 19th-century France to describe an exhibition space, as well as the Academy art exhibitions staged from 1667 in the Louvre's Salon d'Apollon. Beginning in 1737 exhibitions took place biennially and, after the French Revolution, every year in the Louvre's Salon Carré. Towards the end of the 19th century the official Salon jury was dissolved and cleared the way for a committee comprised of state-approved, former Salon artists, who made up

the Société des Artistes Français.

Salon des Indépendants (Fr. "Salon of Independents"), created in 1884 following conflict with the official Salon in Paris, this was an association of "undiscovered and rejected artists" that later became the model for the Secession movements in Europe's art centers. In contrast to the Salon des Refusés they were not publicly organized.

Salon des Refusés (Fr. "Salon of the Refused"), exhibitions mounted in 1863/64 and 1873 in opposition to the conservative cultural policies of the official Parisian Salon; works that had been rejected by the Salon were displayed. The Salon des Refusés was organized by Napoleon III; participants included Edouard Manet, Paul Cézanne, Henri Fantin-Latour, Camille

Pisarro and James McNeill Whistler.

Secession (Lat. *secessio,* "separation"), the separation of one artistic community from an existing traditional union or from the academic Salon system out of protest; examples include the Munich Secession of 1892, headed by Franz von Stuck (1863–1928), and the Vienna Secession of 1897, led by Gustav Klimt (1862–1918).

Still life painting (a direct translation of the Dutch, still-leven), also called *nature morte* or *natura morte* (Fr. and It, "dead nature"), a painting genre that gained particular importance in 17th-century Netherlandish painting and was devoted to the highly lifelike depiction of "still," motionless things. Depending on the emphasis of depicted objects, distinctions are made between flower and fruit still lifes

and hunting, kitchen and market pieces. Classified as an inferior genre in 18th-century academic painting, the style was rediscovered by the Impressionists. They were far less interested in the illusion of the object than in the expression of the quest for a colorful expression and painterly quality of apparently meaningless objects.

Synthetism (Fr. *synthèse,* "summary"), a term that became important in the Pont-Aven School and was primarily used by Paul Gauguin (1848–1903) to describe his process of creating an image. The painting's motif is saved in the painter's mind by means of an intellectual synthesis and reproduced on the canvas according to his memory; the result is not thus realistic colors but rather imagined forms and decorative spatial arrangements on the painting. A real motif is thus rendered superfluous. In 1889 the

Groupe Synthétiste organized an exhibition in which Paul Gauguin, Émile Bernard, Charles Laval and Louis Anquetin participated.

Universal Exposition, or World Fair, in France "Exposition Universelle", following the Great Exhibition held in London in 1851, an international fair or exhibition in which nations present their achievements in the fields of technology, science and culture. The exhibition structures and pavilions are often important elements of the event, famous examples being the Crystal Palace (London 1851) the Eiffel Tower (Paris 1889) and the Atomium, (Brussels 1958). Such events have been held every few years since 1851

Watercolor, painting technique with transparent water-soluble paints. The pigments are mixed with a binding agent, such as gum arabic (a sticky jelly extracted from African acacia), and applied with water, allowing the paints to remain water soluble after they dry. This painting method generally forgoes drawing and line and includes the base coat as an independent form.

Further Reading

Baudelaire, Charles: Der Künstler und das moderne Leben. Essays, Salons, intime Tagebücher, Leipzig 1990

Boime, Albert: The Academy and French Painting in the 19th Century, London 1971

Borchert, Stefan: Heldendarsteller. Gustave Courbet, Edouard Manet und die Legende vom modernen Künstler, Berlin 2007

Broude, Norma: Gustave Caillebotte and the fashioning of identity in impressionist Paris, New Jersey 2002

Clark, Timothy J.: Painting of Modern Life. Paris in the Art of Manet and his Followers, New York 1985

Corot, Courbet und die Maler von Barbizon »Les amis de la nature«. Ed. C. Heilman und J. Sillevis. Catalogue Munich (Haus der Kunst) 1996

Crepaldi, Gabriele: Der Impressionismus. Künstler, Werke, Fakten, Sammler, Skandale, Cologne 2007

A day in the country. Impressionism and the French Landscape. Catalogue Los Angeles (County Museum of Art) u. a. 1984/85

Degas and the Dance. Ed. Jill De Vonyar und Richard Kendall. Catalogue Philadelphia (Museum of Art) 2002

Feist, Peter H.: Impressionismus. Die Erfindung der Freizeit, Leipzig 2007

Vincent van Gogh und die Moderne. Catalogue Essen (Museum Folkwang), Amsterdam (Van Gogh Museum) 1990/91

Gärtner, Peter J.: Kunst & Architektur. Musée d'Orsay, Cologne 2000

Grimme, Karin H.: Impressionismus, Cologne 2007

Hartman, P.C.: Französische Könige und Kaiser der Neuzeit. Von Ludwig XII. bis Napoleon III. 1498 – 1870, Munich 1994

Hofmann, Werner: Degas und sein Jahrhundert, Munich 2007

Impressionismus. Eine internationale Kunstbewegung 1860 – 1920. Ed. Norma Broude, Cologne 2001

Impressionismus. Paris – Gesellschaft und Kunst. Ed. Robert L. Herbert et al., Stuttgart 1989

Impressionismus – Wie das Licht auf die Leinwand kam. Cologne (Wallraf-Richartz-Museum & Fondation Corboud) 2008

Impressionistinnen. Ed. Ingrid Pfeiffer und Max Hollein. Catalogue Frankfurt a. M. (Schirn Kunsthalle), San Fransisco (Fine Arts Museum) 2008

Japan und Europa 1543 – 1929. Ed. Doris Croissant. Catalogue Berlin (Martin-Gropius-Bau) 1993

King, Ross: Zum Frühstück ins Freie. Manet, Monet und die Ursprünge der modernen Malerei, Munich 2007

Knaus, Albrecht: Das Tagebuch der Julie Manet. Eine Jugend im Banne der Impressionisten, Munich – Hamburg 1988

Landschaft im Licht. Impressionistische Malerei in Europa und Nordamerika 1860 – 1910. Ed. Götz Czymmek. Catalogue Cologne (Wallraf-Richartz-Museum), Zürich (Kunsthaus) 1990

Malerei des Impressionismus. Ed. Ingo Walther (2 Bde.), Cologne 1996

Manet and the sea. Ed. David Updike. Catalogue Chicago (The Art Institute) 2003/04

Meier-Graefe, Julius: Renoir, Frankfurt a. M. 1986

Claude Monet (1840 – 1926). Ed. Odile Poncet. Catalogue New York (Wildenstein Gallery) 2007

Monet, Kandinsky, Rothko und die Folgen. Ed. Ingried Brugger und Johannes Meinhard. Catalogue Wien (Kunstforum), Munich 2008

The New Painting: Impressionism 1874 – 1886. Ed. Charles S. Moffet et al., San Fransisco (Fine Arts Museum), Washington (National Gallery of Art) 1986.

Origins of Impressionism. Ed. Henri Loyrette und Gary Tinterow. Catalogue Paris (Galeries Nationales du Grand Palais), New York (The Metropolitan Museum of Art) 1994

Auguste Renoir und die Landschaft des Impressionismus. Ed. Gerhard Finckh. Catalogue Wuppertal (Von der Heydt-Museum) 2007

Rewald, John: Die Geschichte des Impressionismus. Schicksal und Werk der Maler einer großen Epoche der Kunst, Cologne 1979

Rewald, John: Von van Gogh bis Gauguin. Die Geschichte des Nachimpressionismus, Cologne 1987

Ross, Werner: Charles Baudelaire und die Moderne, Munich 1993

Schreiber, Hermann: Die Belle Epoque. Paris 1871 – 1900, Munich 1990

The Second Empire. Art in France under Napoleon III. Catalogue Philadelphia (Museum of Modern Art) et al. 1978/79

Sagner – Düchting, Karin: Claude Monet und die Moderne, Munich 2002

Spies, Werner: Dressierte Malerei – Entrückte Utopie. Zur französischen Kunst des 19. Jahrhunderts, Stuttgart 1990

Sternberger, Dolf: Panorama oder Ansichten vom 19. Jahrhundert, Düsseldorf-Hamburg 1974

Szenen aus der fließenden Welt. Meisterwerke des Japanischen Holzschnitts. Neuss (Clemes-Sels-Museum) 2007

Vollard, Ambroise: Erinnerungen eines Kunsthändlers, Zürich 1996

Wilms, Johannes: Paris. Hauptstadt Europas 1798 – 1914, Munich 1988

Zola, Émile: Schriften zur Kunst. Die Salons von 1866 – 1896, Frankfurt 1988

Index of Works

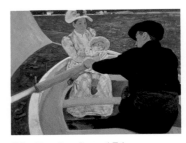

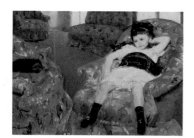

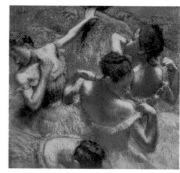

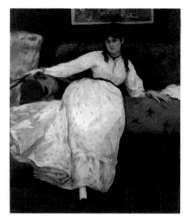

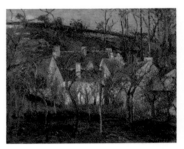

Picture Credits

© AKG images, Berlin (108, 109, 110, 163, 169, 194, 238, 239; Erich Lessing 84), © Artothek/Washington National Portrait Gallery (176), © The Bridgeman Art Library, Berlin (Art Gallery of South Australia, Adelaide 261; Art Gallery of Ontario, Toronto 200; Art Institute of Chicago, IL 159, 228, 229; Ashmolean Museum, University of Oxford 136; The Barber Institute of Fine Arts, University of Birmingham 50; The Barnes Foundation, Merion 89; Bibliothèque Litteraire Jaques Doucet, Paris/Archives Charmet 111; Brooklyn Museum of Art, New York 44, 263; Brooklyn Museum of Art, Museum Collection Fund 79; Burrell Collection, Glasgow 187; Cleveland Museum of Art, OH 65; Collection Kharbine-Tapabor, Paris 20; Fitzwilliam Museum, University of Cambridge 265; Fogg Art Museum, Harvard University Art Museums Bequest of Annie Swan Coburn 90; Fogg Art Museum, Harvard University Art Museums, Bequest from the Collection of Maurice Wertheim, Class 1906 195; Galleria d'Arte Moderna, Palazzo Pitti, Florence/Alinari 267; Gemäldegalerie, Berlin 121; Haags Gemeentemuseum, The Hague 266; Hamburger Kunsthalle 39, 151, 161, 205, 256; Hermitage, St. Petersburg 38, 183; Hugh Lane Gallery, Dublin 68; Isabella Stewart Gardner Museum, Boston 254; Kunsthalle, Bremen 102; Kunsthistorisches Museum, Vienna 66; Mellon Coll., National Gallery of Art, Washington D.C. 96; Metropolitan Museum of Art, New York 98; Metropolitan Museum of Art, New York/Lauros/Giraudon 42, 160; Musée des Beaux-Arts, Rouen/ Lauros/Giraudon 34, 61, 220; Musée des Beaux-Arts, Tounai 114; Musée Claude Monet, Giverny/Giraudon 76, 77; Musée de la Ville de Paris, Musée du Petit-Palais/Giraudon 253; Musée de l'Orangerie, Paris 149; Musée d'Orsay, Paris 10, 11, 14, 15, 28, 30, 31, 70, 131, 166, 198, 206, 236; Musée d'Orsay, Paris/Giraudon 6, 9, 12, 17, 33, 69, 92, 94, 100, 106, 127, 134, 137, 141, 142, 146, 152, 154, 156, 157, 167, 170, 172, 199, 262; Musée d'Orsay, Paris, Lauros/Giraudon 11, 14, 15, 112, 105, 180, 188, 202, 203, 230; Musée d'Orsay, Paris/Peter Willi 64, 221; Musée du Petit Palais, Paris 140, 162; Musée Marmottan, Paris/ Giraudon 6, 48, 56, 62, 126, 133, 173, 185; Musée du Petit Palais, Paris 140, 162; Musée Rodin, Paris/Peter Willi 80, 81; Museo d'Arte Moderna di Ca' Pesaro, Venice 258; Museu Calouste Gulbenkian, Lisbon 71; Museum of Art, Santa Barbara 179; Museum of Art, Rhode Island/Lauros /Giraudon 164; Museum of Fine Arts, Boston – Anonymous gift in memory of Mr and Mrs Edwin S. Webster 124; Museum of Fine Arts, Boston, The Hayden Collection – Charles Henry Hayden Fund 177; Museum of Fine Arts, Boston, Bequest of John T. Spaulding 128; Museum of Fine Arts, Boston, M. Theresa B. Hopkins Fund 97; Museum of Fine Arts, Boston, 1951 Purchase Fund 74, 104; Museum of Modern Art, New York 242; National Gallery, London 85, 87, 192, 233; National Gallery of Art, Washington D.C. 23, 174; National Gallery of Scotland, Edinburgh 244, 245; National Museum and Gallery of Wales, Cardiff 218, 220; Nelson-Atkins Museum of Art, Kansas City 82; Neue Pinakothek, Munich 18, 58, 247, 248; Norton Simon Collection, Pasadena 193; Philadelphia Museum of Art, Pennsylvania 196; Philadelphia Museum of Art, Pennsylvania/Peter Willi 93; Petit Palais, Geneva/Peter Will 168, 169, 208, 209; Phillips Collection, Washington D.C. 144; Portland Art Museum, Oregon 117; Private Collection 7, 24, 27, 47, 54, 122, 211, 213, 214, 216, 250; Private Collection/Archives Charmet 8, 148, 178; Private Collection/DACS 259; Private Collection/DACS/Giraudon 236; Private Collection, Lauros/Giraudon 118; Private Collection/Peter Willi 36; Private Collection/Photo Lefevre Fine Art Ltd, London 45, 73; Pushkin Museum, Moscow 54, 190, 251; Samuel Courtald Trust, Courtald Institute of Art Gallery 86, 182; Sheffield Galleries and Museums Trust 231; Städelsches Kunstinstitut, Frankfurt-am-Main 21; Städtische Kunsthalle, Mannheim 120; Walters Art Museum, Baltimore 37; Worcester Art Museum, Massachussetts 78

Publisher's Information

Thanks to Anne Williams and Felicitas Pohl for their assistance in finding illustrations.

© h.f.ullmann publishing GmbH

Original title: *Impressionismus*
ISBN 978-3-8331-4938-2
Project management: Lucas Lüdemann
Author: Martina Padberg
Contributors:
Anke von Heyl, pp. 108–111
Antonia Loick, pp. 202–205
Holger Möhlmann, pp. 238–241
Editor: Kathrin Jurgenowski
Graphics editor: Hubert Hepfinger
Layout: Buchmacher Bär
Cover Design: Simone Sticker
Cover: *The Sleeper,* Auguste Renoir
Photo © Lefevre Fine Art Ltd., London / The Bridgeman Art Library

© for the English edition: h.f.ullmann publishing GmbH
Special edition

Translated by Miriamne Fields and Marie Frohling
Edited by ce redaktionsbüro für digitales publizieren
Typeset by ce redaktionsbüro für digitales publizieren
Project coordination for the English edition by Kristina Scherer
Overall responsibility for production: h.f.ullmann publishing GmbH, Potsdam, Germany

ISBN 978-3-8480-0392-1

Printed in China, 2013

10 9 8 7 6 5 4 3 2 1
X IX VIII VII VI V IV III II I

www.ullmann-publishing.com
newsletter@ullmann-publishing.com